New Mexico Artists at Work

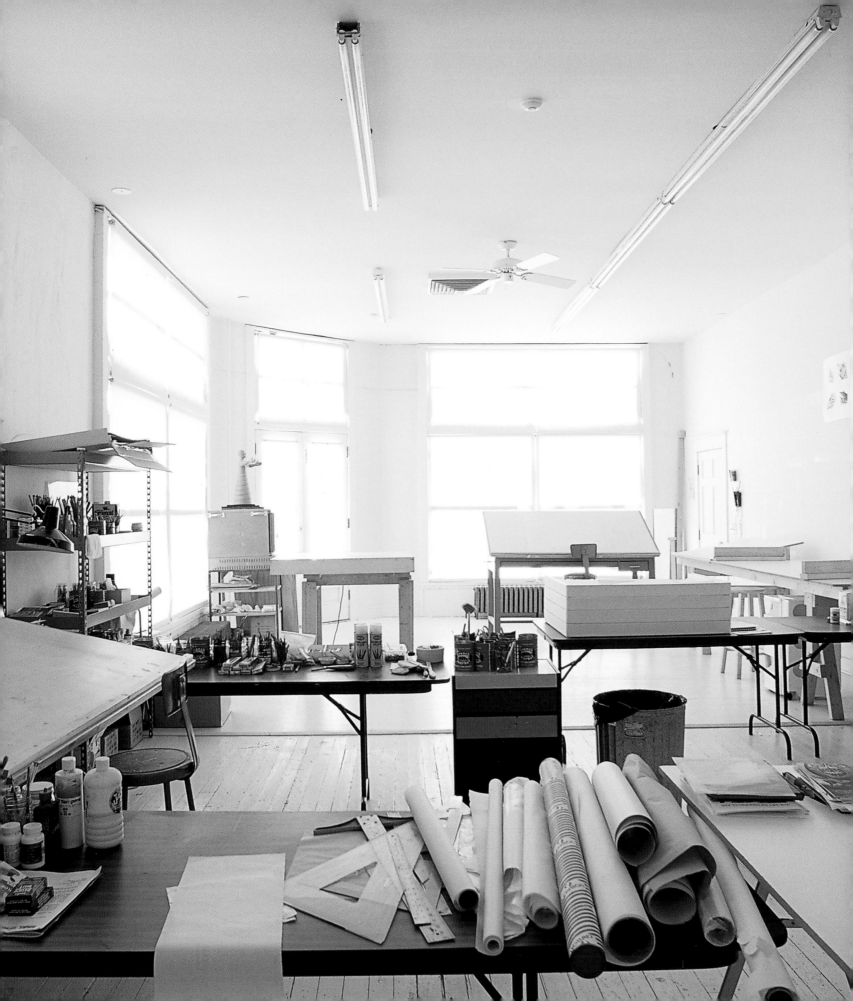

New Mexico Artists at Work

TEXT BY DANA NEWMANN

PHOTOGRAPHS BY JACK PARSONS

MUSEUM OF NEW MEXICO PRESS

SANTA FE

DEDICATION

To our families, Gene and Alba, Rebecca, Alex and Chris.

ACKNOWLEDGMENTS

We are grateful to Linda Durham for her invaluable introductions to several artists featured in this book. We would also like to thank Mary Wachs, David Skolkin, and Anna Gallegos for their fine work and commitment to this project.

Dana Newmann
Jack Parsons

Project editor: Mary Wachs
Manuscript editor: Nicky Leach
Design and production: David Skolkin
Manufactured in Singapore
10 9 8 7 6 5 4 3 2 1

Library of Congress Cataloging-in-Publication Data
Newmann, Dana.
 New Mexico artists at work / text by Dana Newmann ; photographs by
Jack Parsons ; foreword by Joseph Traugott.— 1st ed.
 p. cm.
 ISBN 0-89013-439-1 (clothbound : alk. paper)
 1. Artists' studios —New Mexico. 2. Artists —New Mexico —Biography.
I. Parsons, Jack, 1939– II. Title.
 N8520.N49 2005
 709'.2'2789—dc22

 2004016748

Museum of New Mexico Press
Post Office Box 2087
Santa Fe, New Mexico 87504

Frontispiece: Studio of Judy Chicago (see pages 99–101).

CONTENTS

S

ECLUDED IN THEIR PRIVATE STUDIOS, contemporary New Mexico artists fashion mysterious materials and diverse philosophical outlooks into eclectic works of art. As personal retreats, these cultural laboratories promote aesthetic production by shielding an artist's creativity from public inquiry. Closed studio doors serve as polite "keep out" signs protecting artists from interruptions and unwanted influences.

Romantic misconceptions about artist studios can be traced to the end of the nineteenth century when the literary journals published articles showing behind-the-scenes studio views. For example, the illustrations in Charlotte Adams's essay "Artists' Models in New York," published in the February 1883 issue of *Century* magazine, illuminated more about the studios than the artists and their models. Large, plush, and filled with exotic props, these dated stereotypes bear little relationship to the constructed, often spare, almost sacred spaces described by Dana Newmann and Jack Parsons.

Contemporary works of art look significantly different in and out of the studio. Consequently, New Mexicans have come to regard the way images appear in the studio as an artist's real work. The arts community seeks these insider views of art and culture so that they can see an artist's work in its purest form, unsullied by commerce and the influence of other artists' work.

FOREWORD

By Joseph Traugott, Ph.D., Curator of Twentieth-Century Art, Museum of Fine Arts, Museum of New Mexico

Curiosity about the works hidden behind studio doors encourages outsiders to wonder what motivates artists. What new images and ideas are developing now? As viewers wish for a peek inside a studio, they seek to be the first to respond to new creations. It often seems overly intrusive and wholly inappropriate to ask artists to allow a visit into their studio worlds. They have generously solved this dilemma by allowing us to peek into their private lives and to scrutinize their books, collections, interests, and sources. And how clever of Newmann and Parsons to transform us, as curious outsiders, into sophisticated insiders as they make these fascinating New Mexico artists accessible to all.

I FIRST MET PHOTOGRAPHER JACK PARSONS in September 2002, when he came out to our place in Ribera to photograph my husband, painter Eugene Newmann, in his studio. After the shoot, while Jack was packing up his equipment, we chatted about some of his books. I told Jack, "The only book *I'd* be interested in doing would be one on artists' studios." To which he replied, "If *you'll* do it, *I'll* do it." This project had its origins in that simple exchange.

I had been collecting studios, in my head, for thirty years, since first coming to Santa Fe: Sam Scott's, the Riekes', the Grahams', Carol Mothner's. The relationship of artist, work, and studio has always fascinated me. The particularity and quirkiness of each artist's response to the task of making an environment in which to work says a lot about their view of the world and their place in it. Beyond that it offers a glimpse of, and a clue to, the alchemical process by which something apparently comes from nothing.

By the time of that first conversation with Jack, it was already too late to document some of my favorite studios. Bruce Lowney's boxcar parked out between Grants and Zuni and Eli Levin's handmade and ultra-Bohemian adobe on Camino Don Miguel were both gone by the turn of the millennium, converted to other uses. Even so, Jack and I felt enthusiastic about the prospect of putting notable studios on the record.

For a long time I had admired the work of photographer and writer Alexander Liberman, whose book *The Artist in His Studio* (1960) chronicled the ateliers of a generation of French artists. But it is not only in Paris and New York that artists and their studios have been the subjects of curiosity and research. While gathering information for this book, I was reminded again that the practice of documenting the artistic life and its locations has a long tradition in New Mexico.

In the 1970s and '80s, when I scoured Santa Fe garage sales looking for treasure, I was able to collect some of the early photographs that popularized the iconography of New Mexico's "enchantment." Along with the pictures of pueblos, churches, adobe house interiors, and Santa Fe Fiesta celebrations—by photographers both anonymous and well known—I also found images of early New Mexico artists captured by Will Connell, Ernest Knee, and T. Harmon Parkhurst.

In her unique way, Mabel Dodge Luhan, for decades a powerful patron of the Taos art scene, made a significant contribution to the record. Luhan described her friends, and sometime guests, in the book *Taos and Its Artists* and included photographs by Laura Gilpin, Alfred Stieglitz, and John Candelario—hired specifically by Luhan to portray the artists in her circle.

Our knowledge of the early history of art in New Mexico is fleshed out by the artists themselves who recorded their experiences and romantic enthusiasm in letters, journals, articles, and photographs. Among the earliest events chronicled by American artists in this state is the legendary arrival of New York painters Bert G. Phillips and Ernest Blumenschein in 1898. The two friends had arrived by railroad in Denver and were headed for Mexico via New Mexico on a painting trip when a wheel on their horse-drawn wagon broke outside Taos. Blumenschein lost the toss of a coin and had to take the broken wheel to be fixed in town. It is notable, and it attests to how old the impulse is to document the artist's life in New Mexico, that Phillips immediately photographed the collapsed wagon and the retreating Blumenschein. Looking back, this act seems almost prophetic of the persistent self-conscious documentation, by artists and others, of the Bohemian adventure in New

Photograph taken outside Taos on September 4, 1898, by Bert G. Phillips—documenting Ernest Blumenschein and the broken wagon. Courtesy Museum of New Mexico Photo Archives, Negative 40377.

Mexico. This continuity of documentation makes clear that there are certain recurring motifs—they almost constitute a tradition—found in the ways New Mexico artists occupy their workspaces.

Bert Phillips never got to Mexico. While waiting for his friend's return—it took two full days for Blumenschein to get back—Phillips succumbed to the high-country beauty and clear light of northern New Mexico. He abandoned his original plan and instead decided to stay in Taos, eventually building a house and studio at the edge of town. It showed features that can be seen in many art studios today.

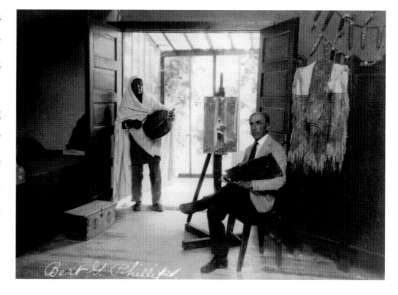

Bert G. Phillips in his studio with a Pueblo Indian model, ca. 1925. Courtesy Museum of New Mexico Photo Archives, Negative 40392.

Phillips shared with painters Frederic Remington, Joseph Henry Sharp, and others a sense of mission to record the life and culture of what was then thought to be the vanishing American Indian. At Taos Pueblo he hired native models to pose for him in their homes, and later, when a serious eye ailment impaired his ability to travel, his models and friends built a replica of a pueblo room in one corner of his studio. They made the replica authentic in every detail, including *vigas* (ceiling beams), a corner *kiva* fireplace, and even adobe walls with an alcove, or *nicho*. The addition allowed Phillips to work with Indian models who sat for him "in the interior of a Pueblo home." If this situation blurred the line between stagecraft and authenticity, it also facilitated some of his most memorable works.

Forward-looking artists at the turn of the twentieth century were appreciative of the arts and culture of other civilizations. We know that Van Gogh admired Japanese woodcuts and that the young Picasso frequented Paris flea markets, snapping up African sculptures on the cheap long before the taste for so-called primitive art became a sign of cultural sophistication. American artists who traveled throughout the Plains and the Southwest acquired pre-American goods. Indian pots, rugs, medicine-bags, and parfleches were displayed in their studios along with the more standard holdings.

The ornate studio prevailed in the nineteenth and early twentieth centuries, reflecting the range of cultural interests found in the Victorian aesthetic. Even in New Mexico, painters frequently worked in sumptuous rooms, with Persian or Navajo rugs underfoot and surrounded by their extravagant ethnographic collections. The fascination with this grand style is revealed in the many photographs of the era that show the artist triumphant in this setting.

Victorian furniture and American
Indian artifacts grace the Oscar E.
Berninghaus studio of the mid-
1920s. Courtesy Museum of New
Mexico Photo Archives, Negative
40393.

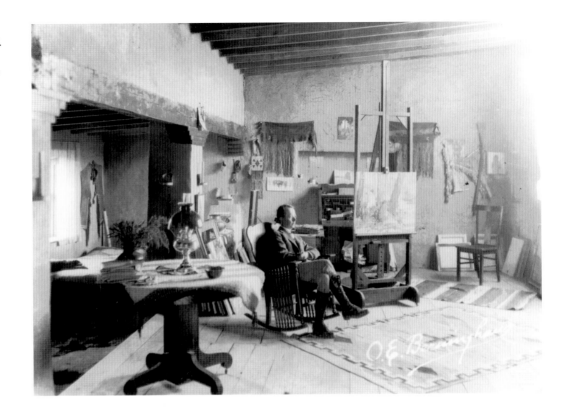

Ernest Blumenschein's and Nicolai Fechin's residences in Taos border on the baroque. Both houses, now open to visitors, are preserved much as they were when in use by the artists. Russian-born Fechin handcrafted—in a combination of Pueblo, Spanish, and Russian styles—all the decorative elements of his dwelling, whereas Blumenschein surrounded himself with fine European and Spanish Colonial furniture, antiques, and paintings.

Accumulating and displaying things by category, or by some other associative order, seems to be fatefully appealing to artists; most collect something, whether it be brushes or art book—or positive reviews of their work. Although the tastes and sensibilities of today's artists differ from those of a traditional collector like Blumenschein, many of them nonetheless have displays and arrangements in their studios through which they proclaim their sense of what counts. Some artists thrill to the formal perfection they discover in nature or even in humble man-made objects not traditionally valued as beautiful. Others respond to the metaphoric or subconscious resonance in a cast-off glove or a weathered metal sign. With age certain objects acquire a patina, the iridescence of time or decay; the act of retrieval and display celebrate a kind of heroic promise

of resilience and transformation. Perhaps these impulses have special poignancy here in New Mexico where erosion of land and culture is always threatened.

Southwest artists especially appreciate Native American and Hispanic art and artifacts, display them in their studios, and reference them in their own work. They also, in hard times, use their expertise in material culture to augment their income by trading in these goods.

Lean periods are a familiar experience among artists in these parts, as elsewhere. The individuality that makes studios interesting is often the result of creative ingenuity overcoming economic constraints. Artists are among those who place a high premium on recognizing the promise in prospects others would consider barren. Hence, in the early twentieth century, those who trusted their originality and wit put their money on Taos. Other New Mexico communities have since received the stamp of approval: Santa Fe, Roswell, El Rito, the list goes on.

The painters who came west wanted to paint inside nature, not at its edge, as they felt the French Impressionists had done. This required special arrangements. Taoseño Joseph

"Ourselves and Taos Neighbors," painting by Ernest Blumenschein. Artists Bert Phillips, Victor Higgins, Ernest and Helen Blumenschein, Walter Ufer, and Joseph Henry Sharp are pictured, along with Mabel Dodge Luhan.

Joseph H. Sharp working beside his mobile outdoor studio, a converted shepherd's wagon he affectionately referred to as "The Prairie Dog." Courtesy Taos Historic Museums.

Henry Sharp would work on location in a shepherd's wagon he had adapted for use as a mobile outdoor studio. The Prairie Dog, as he christened it, even had a skylight made of sheet mica. Living in the landscape while painting it was loosely in keeping with the eccentric recommendation of the early Long Island genre painter William Sidney Mount, who believed that an artist should have no home. Mount devised a horse-drawn atelier and found it to be, in his words, "an extract of the very best studios in the world."

When the automobile came into practical use, it became a lot easier to scout the countryside and do paintings on the spot. Andrew Dasburg, an early modernist painter who originally came out to New Mexico in 1918 and went on to have a long and influential career here, would drive out and park on the shoulder of some rural road, or overlooking a little village, and draw there. That the practice was common is clear from the many 1930s photographs that show artists setting up their easels near a car.

A century after Sharp's outings in his shepherd's wagon, Galisteo artist Catherine Ferguson and fellow painter Paul Steiner use a van as their studio. Their working method is to drive around the countryside looking for a location. Often, Ferguson says, this will entail some argument between them. When they agree on a place—if the weather is nice—the two oil painters set up their easels outside. If the weather is bad, Ferguson works in the back of the van (in the company of the dogs) while Steiner paints up front.

Actually, Sharp's *plein air* experience was limited to making preparatory sketches; the work was usually completed in the substantial studio he established in downtown Taos, where he always had three or four easels set up so that he could paint several canvases at one time. In 1910 Sharp purchased a convent and renovated its flat-roofed chapel, removing one wall to create a large studio, replacing the dirt floor with wooden flooring, and raising the beams to create a steeply pitched roof into which he built a great north window. Light from this window shone directly on a large model's stand. Sharp also built a traditional kiva fireplace with mantel and hearth. On high shelves and throughout the room, the artist displayed his extraordinary collection of Indian pottery, gathered during painting trips in New Mexico and Arizona.

By the 1920s, a consistent pattern of design characteristics, many derived from Pueblo and Hispanic traditions, formed recurring motifs in the construction and decoration of artists' homes in New Mexico. Lady Dorothy Brett's studio in Taos and Olive Rush's place in Santa Fe are good examples of the preferred style.

Olive Rush bought her hundred-year-old adobe, at 630 Canyon Road, from the Sena-Rodriguez family in 1920. The renowned muralist loved the thick adobe walls and the inner portal that faced a spacious garden. Once she had put in electricity and plumbing, Rush established a studio in one of the rooms, decorating it in what was to become classic "Santa Fe Style": *vigas* and the fireplace were ornamented with American Indian symbols, Navajo rugs lay on the floor, furniture was carved in traditional northern New Mexico fashion, and Rush's Pueblo pottery collection was displayed. A lifelong Quaker, she hosted weekly meetings in her home and bequeathed her house and studio to the Religious Society of Friends when she died in 1966 at age ninety-three. The property continues to belong to the society.

The Canyon Road *barrio* where Rush lived became a principal art neighborhood in Santa Fe with the rise of the art colony beginning in the late teens. In those same years an active art community was developing in Taos. As far back as 1912 the pioneering artists there had organized a cooperative, The Taos Society of Artists, that promoted their work nationwide. By the end of the decade the Taos art colony featured a central personality, the magnetic Mabel Dodge. The artists, writers, and intellectuals whom she attracted there were drawn by a number of incentives, including, in no small measure, the free studio space she offered her guests.

The story of Mabel Dodge's arrival in Taos has the same flavor of serendipity that permeates many artists' descriptions of their discovery of New Mexico. While living in Paris, the young Dodge, a wealthy, restless New York socialite, had become friends with Gertrude Stein, under whose influence and example the visiting American came to value the idea that artists have the power to create new realities and reinvent their lives. Mabel came to New Mexico in 1917 to reunite with her husband, painter Maurice Sterne, whose health problems had brought him earlier to Taos. Upon her arrival in Santa Fe she found it "too touristy"

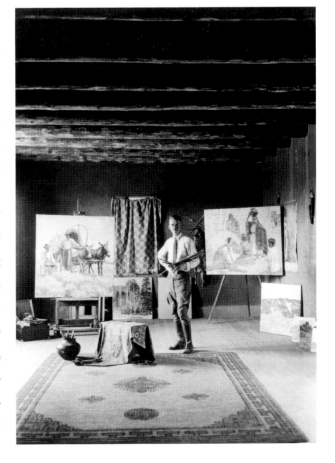

The Pueblo-Hispanic architectural traditions are evident in the grand Taos studio of E. Martin Hennings. Courtesy Museum of New Mexico Photo Archives, Negative 40395.

and hired a car to take her to Taos. Once there she announced, "Here I belong and here I want to stay." Within the month an enthusiastic Mabel wired painter Andrew Dasburg in New York to come to Taos and "bring a good cook." Dasburg arrived, with a chef in tow, early in 1918.

While living in Taos with her husband, the free-spirited young woman responded at once to the physical attraction she felt when she met Taos Pueblo leader Tony Luhan. Her feelings were immediately reciprocated, and the two formed a deep bond. Luhan recommended to her a twelve-acre site adjoining Pueblo land that had a small adobe house on it. Dodge bought the property, and the two began at once to draw plans for the building they intended to put there, scratching them into the red-brown dirt with a stick. Built in neo-Pueblo style, the realized structure was large and commodious and absorbed the little adobe homestead within it, a swallowing process still seen in village architecture "upgrades" in New Mexico. Within ten years of coming to Taos, Mabel had shed Sterne, married Luhan, and added five houses—plus studios, walls, stables, corrals, and a pigeon cove—to her property. She delighted in filling the premises with famous, creative, and entertaining guests.

By our contemporary standards the artist facilities in "Mabeltown" were rudimentary. Looking back at those early years, Mabel would later reflect on how basically inconvenient the studios must have been for her guest artists. The rooms were heated by smoky woodstoves, there were no refrigerators for cooling drinks (or beer), and steep ladders—rather than stair steps—gave access to the sleeping lofts. "Yet," she said, and surely this was a bit of irony, "no one ever complained."

A pivotal event in New Mexico's art history took place in 1929 with the arrival of Georgia O'Keeffe in Taos. Mabel Dodge Luhan had contacted the painter in New York City, offering her a studio ". . . any time she wished to come." O'Keeffe, who at that time was nursing her husband, photographer Alfred Stieglitz, to health after a heart attack, decided that a sojourn in the Southwest would be revitalizing. She convinced her friend, artist Rebecca Salisbury Strand, to accompany her, and on May 28 they arrived in Taos. O'Keeffe was captivated by the land, the air, and the colors she found there.

During the first three weeks, the New York visitors stayed in the so-called Big House with Mabel, but then they relocated to the more private Pink House. O'Keeffe was given a separate adobe studio on the property. She painted well in that space and returned to New York with images of sky, land, adobe, and light. She would come back to Mabel's place in 1930, once more painting in a studio on the estate. During that trip, O'Keeffe

discovered Abiquiú and Ghost Ranch, and by 1949 she was permanently settled in the area. She continued to live and work there until shortly before her death in Santa Fe in 1986.

For more than two decades, the charismatic Mabel hosted a glittering array of writers, musicians, and artists at her Taos compound. The world-class guest list included D. H. Lawrence and his German wife Frieda, Dorothy Brett, Paul Strand, John Marin, Maynard Dixon, Ansel Adams, Leon Gaspard, Carlos Vierra, Edward Weston, and Mabel's friends Andrew Dasburg and Leo Stein.

As the Taos art colony was revolving around Mabel's fabled soirées, artists in Santa Fe were laying claim to their own neighborhoods of preference. From 1920 on, as many as eight artists clustered their studios around the intersection of East Buena Vista, the picturesquely named Camino de las Animas—Path of the Spirits—and Old Santa Fe Trail, known in those days as College Avenue. This district became one of the first of Santa Fe's art settlements. Resident there were Paul Burlin, a New York painter; Carlos Vierra, the first painter to live in Santa Fe (1904); Randall Davey, who worked in this location for a year before moving to Upper Canyon Road; and Will Shuster, who over the years had several residences in town. Henry C. Balink was nearby on Old Pecos Trail and, at some point, both Raymond Jonson and B. J. O. Nordfeldt had houses on Camino de las Animas.

At 409 Camino de las Animas, master printmaker Gustave Baumann had a cottage that he had designed around a large studio, built in 1923 by architect T. Charles Gaastra and builder George Gaastra. The original studio was a long room that ran along the rear of the residence and received its illumination via the almost obligatory north-facing windows. (Even today, in an age of sophisticated lighting technology, many artists still design their studios to take advantage of the vaunted "evenness" of the natural light that comes in through north-facing windows, clerestories, or skylights.)

In the main house, two distinctive rooms related to Baumann's profession as an artist. One was a long, eight-sided space, lit by an octagonal skylight. It was referred to as "The Little Gallery" because of the framed paintings on the walls and matted prints displayed on a bookcase. Guests as well as patrons often gathered there. The other eccentric space was a windowless concrete room fitted with a steel door. Baumann used this room as fireproof storage for prints, printing blocks, paintings, and documents.

As his family grew, Baumann converted his studio into the family living room and built himself a separate workspace behind the house. The studio there was strictly for

work and off-limits to visitors. It was a small two-room building whose interior walls were painted white and left otherwise unadorned, which was in direct contrast with the rooms in the house, where, in addition to other decorative themes, the artist painted Indian-derived friezes in green, red, white, and black along the upper parts of the walls.

About a mile east of Baumann's house is famed Canyon Road, today lined with art galleries. Originally an Indian trail that wound its way along the Santa Fe River and up into the canyon, it was used to cross the Sangre de Cristo Mountains en route to Pecos Pueblo. In Spanish times, sheep were herded along it to pastures upriver. One block south of Canyon, a parallel road, Acequia Madre, is shaded by large cottonwoods and lined with homes, small garden plots, and orchards that still draw their water supply from the *acequias*, the traditional irrigation ditches in the Spanish Southwest. The exotic lifestyle and architecture of these neighborhoods intrigued tourists and painters alike, and, by 1920, artists began living and working on or near Camino del Cañon, as it was known.

This east side district continues to be identified with the art history of the city the way Greenwich Village is the icon of New York's artistic and Bohemian heritage. Judy Chicago, Fritz Scholder, and John Chamberlain have lived along its picturesque streets. Many of the residences have been in continuous use as artistic, commercial, and cultural venues ever since the early artists settled there. The building at 553 Canyon, for example, was designed and used by artist and architect William Penhallow Henderson, husband to poet Alice Corbin. It later became Fremont Ellis's studio. In the 1930s and '40s, artist Hal West, father of painter Jerry West, worked and entertained, famously, at the corner of Canyon Road and Camino Escondido. In the early 1970s, that modest building was converted into an art gallery by the Uruguayan artist and writer Ernesto Mayans.

At the upper end of Canyon Road, near the aqueduct and traditional Hispanic grazing lands, is Randall Davey's estate. In 1920, Davey, an artist of international reputation, bought the land and sawmill on it from the Manuel Trujillo family. He converted the two-story stone mill into his residence and built a separate adobe studio. The flat-roofed Spanish Territorial-style building, with its wooden floors, high bank of windows, and kiva fireplace, has been preserved in its original condition and is, along with the Davey residence, open to the public. (In 1983, the Randall Davey Foundation gave the property to the National Audubon Society, which now administers it as an educational center, bird preserve, and historic site.)

Camino del Monte Sol, which intersects Canyon Road, was once known as "Artist's Row" because of the many writers and painters who lived along it, most notably the five

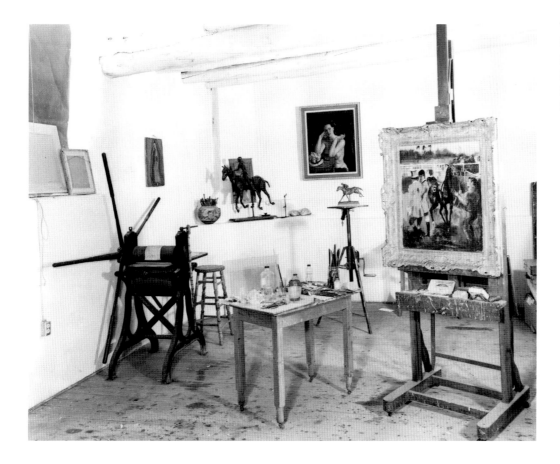

artists known as Los Cinco Pintores. They were Jozef Bakos, Fremont Ellis, Willard Nash, Will Shuster, and Walter Mruk, a group of young arrivals "pledged to take art to the people and not to surrender to commercialism." On the whole they were individualistic artists who, unlike the members of the Taos Society of Artists, did not share much in the way of a common theory or professional strategy. They had come to Santa Fe to paint and were inclined to support each other personally, if not stylistically. Their solidarity was reflected in their decision to build their houses and studios side by side and, to a large extent, cooperatively. By 1922 they were settled in on the camino, as Bakos remarked "the five little nuts in five adobe huts." Parties were the order of the day, and studios were always open.

Even before the free-wheeling *pintores* crowd was inventing a colony on the east side, the Museum of Fine Arts—as early as 1917—was trying to draw artists to Santa Fe by offering, as their declaration stated, "all possible facilities to the artists who come to the Southwest." This included "studios freely at their disposal and other conveniences to save their time and make the most of their powers."

Over the years, the museum provided free temporary studios in the restored Palace of the Governors and adjacent buildings to many artists. Among them were Robert Henri—a teacher of both Andrew Dasburg and John Sloan—George Bellows, Gerald Cassidy, Marsden Hartley, Randall Davey, Olive Rush, Willard Nash, Gustave Baumann, and, later, Pueblo artists Crescencio Martinez, Awa Tsireh, and Ma-Pe-Wi, as well as famed Hopi artist Fred Kabotie.

The New Mexico magic, however, did not work for every guest. Even though Marsden Hartley persisted in painting New Mexico themes long after his stays in the state, he was disdainful of the quality of the work he saw done while he was here in 1918. Taos, he wrote, "is the stupidest place I ever fell into. Lovely landscape here and there, but the society of cheap artists from Chicago and New York makes the place impossible, and they tell themselves that the great art of America is to come from Taos. Well there will have to be godlike changes for the better in this case." Modernist painter Stuart Davis, who was offered one of the free studios at the Palace of the Governors, came all the way from New York to find himself overwhelmed and incapacitated by the scale of the landscape and spent much of his residency inside his studio painting still lifes.

The windows of the studios face out onto the Palace of the Governors courtyard, where a group of artists is painting, 1917. From left, Kenneth Chapman, Carlos Vierra, ?, Edgar S. Cameron, and Sheldon Parsons. Photograph by Wesley Bradfield, courtesy Museum of New Mexico Photo Archives, Negative 3325.

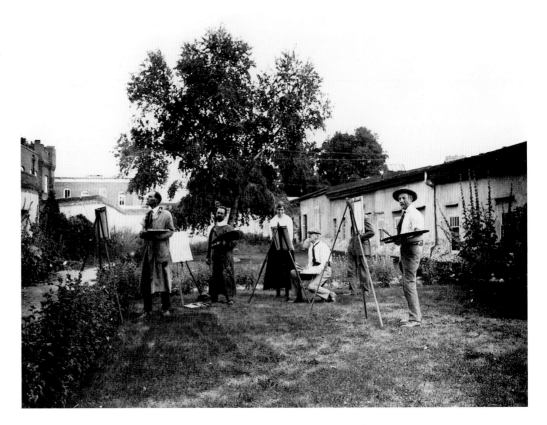

Although Santa Fe's Museum of Fine Arts modified its policy in 1920—("The museum extends its privileges . . . to all who are working with a serious purpose in art.")—the concept of the studio as a form of public recognition and reward continues to play a role in New Mexico to this day.

The practice of offering studio space to artists, initiated in Taos by Mabel Dodge Luhan, has been continued there by the Helen Wurlitzer Foundation. When asked how painters sustained themselves in Taos in the 1950s, Earl Stroh recalled how the Wurlitzer kept him "afloat in those early years." In addition, some one hundred and fifty artists, as of this writing, have benefited from the Roswell Artist-in-Residence Program in southern New Mexico, and The Santa Fe Art Institute offers partial residencies and studios to approximately forty artists and writers each year.

Many artists' first studio experience comes in a classroom setting. The historically important Studio at the Santa Fe Indian School, a program initiated by Dorothy Dunn in 1932 to teach Indian students nonethnographic easel painting in a fine-art context, provided talented student-artists such as Oscar Howe, Awa Tsireh, Quincy Tahoma, Pablita Velarde, and Pop-Chalee with sustained support in their formative careers. Pop-Chalee eventually joined the other artists on Santa Fe's east side, at 720 Acequia Madre. Chalee, who was Tony Luhan's niece and lived at Taos Pueblo as a child, said of Mabel Dodge: "She didn't have to introduce *me* to the artists [in Taos], I knew all the big artists there. I used to go to their studios and watch them paint. That's where I spent half my time as a kid. . . . I was crazy about art!"

Artists have always clustered together in the face of meager resources. A recent example of the dynamics that shape the growth of an art community is Santa Fe's historic Guadalupe Street and Railyard district, which in the 1970s and '80s was mined for studio space by painters and sculptors who found the under-used warehouses and derelict buildings ideal for their purposes.

The Garfield Apartments on the then-unpaved intersection of Guadalupe and Garfield streets, offered affordable, if grungy, flats that some artists converted to studios. At the same time, Ron Adams set up his Hand Graphics lithography shop next to the tracks on Montezuma Street and the Bob Tomlinson Gallery went into business in the basement below. Santa Fe's first art movie house, The Collective Fantasy, was situated next door.

Across the tracks, the Sanbusco building, in earlier years a lumberyard, became a haven for artists and eventually a warren of studios. Painter Sheffield Van Buren was one of the early artist tenants there. "In 1975," Van Buren recalls, "there weren't that

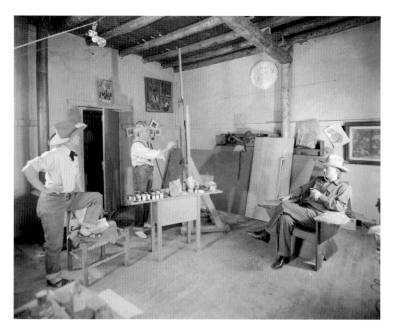

John Sloan at his studio easel, with Will Shuster and Jozef Bakos looking on. Photograph by Ernest Knee, courtesy Eric Knee.

many empty places around that had skylights, so I approached the manager of the nearly uninhabited building and asked if I could rent from him. He said, 'Sure,' and I asked if I could have any part of the space I liked, and he said, 'Sure.'"

"I just got some chalk," Van Buren continues, "and marked off a rectangle of space I wanted, right under the big skylight and long enough to include an outside exit door, and for the back wall I just used sandboard, I think. The owner nailed up some chicken wire to section off the remaining space, and the sculptor John Connell took part of that. Occasionally I'd go over there and see how he was doing. At night I'd often just drive my car through the warehouse gate and park it with the lights shining into the dark of the building, and it was magical."

Over the years more than a dozen artists established workspaces on the Sanbusco property. By the time the new owners decided to turn it into a sales complex, there were artists occupying almost all the space in the main warehouse, outside in the old yard, upstairs in a couple of small offices, and even in the underlit basement. Besides Van Buren and Connell, artists Sam Scott, Eugene Newmann, T. C. Cannon, Julie Sullivan, Dave Rettig, Shelley Horton-Trippe, Harmony Hammond, and Brad Smith—among others—had space there.

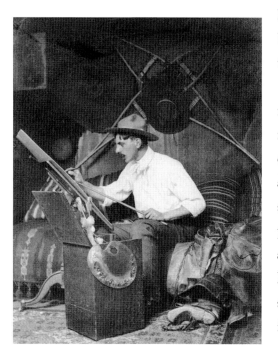

The studio of W. Herbert "Buck" Dunton. The artist felt an urgency to record the vanishing southwestern life. Courtesy Forrest Fenn Collection.

At about the same time, a group of newly arrived "modern" artists in Santa Fe met under the banner of "The Alliance" to criticize commercialism and "reactionary" art. At meetings in artists' studios and at sympathetic galleries, the role of contemporary art in Santa Fe was once more argued in heated exchanges; this process led directly to the Armory for the Arts shows later that decade, which put a new face on the Santa Fe art scene.

The debates and arguments brought artists and supporters into contact with one another. The lively exchanges paralleled the discussions that took place in previous generations in salon settings, such as were provided by Dodge in Taos and in Santa Fe by the famous portraitist Sheldon Parsons. In that context artists made contacts and alliances, and, importantly, had an opportunity to socialize with potential patrons.

Most contemporary artists look to the gallery or art dealer to act as the intermediary between themselves and their clientele, but these resources have not always been available—as was the case with the Cinco Pintores, who beginning in 1923 converted their studios into presentation spaces and initiated a series of weekly exhibitions and receptions both in their studios and residences. Soon other artists adopted similar strategies, merging the concept of studio, gallery, and showcase. It is a practice much in evidence in Canyon Road's owner-artist galleries today, and, in a much less commercial spirit, among some of the artists in this book who periodically open their studios to admirers and potential buyers, so that the work can be viewed in the setting in which it was created.

Some studios are clearly designed to be attractive to clients, who for their part appreciate the intimate glimpse of the creative process—the alchemical transformation—which is absent in their dealings with galleries and museums. Another opportunity for personal contact between artists and audience is afforded by the many studio tours—in Galisteo, on the High Road to Taos, in Dixon, and elsewhere—that are currently very popular. Sometimes the showcasing of art in the studio involves the creation of a special setting, as was the case with Baumann's "Little Gallery." Late in his life, Fremont Ellis created a novel kind of theater for highlighting his work. In the 1980s, he worked in a historic home on Canyon Road, where the tone was radically different from the one that characterized the "little mud hut" on Camino del Monte Sol in which he had lived fifty years earlier. The grand house at 553 Canyon—it stands there still, albeit protected by high walls—has a central space that is two stories high. Ellis painted in it at a towering easel, amidst elegant appointments, polished furniture, and deep-piled carpets. Sometimes he would climb to the second-floor balcony to observe his work from a distance, scrutinizing the composition. "I like to see how my pictures look in that surrounding, as that's where they will hang," he stated.

With few exceptions the studios of New Mexico's "Golden Age," that era between the two World Wars, were extroverted. Their artfulness married a kind of exuberant naiveté with the romanticism of the era. Among the contemporary artists we visited we sensed a tendency toward a different, more inward role for the studio. O'Keeffe's move to

Abiquiú and Ghost Ranch engendered a new way of *being in* the landscape, one that embraced the spare dignity of the old Spanish hinterland. The seductive images of the painter in her quarters, so often reproduced, became the model for the virtuous studio, one that combines restraint, functionality, and beauty. More than anyone else in New Mexico, and more than almost any other artist, O'Keeffe's identity is deeply linked with the image of her studios. Reconciling monastic austerity with lyricism may be a Zen-like feat that only O'Keeffe could pull off, but her studios showed the way for a great number of artists in New Mexico, and elsewhere, who saw in them their own ideals.

Some of the artists we visited arrange their studios as zones of clarity, free of entangling distractions, while others follow O'Keeffe's practice of setting up in the heart of the landscape, away from town. These are both variants on the theme of the studio as a place of retreat, refuge, or healing—sentiments voiced by a number of the artists interviewed.

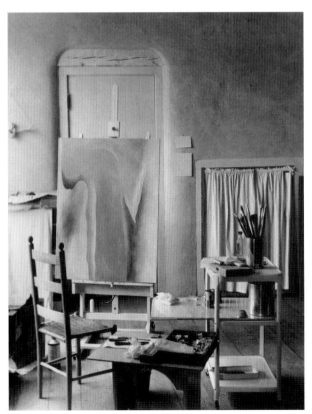

Georgia O'Keeffe studio at Ghost Ranch House, 1962. Photograph by Todd Webb. Courtesy Evans Gallery, Portland, Maine.

The degree to which an artist identifies with his or her studio is a matter of great individual variability. There are studios that grow out of deeply personal processes that are beyond analysis. We visited places that were so elaborately thought out they stand as independent works of art; others were focused places of industry—their features dictated by the artist's practical obligations.

Here in New Mexico, many—though certainly not all—artists seek to integrate the magnificence of the local landscape and its distinctive architectural traditions into their studios. In the course of preparing this book we visited deeply local environments, such as those of native Hispanic artists, as well as classic Santa Fe Style studios based on the *Pintores* tradition. Some of the studios portrayed in this book display urban characteristics, and still others, as indeed can be said for the artists who occupy them, do not fit into any category. The New Mexico art "scene" is composed of a rich mixture of styles—traditional and contemporary, decorative and formal, narrative and abstract, regional and cosmopolitan. This diversity is reflected in the striking individuality of the studios we visited during our travels, ranging from Luis Jiménez's converted apple warehouse in Hondo Valley to Earl Stroh's Taos adobe, evocative of earlier times in northern New Mexico.

New Mexico Artists at Work

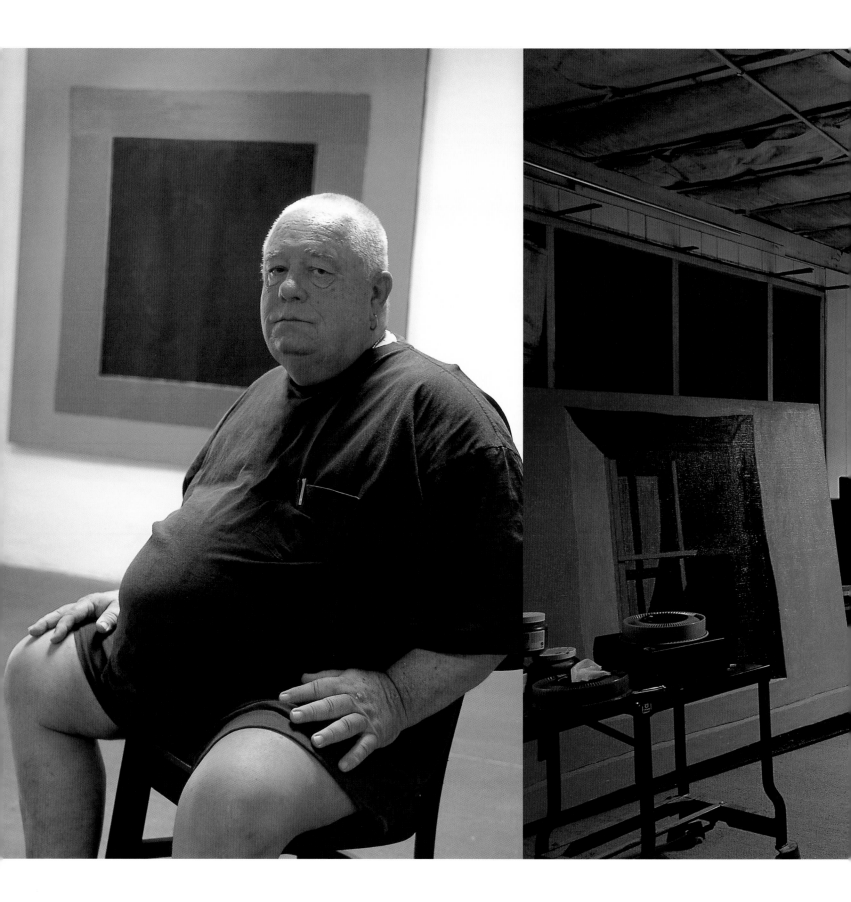

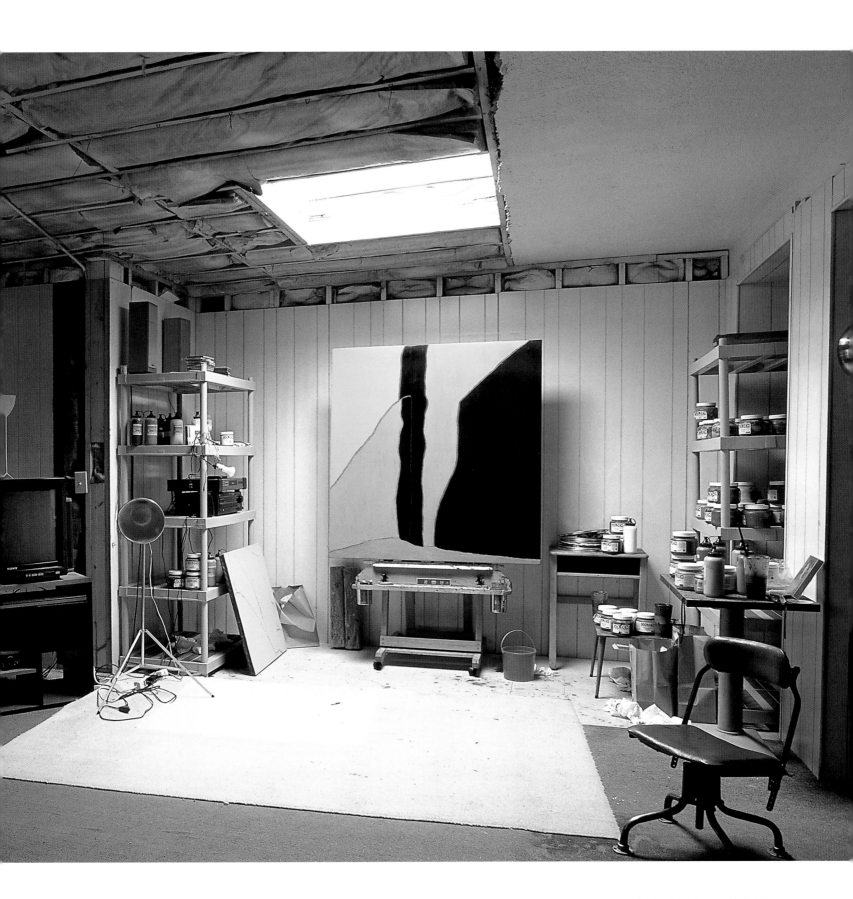

Harold Joe Waldrum

(1934–2003)

IN THE 1980S, artist Harold Joe Waldrum worked in the historic E. I. Couse studio in Taos. Built in the early part of the twentieth century, it has a bank of windows facing north, providing unerringly soft light. It was in this space that Waldrum created many of the New Mexico church paintings for which he is well known.

A decade later, Waldrum moved to Truth or Consequences, in southern New Mexico, where he worked initially in a storefront building on Main Street, and finally in a large building that had been the Ace Hardware store. "I traded a suite of my prints and a couple of paintings for this property," he enjoyed reporting. Before his death in December 2003, he had many plans for the recent acquisition, calling it his *"fantasía gigante!"*

The compound today houses exhibition spaces, the offices of RioBravoArts, Inc.— representatives of his work—as well as living quarters, storage, and his painting area.

Out of the large property he carved a modest studio space, twelve by twelve feet with an eight foot high ceiling, that he stamped throughout with his vivid personality. Left of the entrance was a large double bed comprised of two mattresses, one atop the other; the sheets were tan, the pillowcases were brown, black, or rust. There were two chairs and a table, all on casters for easy mobility. Big acrylic paint jars lined the worktable, and the artist's palette was a new pizza pan—king size. Two easels stood against a far wall, and near the bed there was a large television set with a bright orange Neo-Italian flyswatter on top of it. (The painter asserted that if anything interesting ever came on the TV while he was working he would quickly switch channels.) A sheet obscured the window where once hardware had been displayed, and brilliant green Astroturf covered the studio floor.

On the day he was interviewed, Waldrum was creating spectacular canvases in that room, compositions based on elements of New Mexico church architecture: a buttressed wall, a steeple, a sun-soaked façade. Those vibrating colors, the hint of sunlight along one edge of a building, the stark shadows, were characteristically his.

In his autobiography *Ando en Cueros—I Walk Stark Naked* (1994) he gives extensive details of the rich and colorful life he lived.

For thirty years, the Bell Studio in Taos has been the working space of internationally acclaimed artist Larry Bell. "Originally this was a commercial laundry," he says. "In the late thirties, it served the hospitals, hotels, and restaurants of Taos and New Mexico. It had been for sale for a long time, and when Gus and I got it [referring to photographer Gus Foster] it was a ruin."

The partners split the building, an arrangement that continues to this day. In the 1970s money was tight for Bell, so he renovated his space in very simple, direct ways. He made his studio roughly the same as those he had had in Venice Beach, California. In his words, "Basically I just need a big empty room with high ceilings. My studio is simply a workshop for me."

Twenty-five years later, the building behind his studio, which had been a medical clinic, came on the market, and the artist bought it. Today, the Larry Bell Studio/Annex affords a reception office, large gallery space, personal office and several extensive production areas.

Bell, whose work is found in many major museums, is probably best known for his "light on surface" pieces, which include glass boxes and standing glass walls that were the result of his experimentation with plating techniques. He derived his method from an industrial process that was initially utilized to create shiny silver surfaces in automobile detailing, as well as on children's toy pistols.

The artist used it on his glass pieces to produce an enigmatic and paradoxical transition between transparency and reflectiveness.

Since then, Bell has been associated with art that is accomplished by novel technical means. Because of his work with light, he was known early on, playfully, as Dr. Lux. Subsequently, he has identified some of his series with titles that allude to this nickname: Chairs De Lux, Hydrolux and Game De Lux. Bell says that he works on a series until he exhausts it. "The art is my teacher."

For all the expertise he has developed with the manufacturing processes required to make his art, Bell says that his best working periods are those characterized by spontaneity, improvisation, and intuition.

Currently, the artist is working on a group of large paper pieces he calls Vapor Drawings/Mirage Works. They are created by wrapping sheets of 100 percent rag paper around a drum inside a walk-in vacuum chamber in which minerals such as titanium, platinum, and lapis are vaporized. This procedure deposits extremely thin films of the material on the paper. Each mineral creates a distinct effect. For example, lapis yields a phosphorescent blue, and platinum becomes spectral gray.

The process combines mechanical determinacy with creative spontaneity. Bell quotes John Cage: "Art is a balance between purposeful acts and chance happenings."

Larry Bell

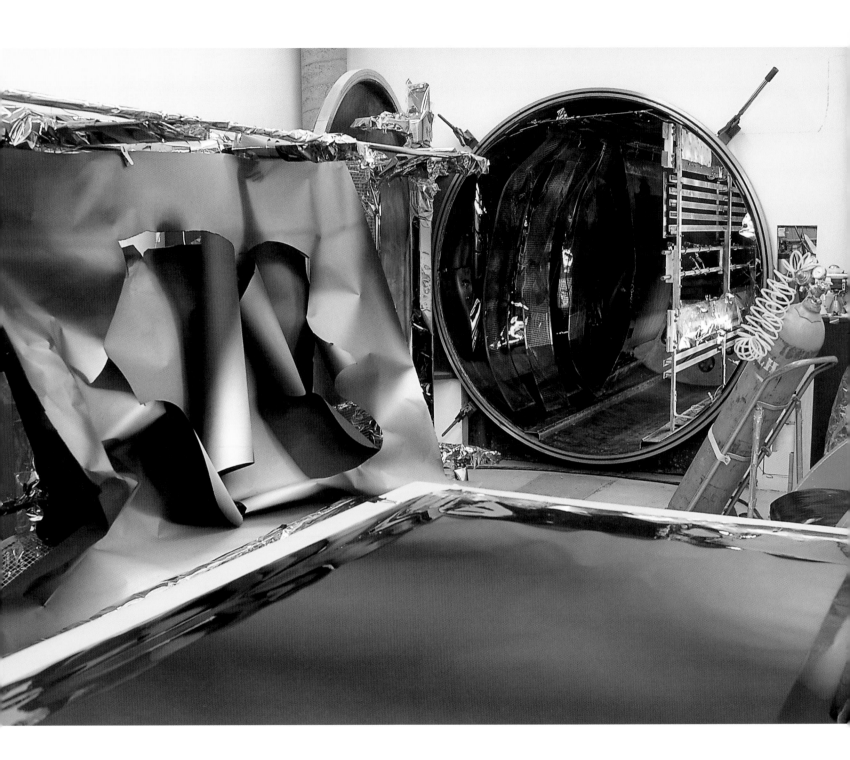

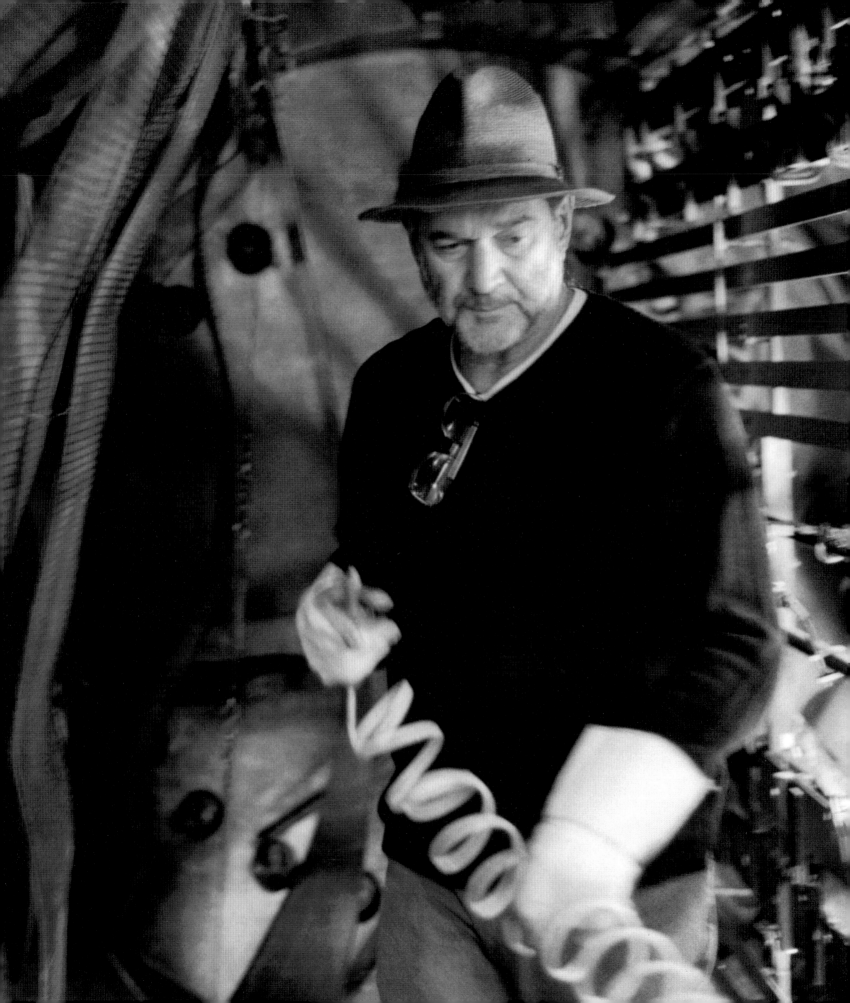

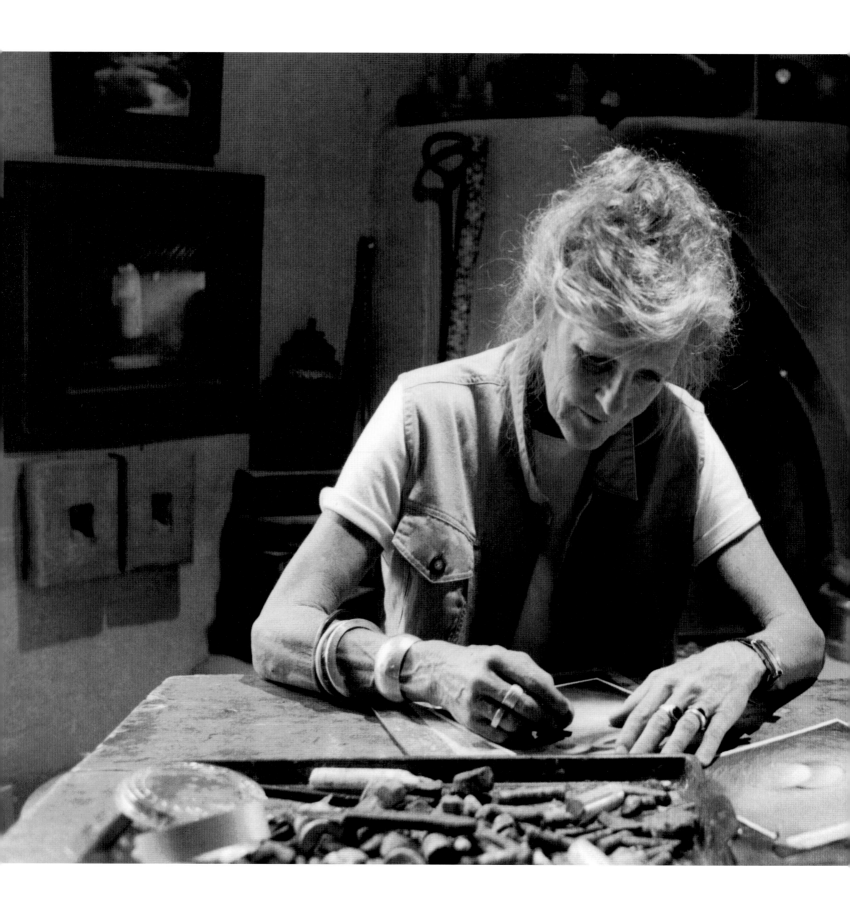

Carol Anthony

SPENDING TIME in these cool, beauty-filled rooms means forgetting the clock and the hour. Gradually, over an afternoon, one notes that when this dedicated artist speaks, often she does so in aphorisms:

"Life is about doing what you need to do: the dogs, the birdseed for the birds, this bowl you fill with eggplants and oranges, the drawing you must work on. All is one."

"New Mexico is a sacred land. I believe that the ones who don't belong here just get as far as the Plaza, but they can never get beyond the silver earrings. You are called here."

"I think of my work as art of the vignette, the Art of the Small."

"I've always been sort of a loner. I've chosen not to have a husband or children—knowing the logistical concerns, and how it could interfere with the silence necessary for inspiration."

"Your work is your nakedness put on the wall."

"In the end it's all there, in the drawing, the painting. Art is who we are."

In an idyllic country setting in Arroyo Hondo, to the southeast of Santa Fe, Carol Anthony lives and works in a hand-built straw-bale house. Her dogs are always with her. "They instruct and inform me," the artist says.

Every room of her house reflects the originality, warmth, and humor of this nationally recognized artist. "This whole house is my studio," she says, in a quiet voice.

And indeed, this is the spirit in which she works. There is a large white drawing table against one wall of the sunken room off the dining room. Her paints and brushes are seen on a table in the light-infused space facing the *ramada*. She often draws, she confides, while sitting at the old monastery table in the dining room, in front of a small fireplace.

Gesturing to the objects in the room, Anthony says, "These are all barters, ancient bits and pieces, gifts from artists, writers, and animal friends. I have always collected special stones and nests, tools, postcards, and books that inspire my work, my life."

Postcards and envelopes have been the subject of two recent series of her paintings and drawings. She says, "Postcards are the footnotes to those love letters we don't need to write."

Like Anthony's enigmatic postcards, the artist's house—that is, her studio—is alive with suggestions of untold stories. What more can we know of the rococo Spanish angel that hangs over the fireplace, or the tiny bird feathers, or the old photos, or the other small, sweet mysteries that fill her rooms? Each remains a seductive enigma.

Bob Haozous

Bob Haozous recalls an experience he had while roughing out an oversized limestone head titled *Screaming Warrior*. The piece had three-inch metal rings screwed into its skull to symbolize its torments. Somehow, the sculpture fell off its pedestal and hit the floor, breaking off its nose. "I've learned not to get mad, but to see such accidents as an opportunity," the artist says. Subsequently, he carved a set of interchangeable noses of different colors, representing separate races. Each nose can be attached to the carved face and, in turn, brings a specific identity to the warrior sculpture. "Because of an accident this piece has gotten better."

Haozous notes that such acts of creativity may occur anywhere and are not necessarily limited to what goes on in the studio. He finds that he is creating, mentally, all day, wherever he is.

Living today on land to the north of Santa Fe, he works in several separate areas. One of them is a three-room building that is so full, both visually and physically, that it is difficult to make one's way through it. The tables, and all other flat surfaces, are stacked with provocative images, many of them culled from popular culture, beauty salons, and department store windows. Some of the mannequins and Barbie dolls have been decorated and embellished by the artist and exist as a kind of work-in-progress, fighting for space with other elements that may be assembled into future work.

Outdoors, there are two sculpting spaces. One he inherited from his father, renowned Chiricahua Apache sculptor Allan Houser, who is now deceased. The other, with an area of approximately five hundred feet, was designed and built by Haozous. It is, in steelworker's terms, "a bay," an area marked off by steel columns, open to the sky except for the beams, fifteen feet overhead. The sculptor inaugurated it by driving his crane up to the structure; now, at last, he could pick up and move pieces weighing ten thousand pounds.

Such industrial-scale facilities are necessary for Haozous, who makes large sculptures in stone and metal, many of which are commissioned for public spaces. The scale and attitude of his work are in contrast to the romanticized low-tech tradition often associated with the work of what Haozous calls "American Native" craftsmen and artists.

Bob Haozous is of Warmsprings Chiricahua Apache descent and could have been expected to go to school at the Institute of American Indian Arts in Santa Fe, where his father established the sculpture program with the school's founding in 1962. Instead, he chose to attend the California College of Arts and Crafts in Oakland in the early 1960s and considers himself lucky to have been in the Berkeley area in those days of social ferment.

Some of Haozous's work is seen as confrontational. Addressing this, the soft-spoken artist defines his work as heavily political but tempered with humor. He believes it is the artist's role to raise questions of identity, of responsibility, and to make the viewer think about issues that are sensitive and difficult.

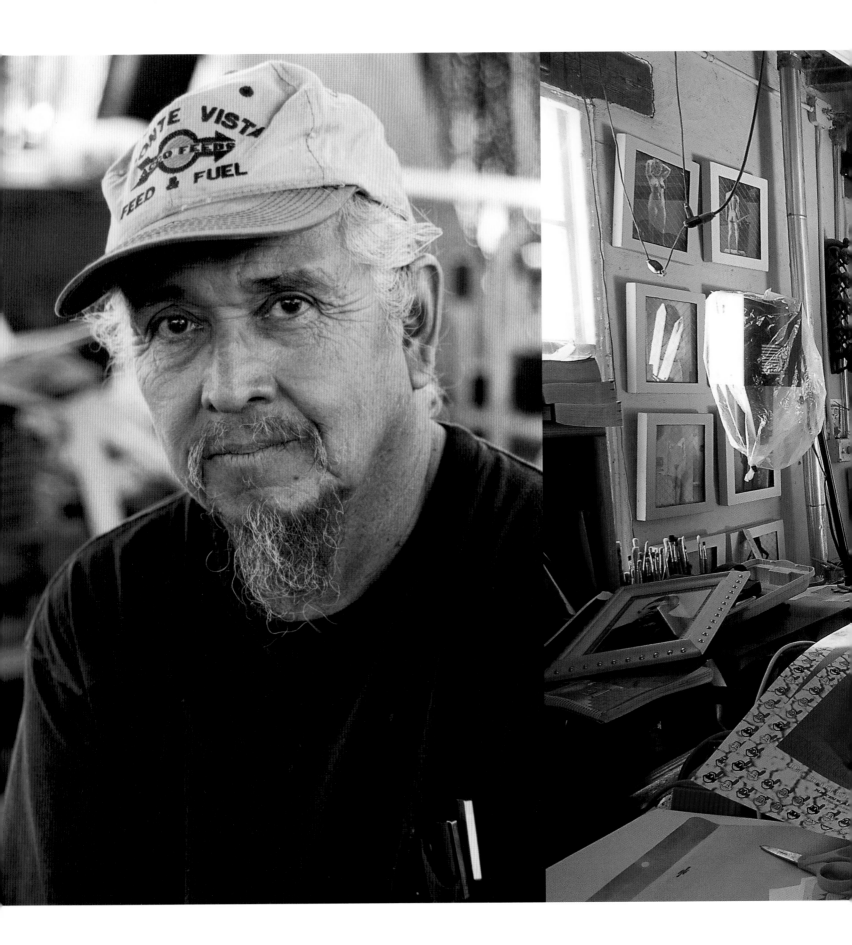

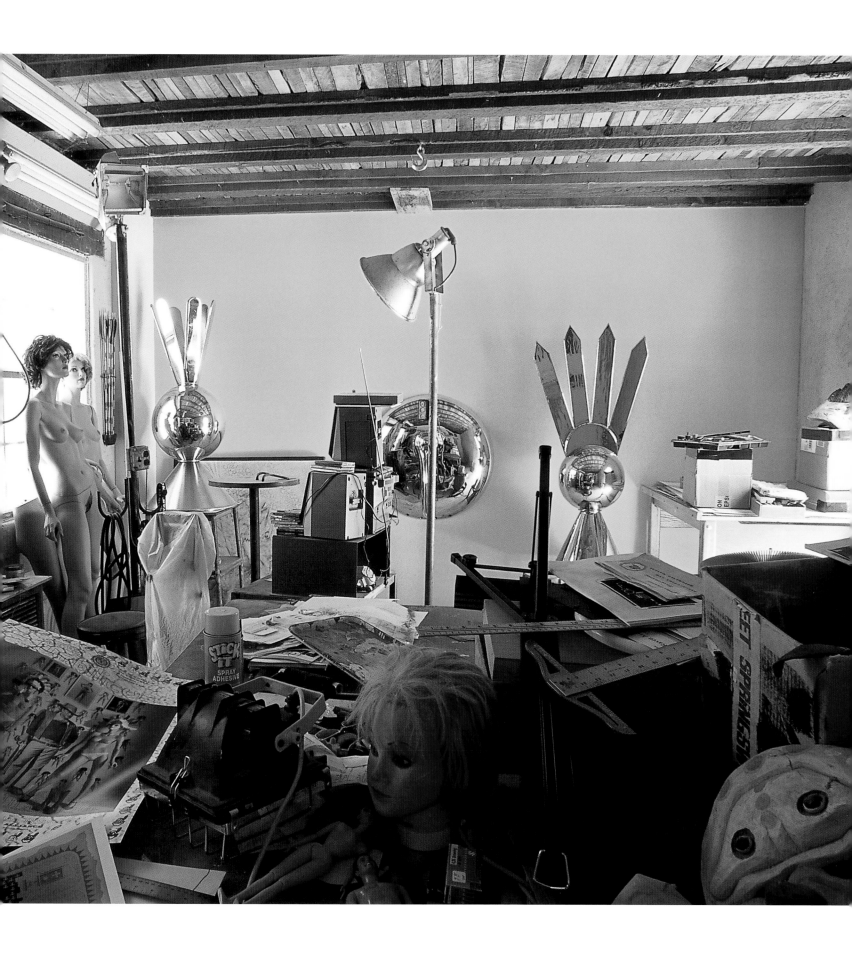

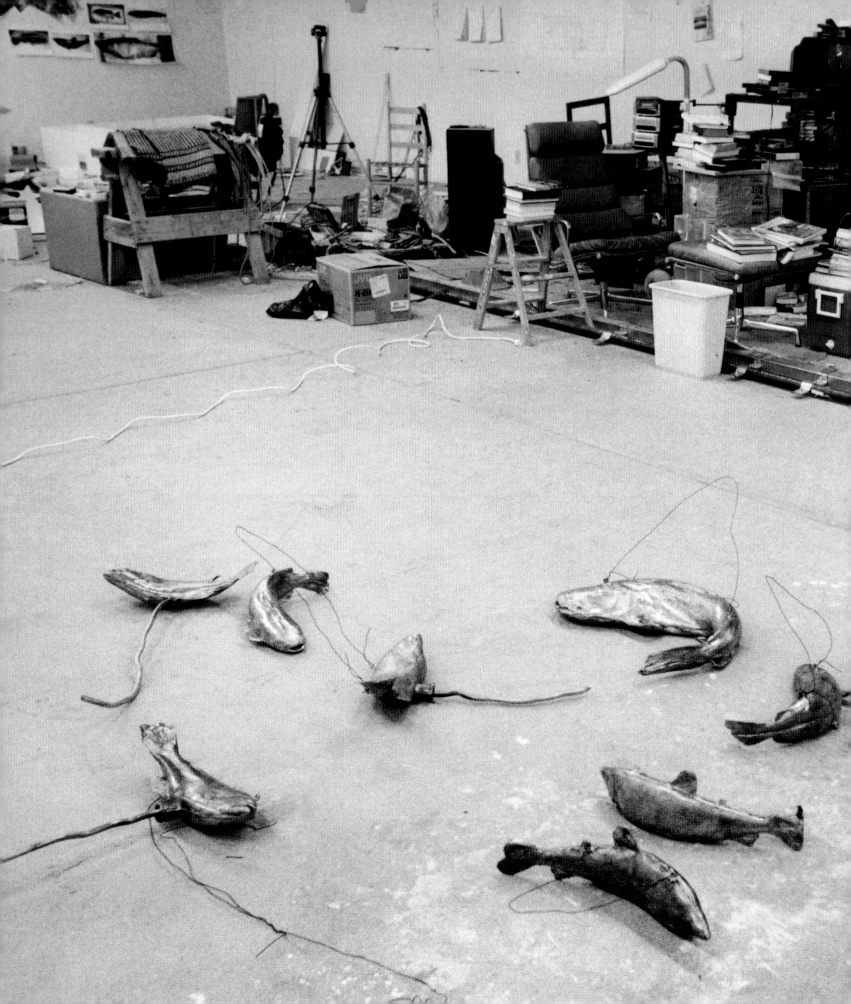

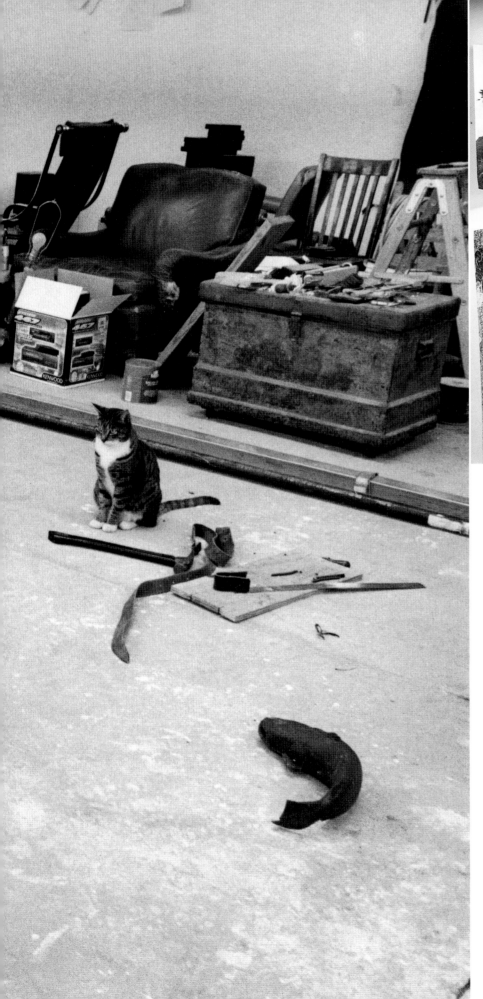
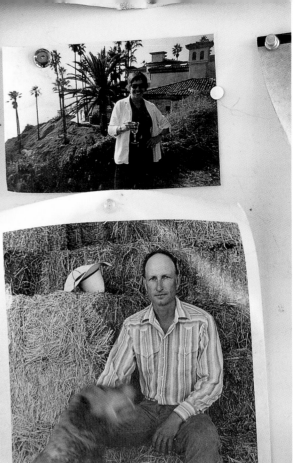

Bruce Nauman

A PAIR OF WEATHERED wooden Chinese dragons flank the entrance to the studio. There is a sign posted on the door:

> Please Don't Let the Cats Out
> Please Don't Let the Cats Out
>
> Please Don't Let the Cats Out

A small utilitarian example of artist Bruce Nauman's work.

"The cats" are two feral felines born in the barn. Quintessential studio cats, they never go outside but have, by way of a cat door, access to an ample wire enclosure adjacent to the building. This protects them from owls and coyotes, yet lets them enjoy the fresh air.

A duplicate of the "Please Don't Let the Cats Out" sign is posted on the door that leads from Nauman's office into his working space. The floor there is covered, completely, with what the artist needs, generates, and uses. Tools, equipment, tack and gear share the floor with reams of paper and fragments of his earlier pieces that he keeps around, available for new projects.

Susan Rothenberg, his wife, says of him, "He never picks up anything in his studio, until he needs space." Just now, in the middle of toolboxes, extension cords, and piles of rope, the artist has cleared and swept out a precise square adjacent to one wall. In the center of the clearing he has arranged large bronze fish, part of a water-spouting sculpture on which he is working.

Nauman has used the studio itself as a subject in various installations, putting a modern twist on a centuries-old practice: the artist's rendering of his own workplace. In Nauman's 2002 installation *Mapping the Studio I (Fat Chance John Cage)*, an array of infrared video cameras captured glimpses of nightlife in his studio, revealing not only the life-and-death game of the cats and mice there but also aspects of the artist's practice. The artist says that he used this traffic as a way of "mapping the leftover parts and work areas of the last several years of other completed, unfinished, or discarded projects."

Nauman's compact office extends into a small, immaculate tack room, where bridles and harnesses hang from wooden pegs; a large wrought-iron tree, which his wife commissioned as a gift for him, holds saddles. He rides every day and also spends time at his working ranch in northern New Mexico, where he breeds and trains horses. Elements of cowboy life make their appearance in his studio and in his practice as an artist.

Nauman has said that, early on, he came to the realization that "if I was an artist and I was in the studio, then whatever I was doing in the studio must be art. At this point art became more of an activity and less of a product."

Allan Graham/TH

Since 1990, painter Allan Graham has compounded his name with the capital letters TH. They stand for Toad House, the name under which he publishes and occasionally does installations. It occurred to him when he and his son, Jess, dug a subterranean room to be used for meditation. Scores of toads were drawn to the spot, and he began referring to the place as Toad House. Only later did he discover that in Zen poetry the toad is a metaphor for mind.

Graham and his artist-wife, Gloria, now live in northern New Mexico, where they have built a home and studios adjoining national forest land. Sensitive to the environment and dedicated to an artful simplicity, they integrated the structures into the landscape with minimum impact.

The artist used straw bales to build his studio, a construction technique first used in Nebraska in the 1880s and now becoming popular in many countries as well as the American Southwest. Heat in the studio is provided by an efficient Danish woodstove supplemented by solar gain, and electricity comes from the Graham's state-of-the-art solar-energy system. Eventually, the artist will expand the studio to include a storage area, so as to leave the main space clear for painting.

The interior has a decidedly Japanese rustic feel, where humble materials are treated with meticulous attention. The modest space is uninterrupted, and there is no plumbing. The golden tans of the straw bales, and their organic texture, contrast effectively with the metal restraints that hold them in place.

A wooden table serves as drawing board, reading table, display space, and escritoire. At one end there is a carpenter's three-legged extension rig, which Graham uses not for holding wood planks but to support his huge drawing portfolios when opening them out.

Currently, Graham is working on nine-foot-high canvases, "because," he says, "I like to get lost in the surface." These compositions consist of cascades of words, each letter a fraction of an inch tall. In describing his process the artist, who for decades has been a student of Eastern thought, says, "The writing has become the meditation for me; and while the body is grounded, the hand—and thoughts—fly."

The wall alongside his easel is studded with pencil notes, jottings, phrases, puns, and thoughts. "My walls are my notebooks," he says.

Wordplay appears both in the painted work and in his artist's books, one of which is called

visual eyes

a punning title that bridges the artist's textual and visual interests. "Puns have changed my whole way of thinking. I especially like to use them when describing the world," he says.

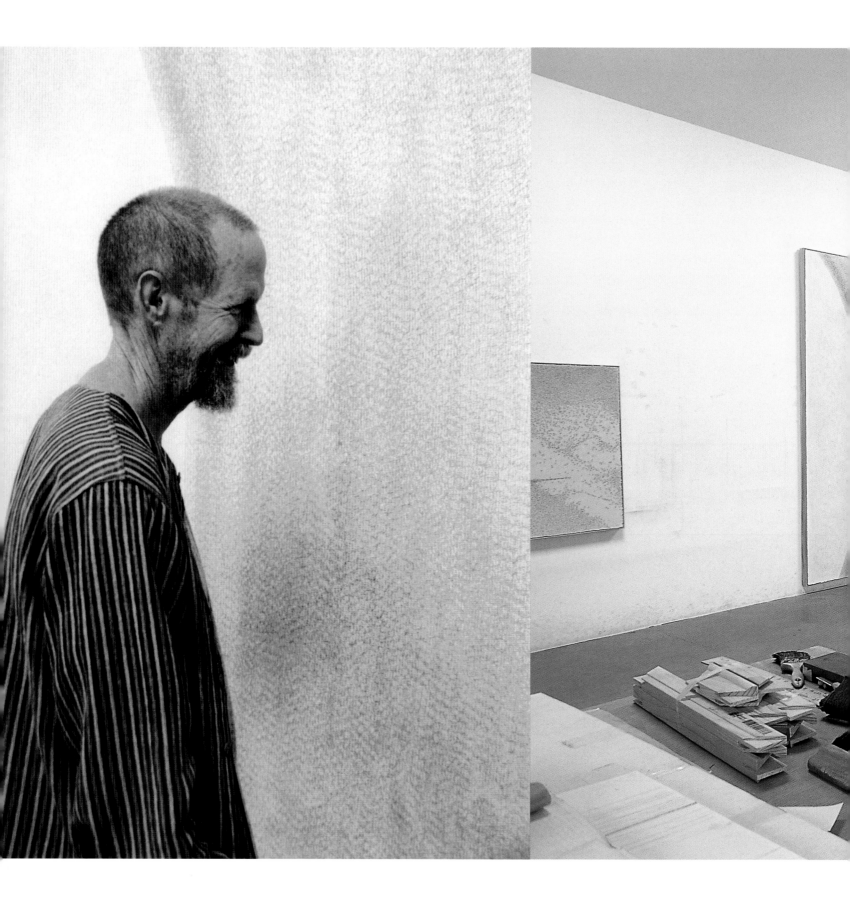

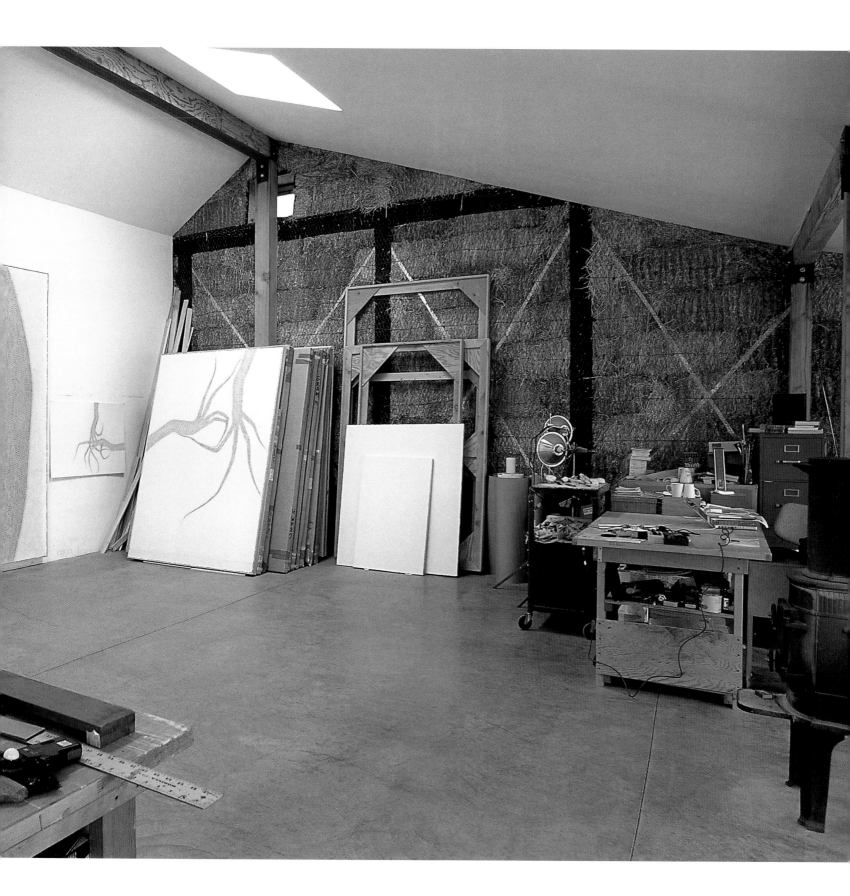

Gloria Graham

Artist Gloria Graham recalls, "For years I had a studio half this width and half this height, and it worked wonderfully."

Graham is referring to the little studio she used during the time when she and her husband, painter Allan Graham, lived on Fourth Street in Albuquerque. Their main house, an adobe built in 1825, stood next to an old motel that they converted into working and exhibition spaces. The Motel Gallery, as it was known, was a focal point for artists in Albuquerque during the 1970s and 1980s.

In 1995 the Grahams moved to northern New Mexico, where they located their new home and studios. The artist designed her workspace: a six-walled room with four vertical windows—facing south for solar gain—and two doors, south and north, with transoms that can be used to regulate airflow.

The walls are beautifully hand-plastered, and the random patterns on the polished cement floor are suggestive of clouds. Relying only on natural light, Graham works primarily in the morning. When composing her pieces—works that are based on her research into atomic structure—she draws on large sheets of tracing paper atop the landscape-architect's desk once used by her grandfather.

Graham prepares her painting panels with kaolin clay and hide glue, materials whose use dates back, in Tibetan practice, at least two thousand years. On this elemental surface she renders patterns derived from images of the molecular structure of natural elements. The work is both descriptive—in the sense that it identifies the element referred to—and abstract, simultaneously.

In connection with this project, Graham has adhered black dots to the three angled walls in her studio. The pattern on each surface refers to the molecular map of a specific substance: salt, silicon, quartz. On the western wall, the artist does large-scale drawings in graphite that further explore the subject. The smooth finish on the hard-trowel plaster permits multiple erasures, allowing Graham to rework her compositions. In a number of her exhibitions she replicates this method, drawing directly on the gallery walls.

Graham makes a piece of sculpture perhaps every three years, "to jar" herself, as she says. In 1996, in an act of pacifist recycling, she used a rocket nose-cone mold in one of her works because she wanted to incorporate, artfully, something that is normally used for destruction.

As she walks in the hills around her studio she scrutinizes the landscape, deepening her already extensive knowledge of flora and herbal medicine. "I remind myself to remember to look at things again," she says.

In the artist's view, the discoveries of modern science indicate that, at the microscopic level and below, what we have thought of as substance is revealed as dynamic patterns, continually changing into one another—a continuous dance of energy.

Her definition of her studio reflects this idea. "It is a free zone where the imagination can fly away," she says.

Gendron Jensen

A DRAMATIC ELK SKULL with massive antlers hangs suspended from the peak of the pitched ceiling in Gendron Jensen's studio. One entire wall is devoted to shelves holding an encyclopedic collection of large bones and skulls, many of them found on his walks out the back door and up into the forest. On the top shelf, cigar boxes hold the small skeletons of rodents, birds, and turtles.

Artist Jensen says, "I like the proximity of these in my studio. I spend 40 percent of my time brooding over them; drawing them puts me in a dream state."

The artist's first experience with his future subject matter happened at the age of six and a half. Among the reeds in Pokegama Lake near Grand Rapids, Minnesota, he found the tiny, perfect skull of a rodent. Even now he remembers clearly the surprise and pleasure he felt.

As a young man Jensen spent four years in Saint Benedict's Abbey in southern Wisconsin, where he worked in the print shop. It was there he taught himself to draw. Subsequently he returned to his home state, where, for seventeen years, he drew in one of the rooms in a rented farmhouse. When he designed his current studio, he nearly duplicated that space.

In his finely honed pencil drawings, elements derived from different specimens in his osteological inventory appear in inventive juxtapositions, creating new and unexpected forms. As he works, Jensen refers to the subject bone, which is held in place on a mass of clay and gently illuminated by the light from a 25-watt bulb. This arrangement varies not at all, from bone to bone and drawing to drawing. To make this meticulous and detailed work requires extreme patience, discipline, and concentration. "I am a monolithic thinker," the artist declares. "I take on one thing, and I do this one thing until it is completed."

Jensen is an enthusiastic correspondent who writes artists and friends worldwide and archives the letters in a file cabinet located behind a shoji screen in his studio. The courtship with his wife, artist Christine Taylor Patten, took place via a hundred letters.

The artist speaks—and writes—eloquently about the reclusive life and keeps to a monastic schedule. After he awakes he brews his morning coffee and then he meditates. He and his wife share a daily ritual: there is no talking in their house before noon. As he says, "In the morning we are both drawing."

"Then, in the afternoon," he continues, "we will share tea or coffee and we will talk—about light or form or Vermeer, Bach, books, social concerns, or music. Christine is my greatest teacher."

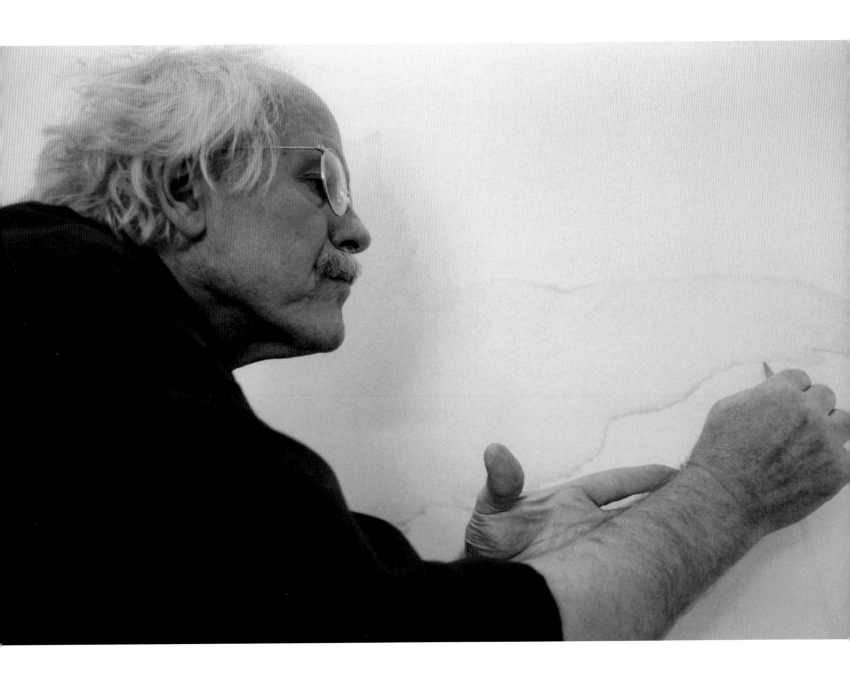

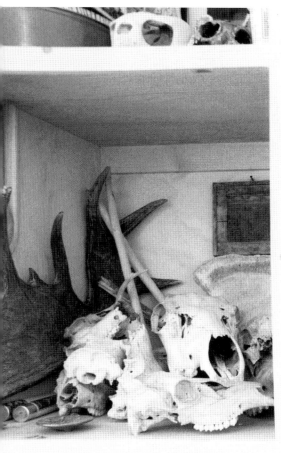
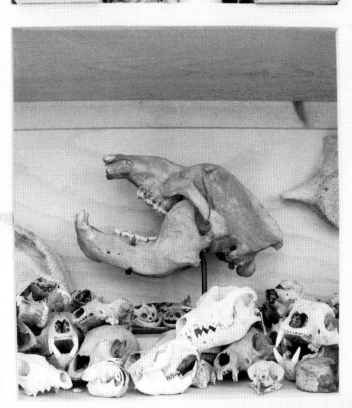

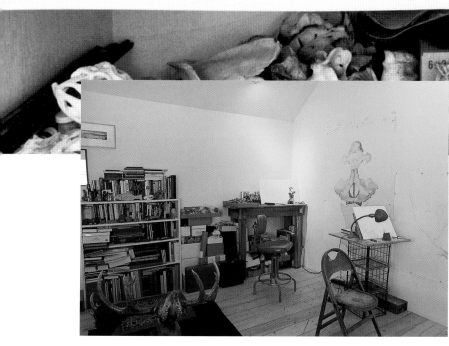

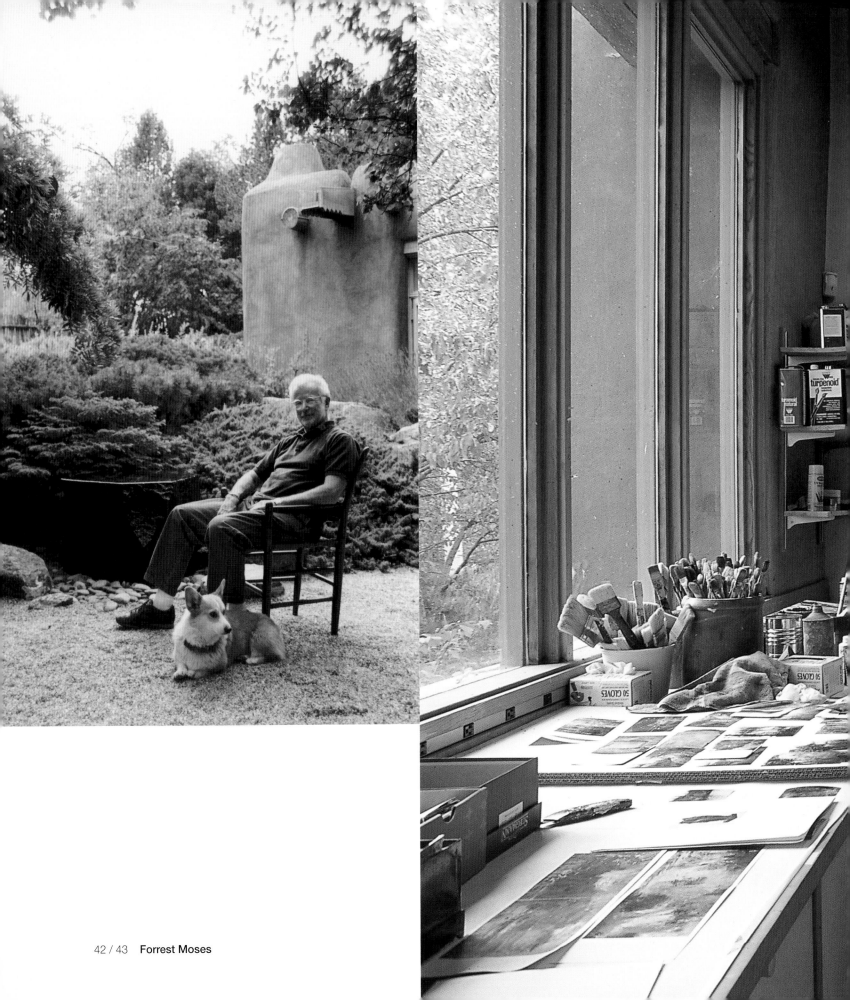

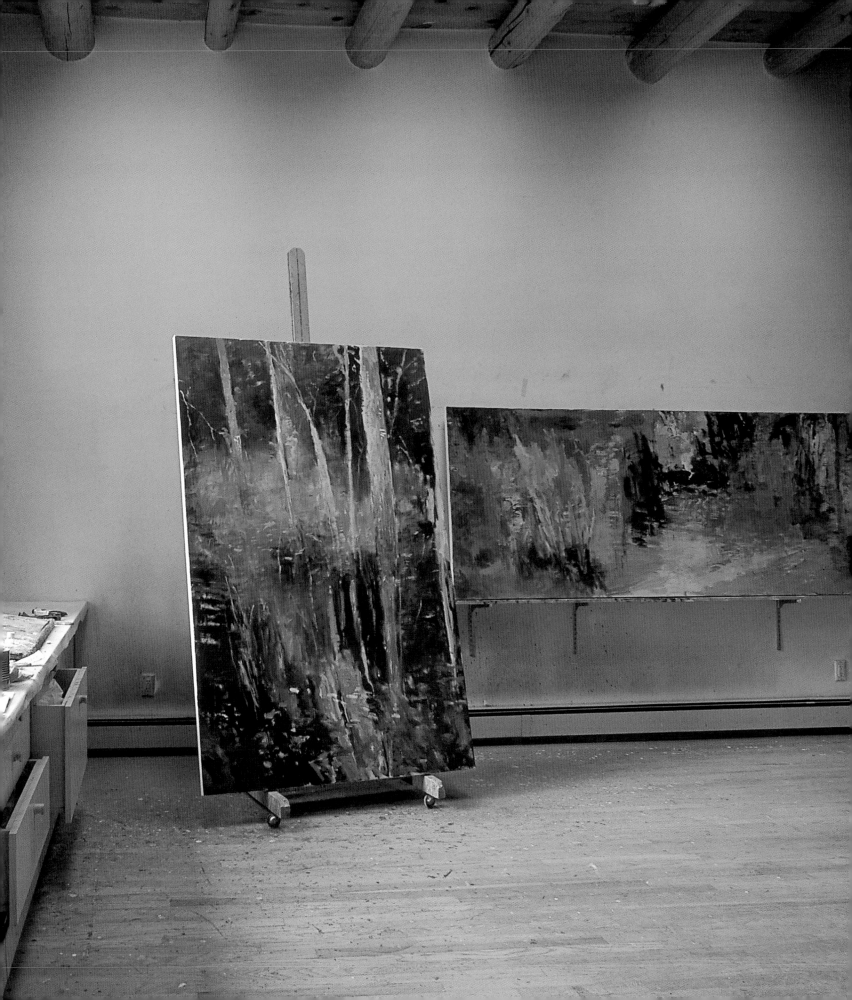

Forrest Moses

PAINTER FORREST MOSES has chosen a life of balance. "It can be hard to get back into the work if you are randomly in and out of the studio; that's why I like to schedule the year."

From September to March he works in his studio. In the summer he socializes, he "breathes," giving himself over to distraction and company. In autumn he travels, photographing, drawing "inspiration from the time of transition: fall to winter."

"Recently," he says, "I concentrated on the reflections on ponds; I also looked at marshes, grasses, and the verticality of trees. I often photograph in the East for its specific motifs of deep forests and streams: Connecticut, Massachusetts, Virginia — and always in New Mexico."

In a tradition as old as photography itself, the painter refers to the pictures he has taken. Moses has written very knowingly about the transformation that takes place in this process. In his book *Forrest Moses*, published in 2001, he writes, "Then using the camera I go deliberately to record. A place is arrested in the moment. Essence is the concept." Later he continues, "Overall, I see abstraction. Paintings are not pictures of nature. Nature is nature and paintings are paintings."

Looking out from his studio at the bare aspen and tall grasses Moses says, "I like the silence of winter, the overcast light, the wonderful reflections in the water. Painting is very subjective and solitary."

When Moses moved to Santa Fe in 1969, he searched for a quiet, traditional house in the old part of town. He found one, built in the 1920s and located on the east side, near Canyon Road and Camino del Monte Sol. The residences and studios of such early figures in the Santa Fe arts scene as Laura Gilpin and Will Shuster were a few short blocks away.

Moses bought the small house. In the beginning, it was all adobe with heavy vigas and brick floors. Over the years it has grown in size and sophistication. The overall effect today is one of reserve and calm; there is a balance between the open and the complex, the polished and the worn. "Beauty dislikes being captive to perfection," he quotes from a Japanese treatise on aesthetics.

The artist added the studio to the original building in 1972. As seen from the entry room to the house, it is set dramatically on a lower level. At first sight it appears that it is open to the outside, with light pouring in from a glade backed by silver-trunked trees. It turns out that this is a well-crafted illusion: the beautiful little forest sits outside the grand window that forms the north wall of the studio.

Every year after his travels Moses returns to this studio to make the work. The artist, whose speech still bears the gentle inflection of his southern upbringing, says that the house has become his sanctuary, his "Tara." "It is still my playground—and the landscape of New Mexico, my vast studio of inspiration."

Christine Taylor Patten

CHRISTINE TAYLOR PATTEN and her husband, artist Gendron Jensen, live down in a little valley near Peñasco on the High Road to Taos. Patten designed their house, including her studio.

It is a complex house, not to be read or understood easily on first encounter. The practical aspects are addressed in the context of a sophisticated aesthetic: shoji screens with tiny paper-covered panels, sliding doors, recessed areas, gentle surprises based on contrasting texture, detail, or line. The wooden building consists of a tall, open, central area connected to smaller, almost hidden, spaces—one of which is the artist's studio.

Patten says that she knew she needed "one wall that was absolutely clear and as large as was affordable, and I needed height." Smiling, she adds, "so my energy could rise."

When executing her intensely personal drawings she uses a crow-quill pen, often working on long scrolls of paper. The surfaces are achieved by multiple layers of linear references, each based, in a sense, on the loss of information beneath it. She invests hundreds of hours in drawing on a twenty-foot scroll. Patten says that she sees her art as being like life: when she gives herself over to it completely, deeply, each achieves its intensity.

Over the past three decades she has had a fascinating variety of working spaces. "I have always had a room in the house, a bedroom, a diningroom wall. In grad school, I shared a studio with three men." In a chronicle entitled *New Mexico Studios and the Table*, Patten tracks the presence of a huge oak library table—acquired in the early 1970s—through the fourteen studios she has had in this state. Speaking of her last one in Santa Fe, the artist relates: "In 1984 I moved to Trades West Road and rented a thousand-foot metal storage shed. I had my holography studio there and called it Coruscari Lab, as that means 'a workspace characterized by brilliant flashes of light or wit.' I had a hot plate, a microwave oven, and the oak table for projects and dinner with friends. There were forty-foot-long walls for doing my drawings. The greatest thing was, with no windows, I lived as I naturally awakened. I slept when I wanted. I drew when I wanted. This went on for a long time."

Before moving into the studio she uses today, she worked for a decade in a six-by-nine-foot room. "I drew my first twenty-foot drawing on that nine-foot wall. I scrolled the paper up at both ends. It took two years to draw, and I probably worked the length of it four times back and forth."

Now she works in her own intimate room: it has a skylight set in a pyramidal roof and a twelve-foot stretch of wall on which to draw. She thinks of the whole house as one large studio, "each individual space used for one project or another, and no barriers between our life and our work."

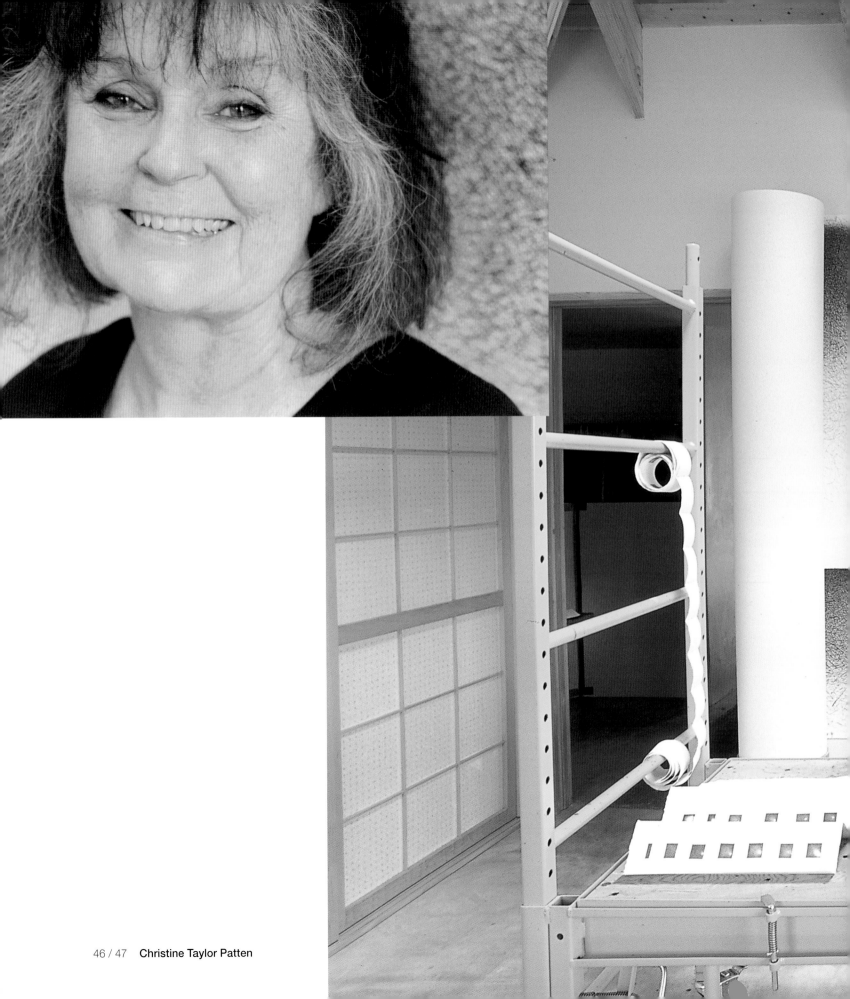

Christine Taylor Patten

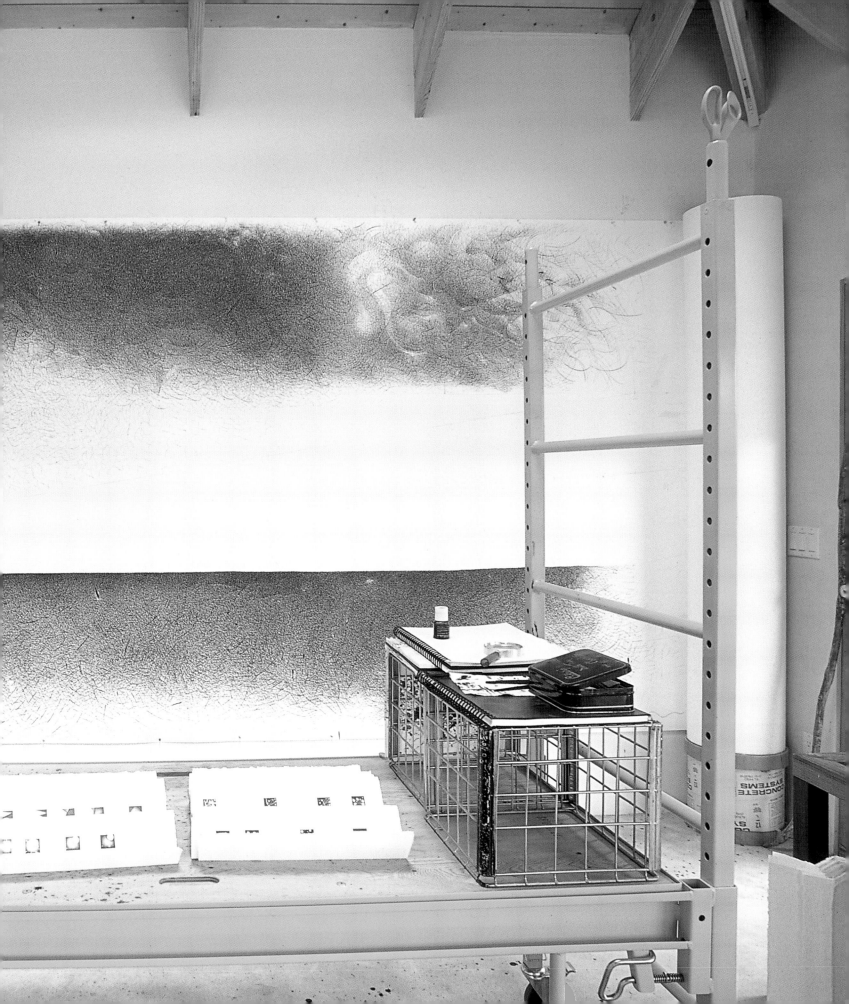

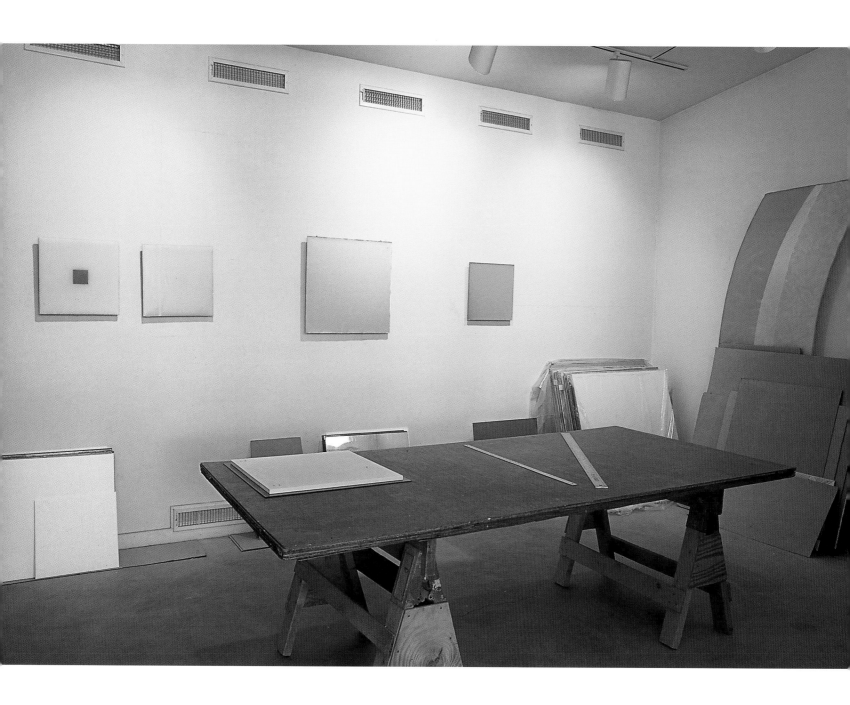

Florence Pierce

THE STATELY WOMAN who opens the door is dressed in black. Her thick white hair is softly waved, and she wears turquoise pendant earrings. She is striking, radiant.

Florence Pierce, renowned resin artist, began visiting New Mexico in 1936, while she was still a teenager. She has lived in this house in Albuquerque since the 1950s.

Articulate and engaging, the artist is an easy conversationalist. She begins by saying, "I have a nine-hundred-square-foot studio. It is solar heated; the construction is frame and stucco. Who'd want an adobe studio? You can't nail into the walls. This is the only studio I've ever had, except for the time I used my father's workshop."

The artist lives on a quiet cul-de-sac on the edge of the city, with only open fields beyond her house. Her studio, a stone's throw away, was built in 1960 with the help of artist friends.

"When I look out from my studio, all I see are fields of grass and tall trees. Forty years, and that land is still open. I feel very fortunate."

Pierce makes it clear that having a separate studio is essential to her process. "You cannot do this work in the kitchen or on your patio. You must have a clear and controlled environment," she says firmly.

The artist began making resin paintings as a result of an accident. While working on one of her wood sculptures she tried to attach a knob to it; in the process she spilled some of the resin onto a piece of aluminum foil. The effect interested Pierce and suggested to her the idea of experimenting with mirrored Plexiglas. The first painting she did in this medium is still in her possession; its red-orange radiance warms her living room. "Many people have wanted to buy it—but it's still here," she says.

"The resin room of my studio is ten by twenty. I don't wear a mask when working with resin, and I've been using it for twenty years. I do have an industrial fan for ventilation. This year I have noticed the fumes some, and I intend to begin using a mask."

Although her work is primarily monochromatic, Pierce is able to achieve—through an almost alchemical process—work that glows with an aura that is distinctive from piece to piece.

It takes her four to six pourings of the resin liquid to complete a piece; each step takes thirty minutes to set up. To some pours she adds color as well as milled fiberglass in different proportions. When applying pigment she may make use of a rubber stencil to isolate areas of color intensity. The final step for each pour involves unrolling a vellum square temporarily onto the wet resin; this gives the surface its characteristic sleekness.

Pierce received national attention as a premier abstract artist in a 1994 CBS television special entitled *Still Working*. Her long tenure in this one studio, more than forty years, attests to her persistent vision and her constancy in its pursuit.

Carol Mothner

THERE IS ONE THING about Carol Mothner that everyone meeting her always notes: her smart, singular, often self-deprecating sense of humor. Perhaps it originated in Brooklyn where she grew up.

Mothner recalls the felicity of that childhood, saying she had "a wonderful mother for art," who brought her into Manhattan on weekends to go to the museums, to look at the window displays, and to watch the skaters at Rockefeller Center. "We went to plays, and I'd draw by the beam of my tiny flashlight. It was invaluable to have a mother who so supported my work."

Mothner, her husband, painter Daniel Morper, and their daughter, Elizabeth, live on a quiet street in the center of Santa Fe. She works in a roomy, sunlit studio towards the back of their home. "This is the only studio I've ever had. I always painted all over the house. That's probably why my husband built it for me." She reflects, "Actually when I'm working all I see is the piece in front of me. In many ways it doesn't matter what's around me."

For decades the artist was known for her meticulous oil paintings and pencil drawings. Mothner has more recently, with the help of artist Michael Bergt, taught herself the ancient technique of painting in egg-tempera, which she characterizes as the medium most like drawing.

The preparation process is lengthy. She takes an egg yolk and gently rolls it on a paper towel. Then she pierces the yolk, collects the fluid and mixes it with water and finely ground German pigments. With this mixture she paints on a Masonite board covered with traditional gesso made from animal glue and calcium carbonate.

While at work, the artist wears dentist glasses: they provide magnification and yet allow her, by flipping up the frames, to look directly at the object she is recording. Responding to a comment on these glasses, she murmurs, a la Groucho Marx, "Ah, yes, Dr. Mothner. . . ."

In speaking of her work habits, the artist says: "I work all day. I go to work like a shoe-maker: first, morning ablutions, then the breakfast. I'm painting by 8:30, and I paint until 5. I work nights also. I keep the food channel on the TV for company, or I listen to books on tape. Oh, I'd rather draw than anything."

In 1998 Mothner bought an eighteenth-century Mexican madonna, Our Lady of Sorrows. Over the next three years she painted representations of this wooden *santo* in many different guises. After September 11, 2001, she dressed it in a parchment paper gown on which she had written the name of every person who died at the World Trade Center. It became the model for a series of paintings.

Of her studio she says:
"I'm little."
"It's little."
"The work is little."
And each, in the details, exquisite.

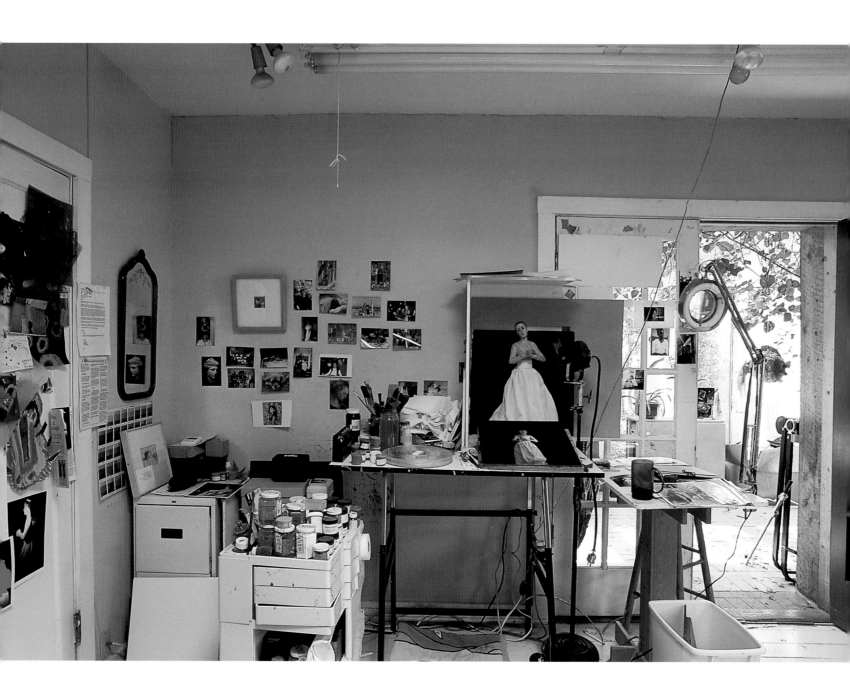

Eliseo Rodriguez

"I DON'T HAVE A SCHEDULE. I like to work when I think, 'This is the right time to work,'" eighty-eight-year-old Eliseo Rodriguez explains cheerfully. Born in 1915 on Canyon Road in Santa Fe, he has been creating art for more than seventy years.

While a youngster, Rodriguez worked as a gardener for the Cinco Pintores, the five painters who lived and painted on Camino del Monte Sol. The young Rodriguez had always enjoyed drawing and painting, and the experience of watching these older men work deeply influenced him.

Eventually Rodriguez attended the Santa Fe Art School on a scholarship provided by the writer T. T. Flynn, for whom he also had gardened. It was 1929, and Rodriguez was the only "Spanish" student in the school.

He married in 1935 and moved into the adobe house on San Acacio Street in which the couple still lives today.

"My wife, Paula, and I have always been together except when I was in the service [in World War II]. I remember we were having lunch with our sons [the couple had seven children, four of whom survive], and I said, 'You know, I would like to have a studio' . . . and they said, 'Let's start now!' So we began digging right here [off the kitchen-eating area], and the four of us worked on it. This went on for some months, and then one son went to California for school and one went to Los Alamos, so Paula and I were left to finish the job. We would make a few adobes each afternoon. It took awhile, but at last it was done and I painted here for many years."

With time Rodriguez began moving around as he worked. Today, the little two-room adobe has grown to thirteen rooms, and he believes he's painted in every one of them.

"Different artists have different ideas, of course, but for me, if you're working in a real studio it's like working in a factory. I like to be *free*," says the spirited octogenarian.

During his long life this artist has made drawings ("In 1924, when I was nine, I made a drawing of a little burro. I still have it."), oil paintings, reverse glass paintings, as well as carved furniture. He has also made *bultos* and *retablos*, the traditional religious sculptures and paintings of northern New Mexico.

Eliseo and Paula Rodriguez are recognized as having saved the Spanish Colonial art of straw appliqué from extinction here in New Mexico. Their beautiful pieces inspired several of their grandchildren, who, in turn, have become accomplished straw appliqué artists.

Rodriguez has received the Governor's Award and was the Rotary Foundation's Distinguished Artist of the Year in 2003. Both Eliseo and Paula have been named Living Treasures of New Mexico. They truly are.

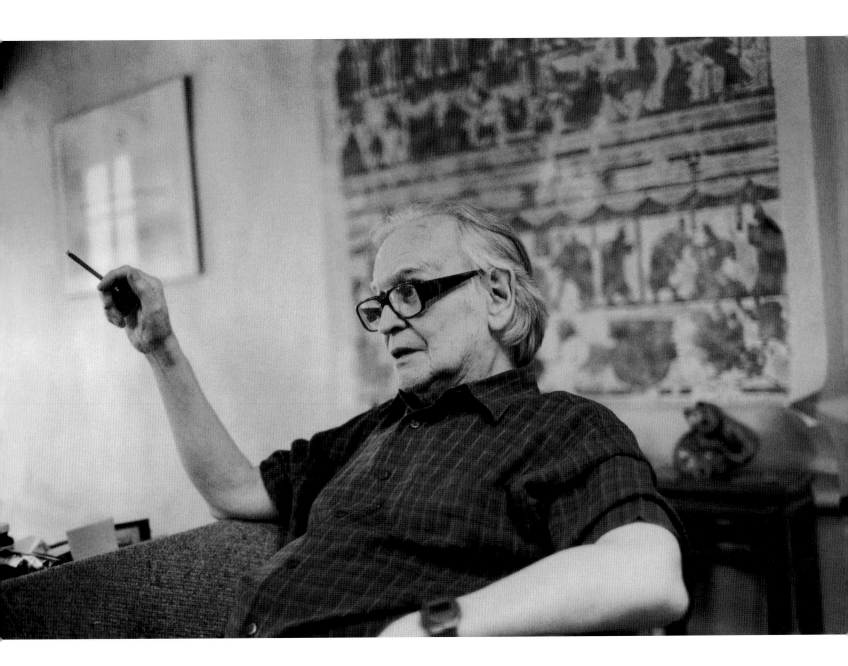

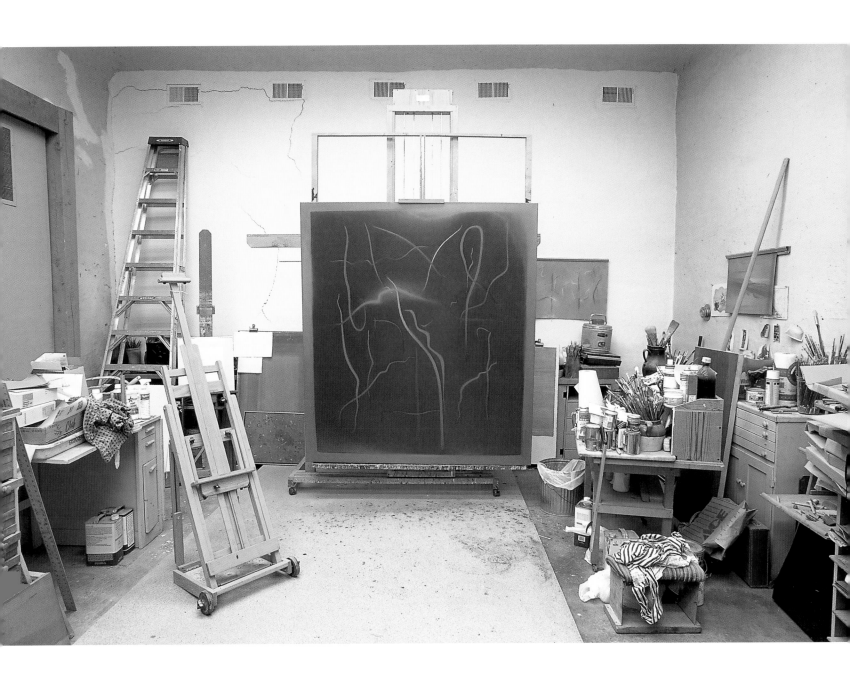

Earl Stroh

EARL STROH, longtime Taos resident and painter extraordinaire, is speaking: "I listen to classical music while I paint." Two four-foot-tall speakers at the back of the studio stand witness to this predilection. "I listen to Monteverdi, Schönberg, Eliot Carter, some Brahms, chamber music, Beethoven, Bach, Mahler, Debussy." When asked if he ever paints in silence, the artist smiles. "Oh, when the record stops playing and I'm too lazy to go and change it," he replies.

Stroh is an engaging conversationalist, and a rich source of reflections on art, artists, and the Taos scene thereof. Of the studios he has had, he says: "At Wurlitzer Foundation [a retreat, which is awarded to artists of merit], before it was Wurlitzer Foundation, I had a nice studio. In Paris I had a little apartment, one room in a large hotel—a toilet on one side, a kitchen on the other, and I painted in the middle. My first studio? I was thirteen. I had a bare lightbulb to paint by—in the basement of our house in Buffalo."

Of his early years he says: "I was raised in Buffalo, New York, with people who were older. I knew early on that I wanted to be an artist. I remember that my mother used to warn me, 'You already have champagne tastes, and [if you're an artist] you'll end up with a beer pocketbook.'"

"I came to the University of New Mexico in 1946 and spent that summer studying in Taos. I'd had ten years of art school when I came here."

"I won prizes with my watercolors but I had gotten too facile. In 1950 I sat down and did my last watercolor. I knew that if I was going to be a painter I'd better get to it."

Stroh built his Taos studio in the 1960s, as an addition to his house. "It was finished one October," he says, "and I was delighted with the light. Come summer I couldn't work in here, it was so hot. So I had a swamp cooler put in." With its woodstove, ferns off to one side, litter box, and couch, the studio has a lived-in look.

Currently, the painter is working on a five-foot-by-five-foot canvas he started at the turn of the millennium. The extraordinary blue light that seems to shine out from this painting, which he has named *Laocoon*, is the result of the application of hundreds of layers of oil medium and pigment. He has placed a three-inch-high platform covered with spongy vinyl in front of the big easel; the padding is helpful for his legs, Stroh says, as he spends hours standing in front of that easel. "What energy I have I like to put into the studio," says the eighty-year-old artist.

The studio holds many memories for Stroh. Near his easel there is a cabinet with eighteen narrow drawers holding pastels organized by color—a legacy from his tutor and friend Andrew Dasburg, the pioneer Taos artist. Stroh remembers with fondness the many conversations about art that he and Dasburg shared with the painters who, over the years, gave Taos its particular identity as an art colony.

Richard Hogan

In 1984 Richard Hogan was living in Corrales, a semirural community west of Albuquerque. One day while driving in the city he spotted a "for rent" sign in the window of an empty building that had previously been a laundry. He rented it, and, after emptying out the debris and cleaning the place, he moved in. Like many big-city artists, he transformed a commercial space into a live-in studio.

The entry is directly on the city sidewalk. Two storefront windows are made opaque inside by white pull-down shades. Tall, mature cacti stand by the front windows, a nod to nature. Inside, Hogan's life is spread out freely. In this discretely divided space the painter works, reads, eats, and sleeps.

The work area takes up more than half the length of the space. In it, Hogan stretches his canvases, paints, works on clay-coated boards, or draws with pastels and colored pencils at a drafting table. Tools, brushes, paints, works-in-progress, finished works—each has its proper place in this ergonomically arranged studio.

Hogan works mainly at night, usually from ten until three in the morning, because those hours are free of distractions. The halogen lights are focused only on the painting wall, the rest of the studio is in darkness. He selects a single type of music—jazz, traditional Irish/Celtic, or hard rock—that will be his accompaniment as he works on a particular canvas.

"My studio is quite relevant for my work. The openness of this space affects the way I paint, just as the light itself changes the way I work. In the morning the light here is cold; at night the halogens give a warm light, and the afternoon light is very warm. This allows me to check the paintings under various conditions."

Hogan has an extensive library—"books are a major part of my life"—covering diverse subjects: art, architecture, anthropology, philosophy, literature. "I think of all these as reference books for my paintings. When I'm painting, I become voracious for shapes, and I look through every book of images that I have."

Although Hogan responds to a range of visual and cultural resources, many of them ethnographic (he reserves a special place for Giacometti among the moderns), his work is distinctive and persistently his own. He developed it over years in this one studio, which has, in the process, become the exact measure of his needs.

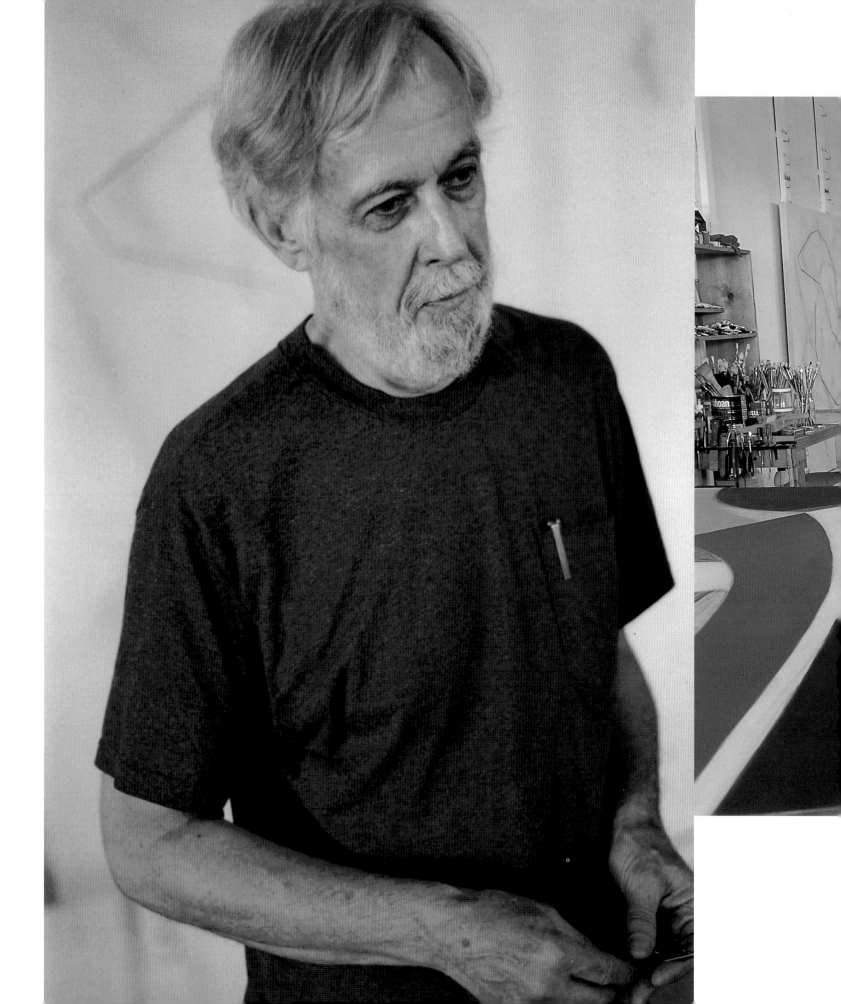

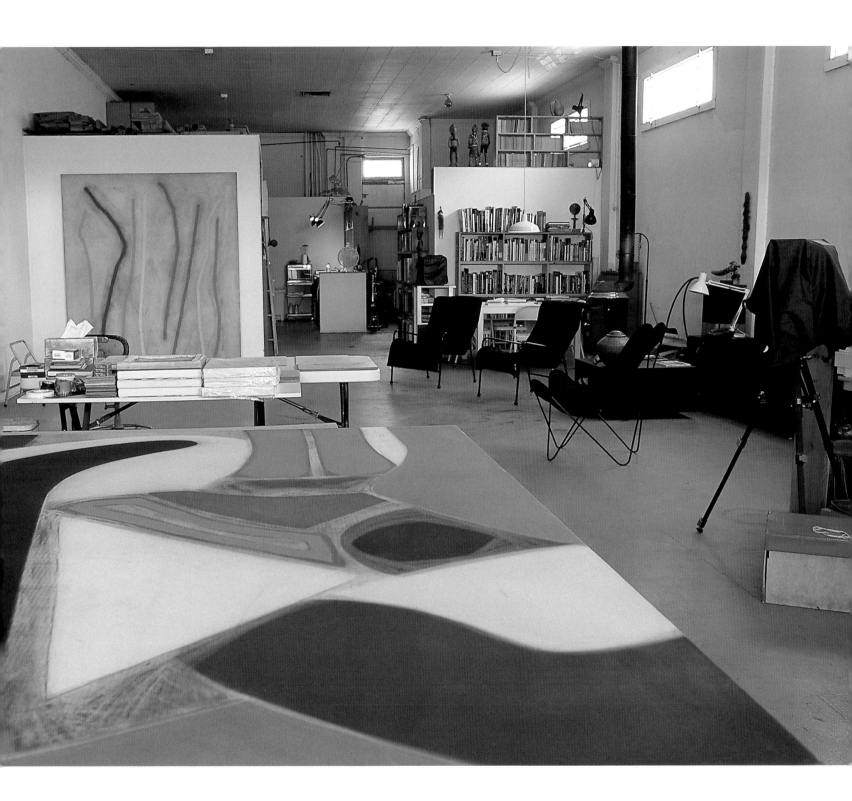

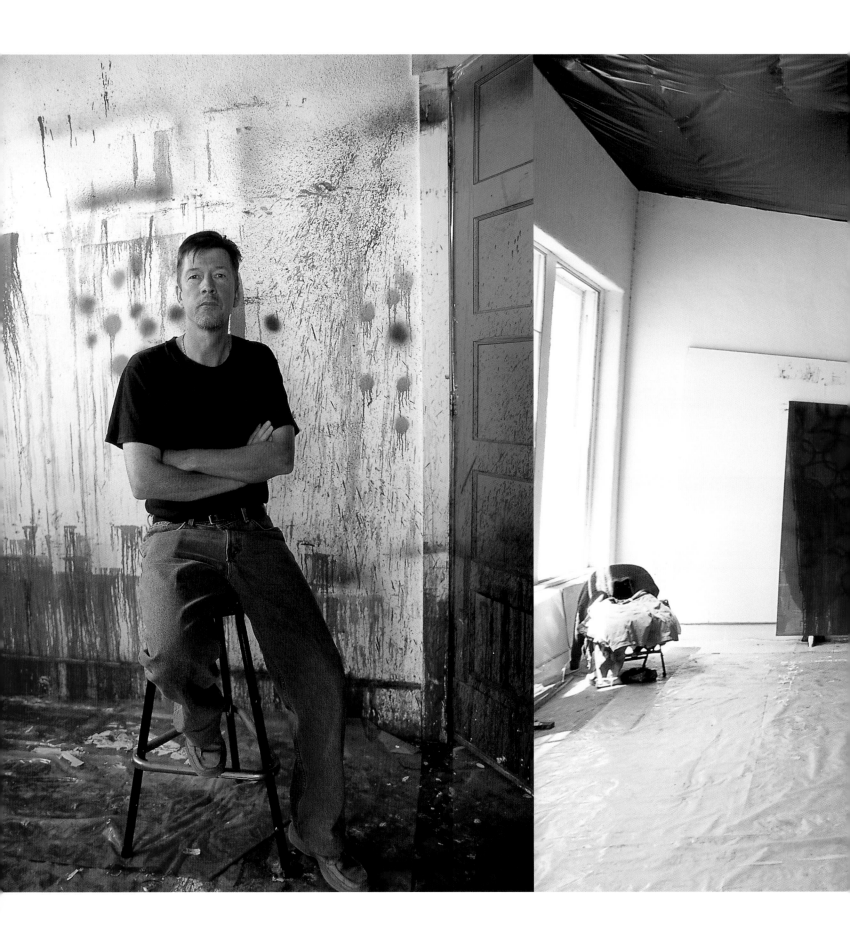

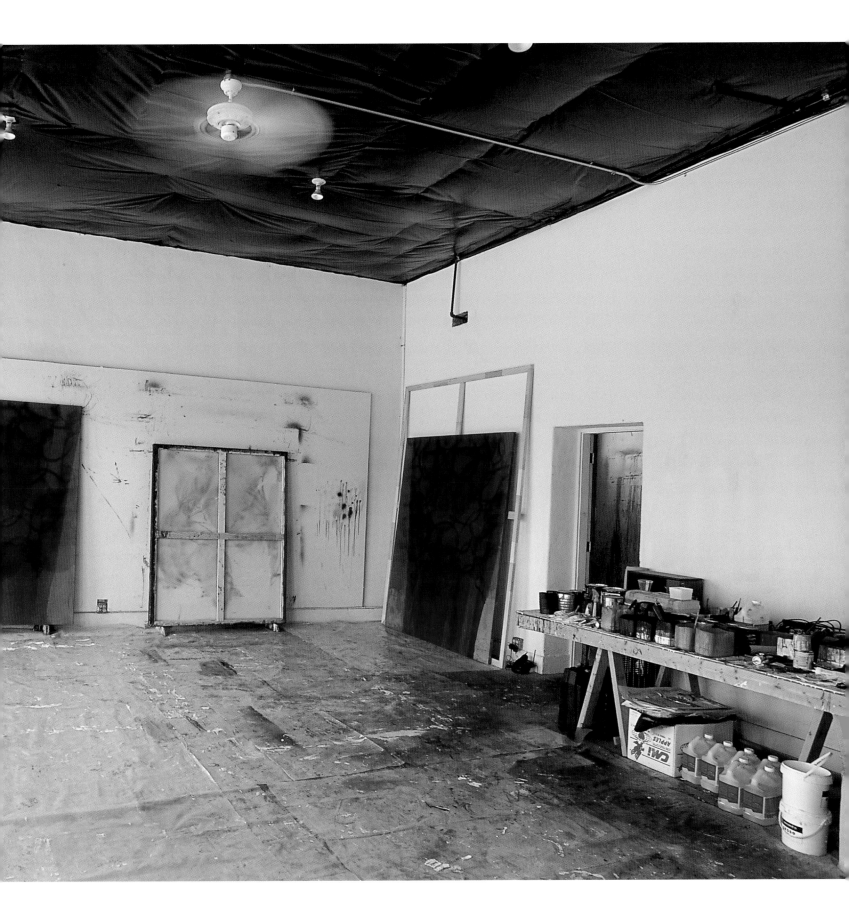

Dirk De Bruycker

ON THE APPROACH TO MADRID an impressive two-story stone building is visible from the road. It is a classic WPA project, a schoolhouse built in the late 1930s that served the region in that capacity until 1952. During the last three decades it has been used, on and off, as artists' studios. One of the tenants, at present, is painter Dirk De Bruycker.

Each floor has six thousand square feet of space, divided in two by the traditional central hallway that runs north/south the length of the building. The oak floors today squeak with age. The roof and plumbing have been redone in recent years, De Bruycker says, but nevertheless heating his quarters is still a problem.

"I have three thousand square feet here—a quarter of the building—and I am very comfortable. This space has been great to me." The artist paints and exhibits his work in cavernous rooms and uses one ventilated space as his spray booth. He shares a small living area adjacent to these with his wife, Jamileth, who is from Nicaragua, and their young daughter. Although he owns a farm, house, and studio in Nicaragua—having lived there for several years—De Bruycker acknowledges that he "needs both worlds"; that country, though beautiful, cannot offer the artistic stimulation that he has here in New Mexico.

Born in Belgium, De Bruycker trained to be a printmaker and first came to the U.S. in 1979 to attend the Tamarind Institute in Albuquerque.

He currently returns to Belgium every two years for a one-man exhibition.

The decision to become an artist was "simple enough" for Dirk De Bruycker. "I grew up with the sounds and smells of art all around me. That's my grandfather's etching press right there." He gestures toward the compact nineteenth-century press standing by the wall. The young artist made his first oil painting at the age of four, attended the Belgium Academy of Fine Arts at nine, and executed his first etching at twelve or thirteen.

Today, De Bruycker creates glowing nonobjective paintings, often seven feet by six feet in size. Heavy plastic sheets cover the floor of his workspace. He places the canvas, which he has gessoed, on the floor, and using asphalt applies a black linear underpainting to it. He likes working with asphalt, which he finds "malleable and very responsive." He then pours paint thinner and pigment on the dampened surface, inducing the pigment to bleed. A thick layer of gesso is next added and a final pouring of ground pigment and paint thinner. The staining that results produces a luminosity that is fundamental to his work.

The artist's manner is measured, his voice soft, serious. "You can only be stimulated within the context of a certain environment, and Belgium was fairly provincial. I had to move to another continent to overcome that."

Luis Jiménez

"I GREW UP IN A SIGN SHOP, and I have a studio that looks like a sign shop!" exclaims sculptor Luis Jiménez, referring to his father's neon-sign plant, well known in the trade, where the artist spent many hours during his youth in El Paso, Texas.

Jiménez has become recognized for colorful fiberglass sculpture that references classic southwestern images he first saw around that shop. The expansive neon displays his father fabricated—called "spectaculars" in the business—were made to be installed in shopping centers, and Las Vegas strips and casinos. They often portrayed the then-popular images of Indians, cowboys, ponies, and The End of the Trail.

Jiménez received his art education in the heyday of abstract expressionism, working as an assistant to Seymour Lipton and making abstract sculpture for a time. After a point he recognized that he was still fixed on those remembered images of his childhood. "For years I used them," he recalls, "but now I don't do cowboys and Indians anymore."

It should be pointed out that Jiménez's Indian and cowboy images were products of a mythic and political imagination nurtured on western and Mexican cultural models that gave these clichés contemporary relevance.

In southern New Mexico's Hondo Valley, not far from where the famed Wyeth-Hurd art family has their Sentinel Ranch, Luis Jiménez works in two very large studios—and he needs them. Jiménez is one of the premier monumental sculptors in America.

His principal studio, the former White Mountain Apple Warehouse, is located on fifteen acres in Hondo. Here he pours, constructs, paints, and refines his colorful fiberglass sculptures. The main workroom, sixty by a hundred feet with a fifteen-foot-high ceiling, is jammed with sculpture in every stage of completion. A second room, thirty by sixty feet, holds two large lithography presses, twenty litho stones, print-drying racks, and wooden crates for shipping and storage. A third room, ten by twenty-five feet, is a gallery space where the artist's drawings, prints, and models for sculpture are displayed.

The other studio, a large stone building, a mile and a half away, was once a WPA schoolhouse. At present it houses a massive work-in-progress, the sections of which will be assembled into a thirty-two-foot-high "Bronco" destined for the Denver airport.

"The big pieces require so much labor that I end up making only 10 or 15 percent of the sale price, and that's it." Jiménez supplements his income by teaching and through the sale of small sculpture, prints, and drawings.

"Come over here," he beckons. "I want to show you my Anne Frank room." Jiménez walks to the far end of the studio, to a door that would be easy to miss. When opened, it reveals a steep set of steps that lead up to a narrow room, a completely private library and study. One long wall is covered with years of imagery: postcards, drawings, photographs. There is a sense of total isolation here, as if one were on a ship far out at sea.

"This is where I come to be alone, to think—to work on ideas. In this room I make art. The rest is all production."

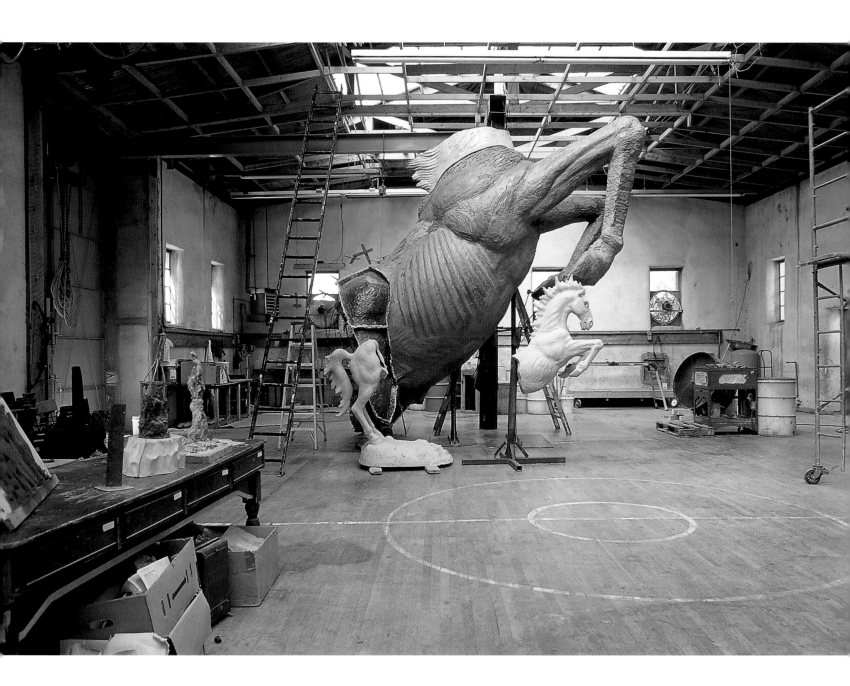

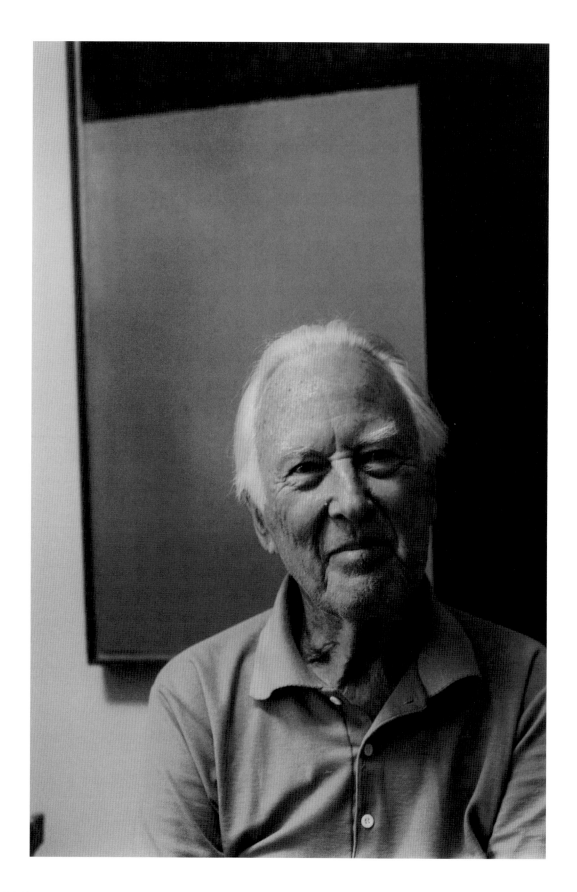

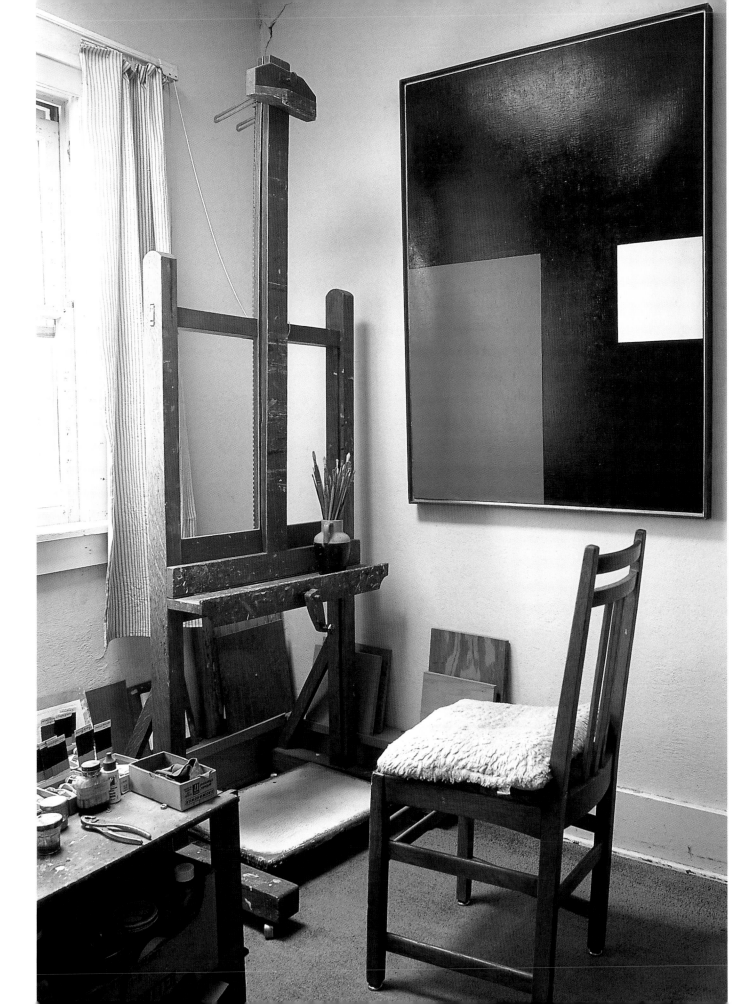

Frederick Hammersley

IN 1968, AT THE SUGGESTION OF A FRIEND, Fred Hammersley came to teach at the University of New Mexico when it was, as he says, "an adobe university, and there was sand in the streets."

During his early years as a painter, he rented studio space, but for the past twenty-five years the artist has worked in his house in Albuquerque, in a small room that is the very heart of his home. Everything radiates from this workspace, which once may have served as a dining room. The walls and ceiling are painted a soothing dove gray. In the style of the 1950s, the western wall, shared with the living room, is just a few feet high; this contributes to the studio's openness and light. There is an underlying clarity and order to the room: the paints (with their identifying color swatches), the brushes upright in a jar, the neat arrangement of the images on the back wall, which are touchstones to earlier days as well as reminders of current ideas.

For the first twenty years of his career, Hammersley filled notebooks with drawings that investigated the structure of a grid; each page was made up of many one-inch squares, every one geometrically divided in a slightly different way. Today those notebooks stand upright on a shelf, easily available to the artist, who refers to them often.

When the artist was sixty-two, after forty years of making art with a geometric approach, he stopped painting for two years. When he returned to the easel, "that's when completely organic forms began to come to me," Hammersley remembers. "I didn't have to think; it was all intuitive. It was marvelous."

"It is," he emphasizes, "a painting principle for me: that there be activity followed by no action—during which time you relax. Later when you come back, you'll go a little deeper [in the work]." The same may be true on a day-to-day basis. "I am so aware of not being young," admits the artist, who was born in Salt Lake City in 1919, "I work here for an hour and a half and then I have to lie down."

He does not paint every day, as other responsibilities, including the vegetable garden, must be addressed. Usually he goes to the studio at ten o'clock, after having learned the day's news, exercised, and breakfasted. His current work may include graceful biomorphic forms, or it may be based on an underlying grid. The colors and tonalities are invariably satisfying and right.

In a good year, Frederick Hammersley makes eight paintings, but, he says, "they each have a long fuse," giving him much on which to reflect later. He devotes a lot of thought to creating titles for his works, relishing every play on words: *Hap and Stance*, *Whether Vane*, *Sugar Free*, *Compound Interest*, *Double Vision*, *Dark and Like* (a composition in lights and darks), *To Plus Two*. His intention is to have the title spark the viewer's interest and provide an entertaining clue to the underlying structure of the painting.

In person, Hammersley radiates vitality, humor, and intelligence, qualities equally reflected in his paintings and his studio.

James Havard

JAMES HAVARD has had a large, two-thousand-square-foot painting studio in New York for years, but he has given it up and is currently having a new one built in Santa Fe. Meanwhile, he continues to work in a space in his house, a perhaps two-hundred-square-foot area where every surface is layered with the detritus of his art making. Drawings of the figure litter the floor, along with paint-covered cloths, brushes, cardboard shapes, plaster models, a workman's glove. The colors red, black, white, and gold appear and reappear on many surfaces.

In his studio, near the paint-encrusted white wall phone, there hangs a denim work apron stiff and heavy with accumulated paint. It is an artifact now, for recently Havard—an enthusiastic cook—has been wearing white chef's jackets while he paints.

To the back of the studio, leaning against another wall, is one of the artist's earlier palettes. It is a large sheet of glass on which there rises an enormous mound of paint scrapings and tailings, calling to mind an African termite mound, as well as the palette of the late English painter Francis Bacon.

Havard is looking forward to occupying his new twelve-hundred-square-foot studio in Santa Fe, which will offer him, in his words, "space, man!"

The internationally known artist is a good storyteller, easy, with a dry wit, and occasionally self-mocking. He relates how, growing up in Texas in the 1940s, he moved with his family following the oil field strikes. His father was a hard-working roughneck, he says, who would, in later years refer to Havard as "my son, the *arteest*."

During his five years at the Academy of Fine Arts in Philadelphia, Havard worked nights as a technical illustrator in order to generate income. While at the academy he received two travel grants, which allowed him to live and work in France, Spain, and London.

Each of us has a catalogue of tales with which we identify and clarify our identity. One of Havard's favorite self-defining stories is how, as a young man, he had a letter of introduction to the great Italian painter Giorgio Morandi, whose work he had long admired. This letter was very official, bearing a gold seal and a red ribbon. The young artist got on the train for Bologna, where Morandi resided. Somehow, however, he missed the Bologna stop and continued traveling into the night. The next morning he read in the papers that during the previous evening Morandi had died.

Havard makes periodic visits to Europe, and a continental flavor is apparent in his bearing, his interests, and his surroundings. A lush French country garden, that delights with its colors, climbs the terraced hillside behind his house. In the spirit of all good cooks, the painter also tends a small kitchen garden of lettuces, sorrel, dill, and other herbs.

In Havard's art there is both the rough and the smooth. In his studio, amid the piles of papers and paint cloths, stands a small beautifully proportioned bronze nude with an outstretched hand. In it the artist has deposited a chewed piece of gum.

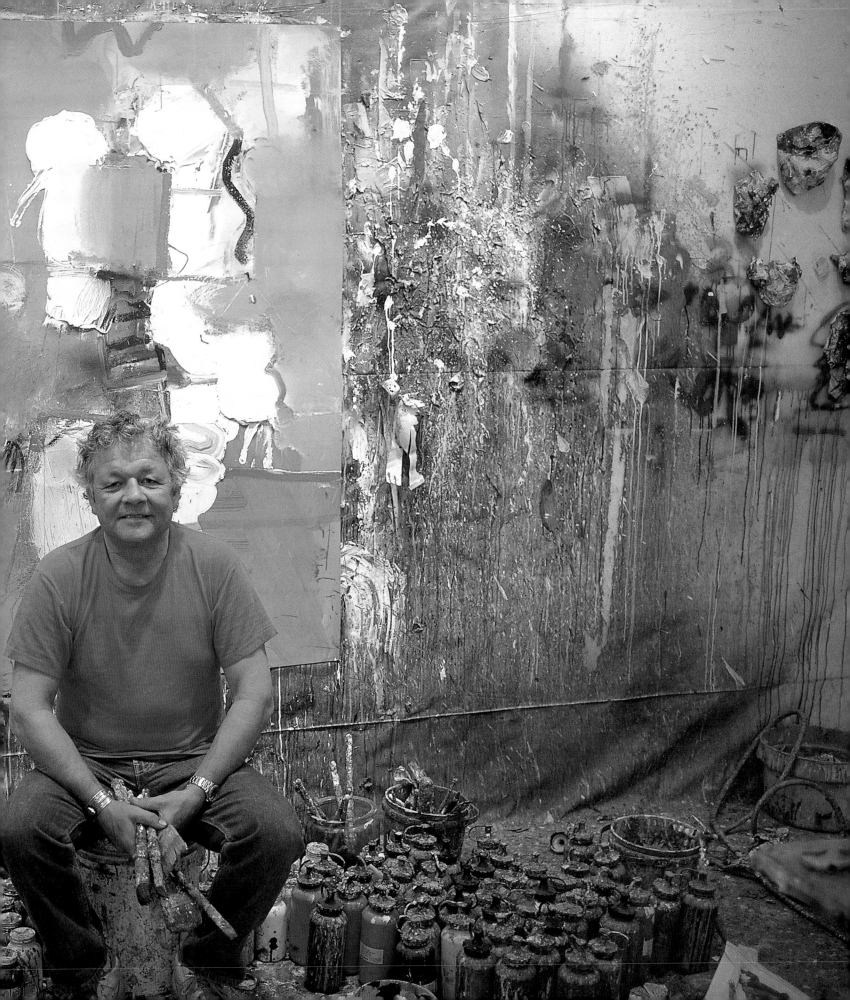

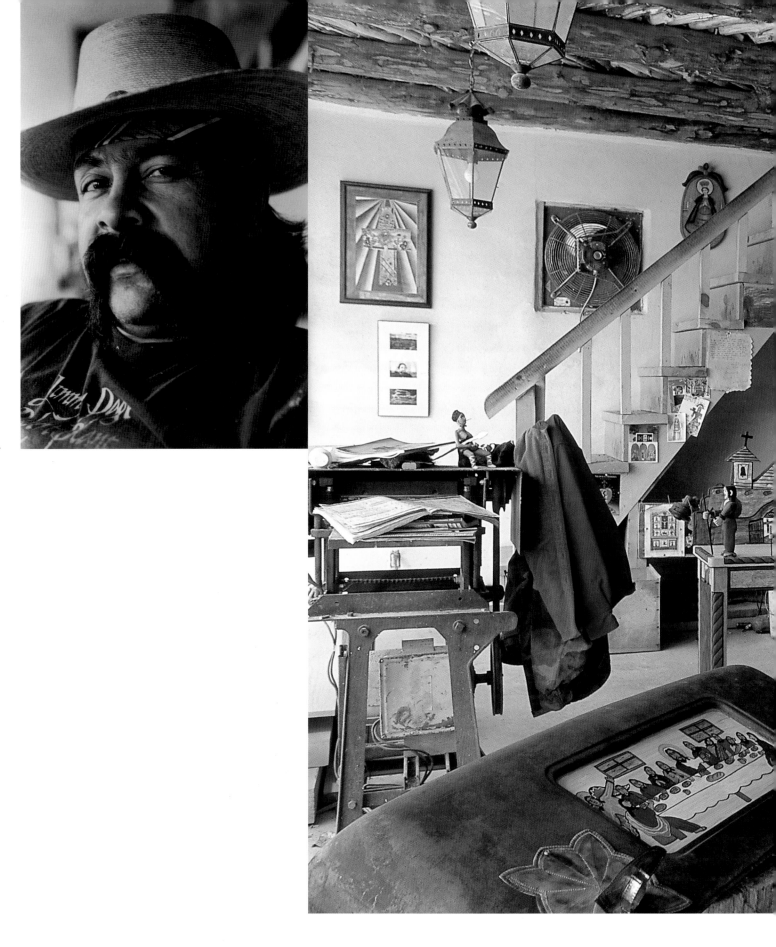

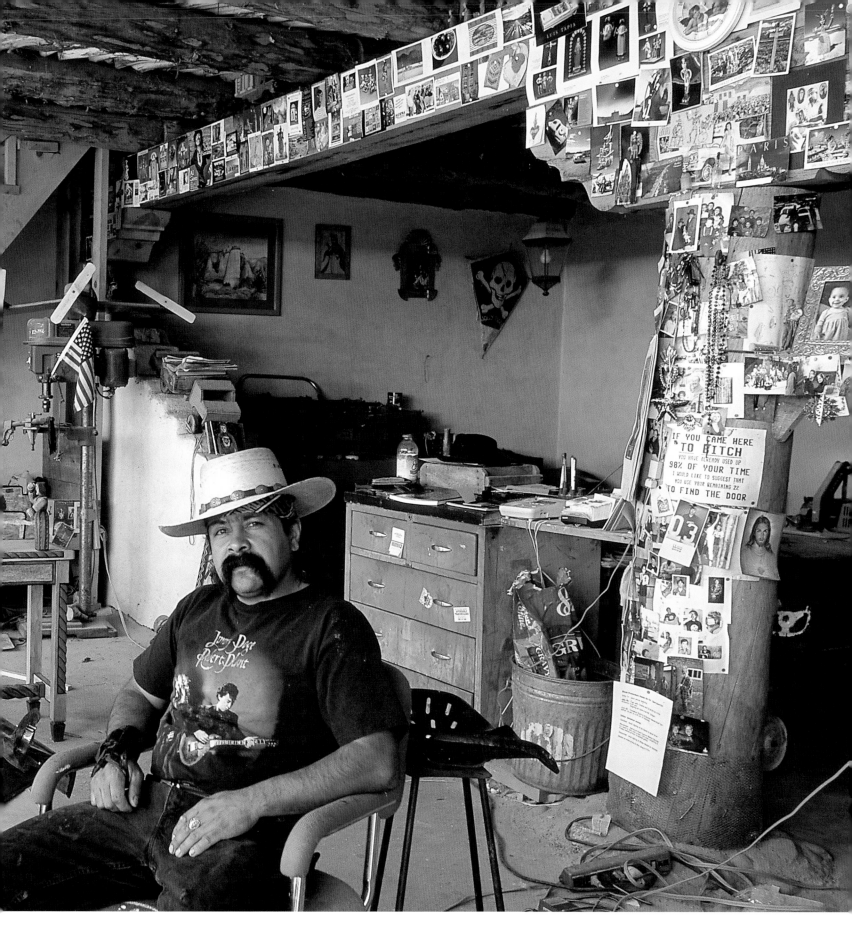

Nicholas Herrera

El Rito artist Nicholas Herrera built his studio behind the house in which he grew up, out in the countryside of Rio Arriba County, about forty miles north of Santa Fe. A large pile of rusted metal, chrome hubcaps, wire, discarded auto parts, an ironing board, rope, and cow bones is stacked outside against the wall. He looks at the collection, some of it rescued from nearby arroyos, and smiles. "That's all my art supplies."

Often, when in need of inspiration, Herrera will extract an ancient bumper from the pile or pull out a grill and carry it into his studio. There it may stand for days or weeks until, as he says, "One day I see it and say, 'Wow! This is what it's gonna be.'"

The artist goes to the front of the building. As he opens the door he announces, "This is where I go for it." When he finished building the studio, Herrera took off his shoes and left his signature. There on the cement floor, next to his footprints, he inscribed "1997." "It's all paid for," he says of his studio, "and that's what counts."

The room is large and sunny. A hard-bristled push broom leans against the wall. Sawdust, wood chips, pieces of cut and chiseled wood are everywhere. Occasionally, mixed in with these, there are bright plastic toys, a sign that kids sometimes play here. Herrera lives in this building with his three-year-old daughter; their sleeping and eating spaces are upstairs.

The sculptor, who did not go to art school, says his mother, now deceased, was his guide. Celia Elena Herrera was, in his words, "just a self-taught artist, but she had a lot of heart. She loved to draw flowers."

Her son, Nicholas, creates satirical edgy sculptures about contemporary Hispanic life in New Mexico that are much in demand. On a table to the back of his studio there is a piece on which he is presently working. It is based on the Hispanic *carreta*, or death cart, traditionally driven by Doña Sebastiana, a skeletal Death figure who is "coming to get you." The artist has carved a big diesel truck as his *carreta*. The flatbed is loaded with SCUD missiles, and the Devil and George W. Bush are riding in the back. "It's already sold," reveals the artist. "It's going to New York as soon as I finish it."

"Now I want to take you to see something," he says. He goes outdoors and heads toward a small building. He unlocks the door, and we enter. The cement floor and cinder-block walls create a low windowless gray room; it is cool in the half-light. At the back there is a six-foot-tall Christ figure carved by Herrera, its shoulders draped in a worn quilt. A small plaque embedded in the floor states that Celia E. Herrera is buried beneath. "When she died I wanted her to stay here, close by. This way I can come to talk to her whenever I want to," the sculptor says.

Outside, Herrera's pickup is framed visually by cottonwoods, a coyote fence, a rusted old tractor, and, in the distance, the hills. The bumper sticker is classic New Mexican. *Las Acequias de Rio Arriba – Vida, Cultura, Tradición.* It can be translated as: "Our irrigation ditches—they mean life, culture, and tradition to us."

When Luis Tapia, master carver, is working, he sees himself in a number of different ways. "I am a historian—a lot of my imagery is historically based. I'm being a storyteller, a comedian, and a fortuneteller. I'm sometimes being religious—and sometimes not."

Luis Tapia and his wife, writer Carmella Padilla, live in a centuries-old adobe nestled in what seems to be a secret valley in La Cienega. Tapia's studio is five miles away; he prefers to separate his art making from his home life. While working he must be completely focused on the effort at hand.

In his studio, a converted two-car garage, orderly shelves line the walls; they hold the tools he's constantly accumulating. An industrial fan is recessed into one of the walls. He has worked in much larger studios, he says, but this space, though small, is very efficient.

Tapia has a daily ritual he performs on arriving at his studio. "Every morning I always address my studio before I come in and turn on the lights. I stop in front of the door and say, 'Good morning, Studio.' I do this so my concentration will be present. For me, art is more of a mentality than it is a job."

And the sculptor addresses his tools, also. "Tools are dangerous," he says. "Before I use a bandsaw or tablesaw I announce, 'I'm with you, Saw.' Doing this makes me alert to what I'm about to do."

Raised by his mother and grandmother in a traditional New Mexico environment, he grew up to become a renowned woodcarver highly respected for work that blends the old religious imagery with modern motifs. He is self-taught, "and I have the scars to prove it," he says ruefully.

By the mid-1970s, Tapia came to the conclusion, based on years of study, that early New Mexican *retablos* and *bultos* were more brightly decorated than had previously been thought. When he introduced vivid colors into his own work, he was criticized by conservative elements, including officials of Santa Fe's Spanish Market, an annual juried exhibit of traditional Hispanic artists and craftsmen. Tapia was eventually vindicated when studies conducted at the Smithsonian Institution confirmed his theories.

"I'm a Hispanic artist, but I am not a traditionalist. I like making something totally new. It's been a challenge to break away and have my work accepted as fine art."

To Tapia's way of thinking, historians keep the record, writers tell the story, and artists work in the realm of spirituality—whether they know it or not.

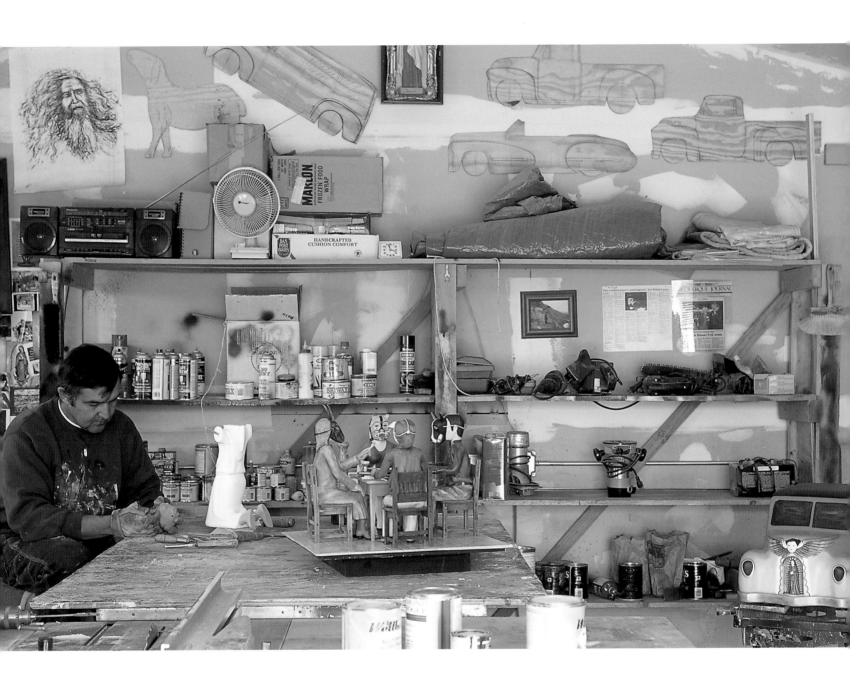

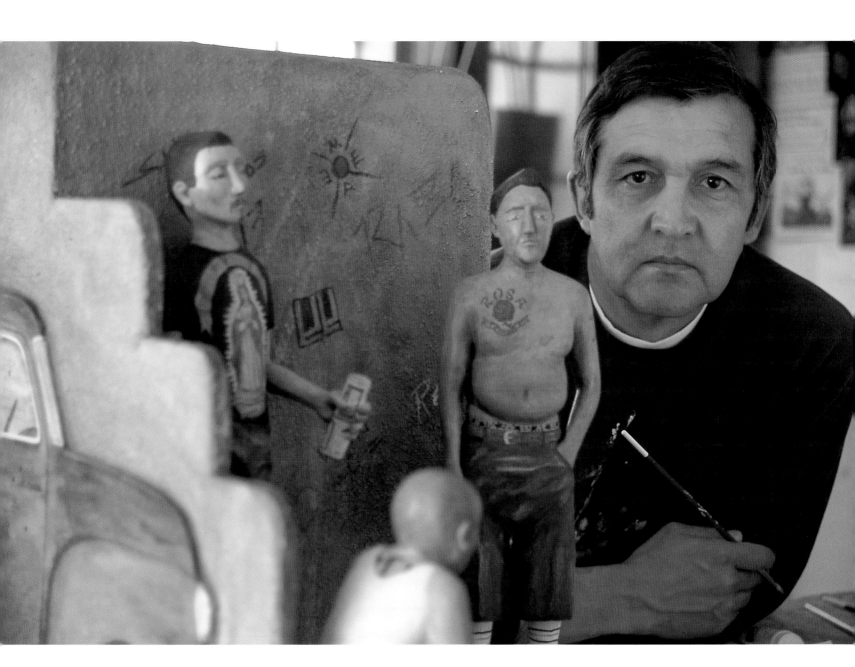

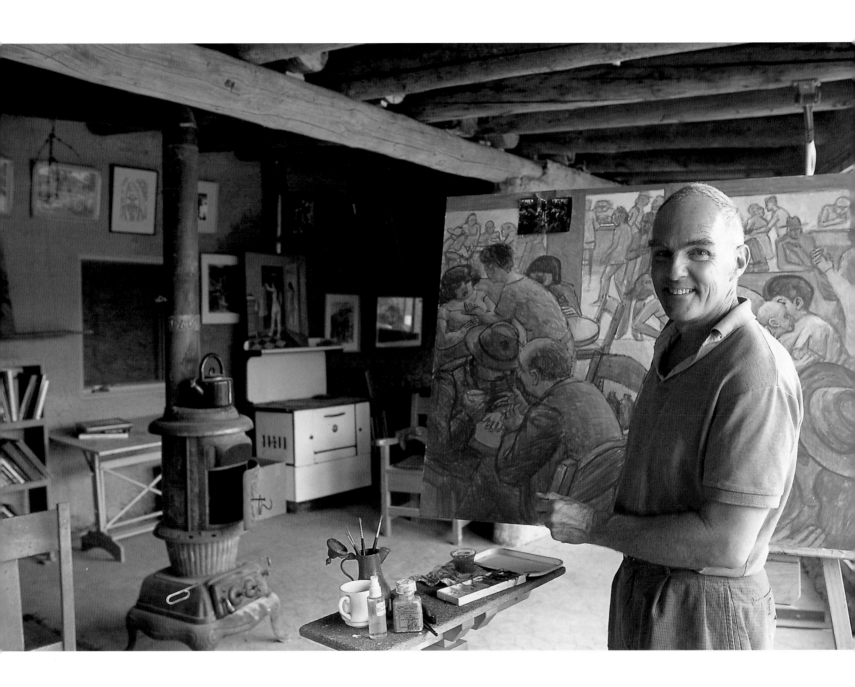

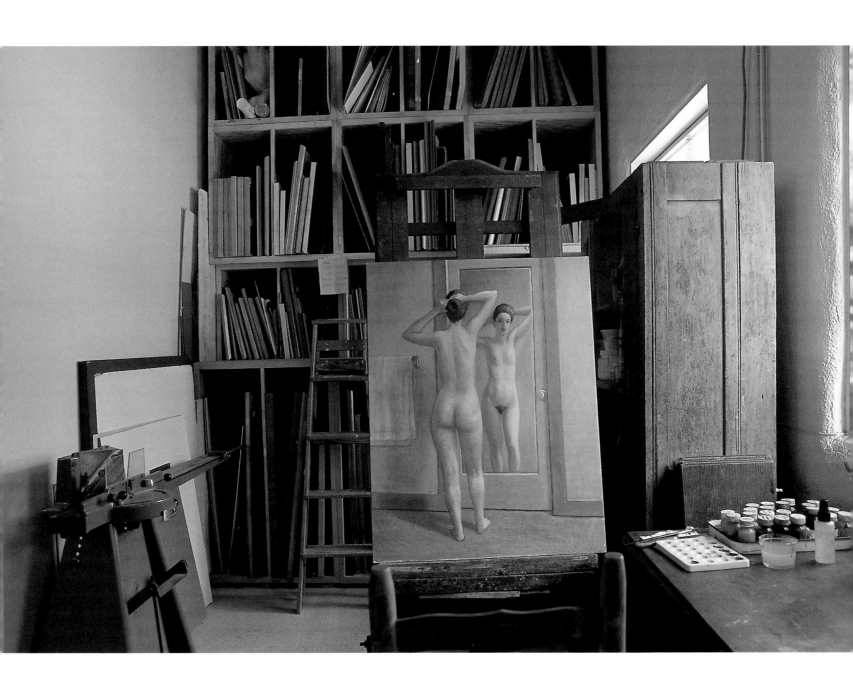

Jo Basiste

WE HAVE EACH KNOWN the desire to escape old ties and patterns, to take on a fresh identity. In 1996 artist Eli Levin, a figure central to Santa Fe's Bohemian art community, legally changed his name. He took his paternal grandfather's name, Basiste, which had been changed to Levin by the immigration officials at Ellis Island. The *New Mexican* ran a small black-bordered announcement of Levin's "demise." It amuses him that several literalists in town actually believed him dead.

Basiste's familiarity with art, and studios, reaches back into his childhood. His interest was supported and encouraged by his family, and by the time he was twelve he already felt he would be an artist. Throughout his youth he spent summers in Paris, in "a wonderful studio where [his] stepmother still lives today." Later, he attended an art-oriented high school in New York City.

Unlike many artists of his generation, he did not have to free himself from the conventions of a bourgeois lifestyle. When he came to Santa Fe in 1964, he says, he had no problem jumping "right into the Bohemian life."

In 1969, Basiste (then Eli Levin) moved into a little house on Don Miguel Street. Over the years he added on to it in ways that were eccentric yet respected the low-tech building conventions of the neighborhood. In those rich, free days of the 1960s and '70s, his studio became a magnet for artists and their friends. There were many parties and potlucks at his place, and he had a communal bathtub. In a salon-like setting artists came to draw from a live model, gossip, romance one another, and debate the merits of this or that way of doing art. Looking back, he muses, "Life has never been as romantic as my early years."

Over the decades Basiste has been loyal to his art muse, painting in the daytime and reading art books into the night.

"All my identity as an artist revolves around the studio. It is my whole social life. I have hardly had a girlfriend in ten years I didn't meet in my house or studio."

Since selling his house in 2002, the artist divides his time between two workspaces: one in town and one in the country.

The Basiste Studio, in Santa Fe, is on Guadalupe Street overlooking the railroad tracks. Housed in a warehouse formerly used for meat refrigeration, it today serves as exhibition and art-class spaces. The drawing group he first organized in 1969, in his former studio, now meets here. This is also where Basiste paints and stores much of his work.

Three or four days a week the artist works at his country studio, which he built himself, locating it on the highest point of his property in Apodaca, near Dixon. One wall is all windows; he uses a sheet to mute the light in winter. The floors are hard-packed dirt; the walls, lovely soft-toned adobe. He has a kiva fireplace and a woodstove. Solar-generated electricity is limited, so he paints by music from an old phonograph in a suitcase—and, yes, he listens to classical music as he works. The walls hold wonderful Southwest paintings—his own, those of friends, and of early *pintores*. There, by the bank of windows, he works at his easel. The quiet room exudes order and charm. He looks up. "In the long run," he tells me with a smile, "in my dreams, I'll end up out here."

Michael Lujan

MICHAEL LUJAN describes himself as "a person who makes things." Certainly, the variety of implements and equipment in his studio attest to his many skills. There are tools specific to metal and stone-working, painting, carving, frame-making, electronics, and even taxidermy.

His fifteen-by-twenty-foot workspace is exceptional in that it has no windows. This is deliberate on Lujan's part, as he prefers to have a constant level of illumination, day and night. There are no empty spaces on the walls here; what isn't covered by shelves filled with souvenirs, relics, and remnants is papered with photos and pictures. A car transmission hangs from the ceiling at one side of the room. The bookshelf holds unusual titles: *Field Notes from the Future Terrain, Anarchist Theory, A Detailed Guide to Our Lady's Rosary, The Solitaire Encryption Algorithm.*

"This is the first real studio I've had," he states. "Always before I worked in carports and spare bedrooms."

"I tend to fill in a space until it feels tiny," he says. Some of Lujan's collages are also diminutive, six by six inches, and even smaller. "I get ideas from the materials themselves," he offers. He works on groups of pieces, perhaps three or four at a time, experimenting with multiple approaches to one theme.

"There are no boundaries here between what I collect and what I make," the artist asserts. In some of Lujan's work, he emphasizes the associations that spring up between the unlike elements that he assembles. In other pieces he celebrates the beauty of the object, isolated, whether a natural form—in one case three tiny dried, as if stillborn, snakes—or a thrift-store lucky find.

Born in California, Lujan is part Mescalero Apache and Taos Pueblo Indian, part Irish-Mexican. He came to Santa Fe to attend the Institute of American Indian Arts. Now he and his wife, artist Amy Westphal, live and work in one of those west-side Santa Fe neighborhoods that is appealing to young artists because its old houses are still affordable.

The artist recollects, "When we moved in here, the roof was caved in, and this room was full of all kinds of stuff. Lots of it was trash, but there were also letters from the thirties and forties left behind by the people who used to live here. I saved those." Lujan has used some of these missives in recent work. By isolating the wartime stamps, the bleeding ink on an address, the faded envelopes, the artist has given dignity to the forlorn fragments of an earlier time.

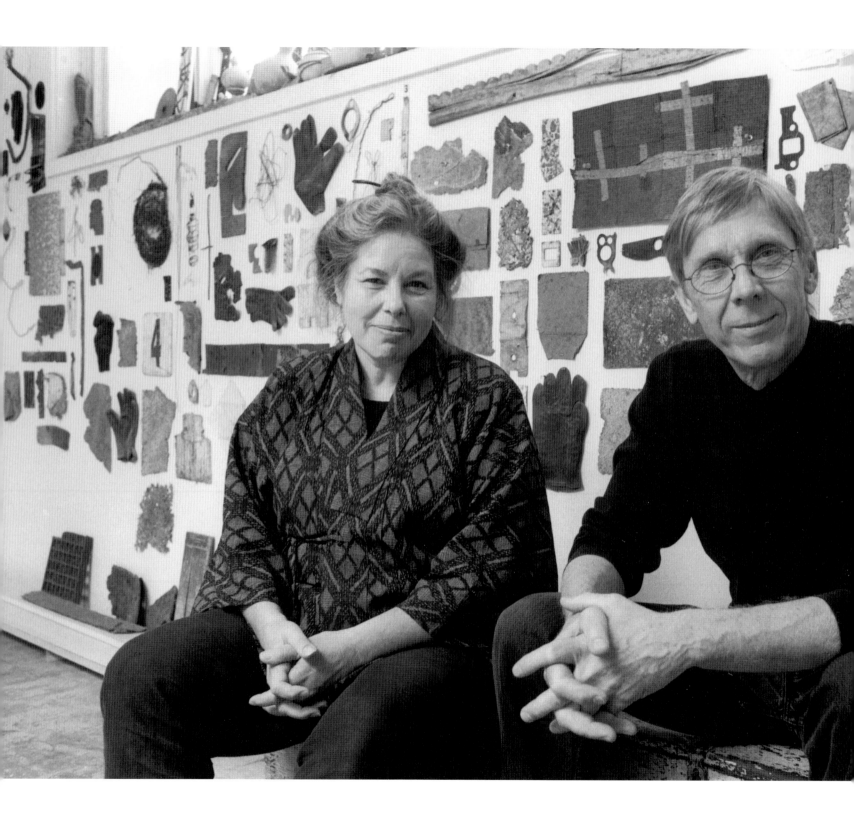

Serena Rieke

Gail Rieke

The room where artist Gail Rieke makes her collages and assemblages glows with a muted natural light. A complex of textural surfaces and subtle tonalities—tans, warm browns, smoky blacks, with rare glints of gold and silver—intrigues and seduces.

Although this space is primarily her studio, the artist sometimes collaborates here with her husband, Zachariah, who built the many drawers in which the couple protects works-in-progress and elements that await inclusion in future pieces. (The Riekes' young daughter, Serena, shares her parents' involvement in the arts. She creates collaged books in her studio, a converted bathroom.) The collage materials in the drawers are visually compelling in themselves, since the Riekes order them, dissimilar as these may be, by color and tonality.

The first room of the collage studio is filled with natural objects—forms recognizable yet, surprisingly in this context, fresh and unfamiliar. The collaged walls are small wonders. The longest one is covered with opened-out papers of spent tea bags—over 250—each with an individual stained beauty. A short southern wall is meticulously overlaid with hand-sized pages of a centuries-old book of sonnets. A third wall is papered with steel-engraved images from a nineteenth-century *Webster's Pictorial Dictionary*.

In this studio, "families" are reunited. In the far room there is a wall of suitcases from the Orient and the Orient Express; many hold journals, collaged tales of Gail's travels. Spheres are present throughout the two rooms—in balls made out of rubber bands or twine or marble, patinated metal balls, sea urchins shells, world globes—and echoed in the perforated surface of a wooden communion tray.

Cast-offs, here, have an eerie beauty: a streamlined Oldsmobile hood ornament, a rusted toy Roadster long cracked. Old keys, three dozen and some in a line, stand at attention on the wall. Collections as dissimilar as early Americana and Japanese ephemera find common ground in these rooms.

Gail asserts: "I don't see the difference between a single collage and the totality of what I do. The pieces are part of each other. The studio environment is a piece. It's about continuity rather than singularity."

On the nineteenth-century desktop, among many little boxes and cunning objects, there is a small piece of abalone shell about the size of one's palm, its irregular edges worn smooth by the sea. Nested in its hollow are very small round abalone buttons, each with two holes in its center—the man-made mirroring nature.

In this studio Rieke's art is at one with nature's art.

Zachariah Rieke

"PEOPLE OFTEN COMMENT on how orderly I am," muses painter Zachariah Rieke. The south wall of his studio confirms this. The brushes in coffee cans, the scissors, the radio—each tool has a specific place. "I say, if I hang up my hammer in the same place, I can find it when I need it. This tool shelf has remained the same for fifteen years now; it's a time-saver, and it's important to me to utilize what time I have to the best advantage. Artwork is pretty much what I do."

"The space I work in was originally an open carport. When we moved here to this house, we asked ourselves what spaces could be turned into working areas as immediately as possible. Right off I built the cabinet of twenty-three long flat drawers for Gail to use in the collage studio. In the following months, I enclosed the carport and moved the front door to the west, so that the entry hall would provide more exhibition space. The size of our studios was dictated by what we could afford at that time. It has always been my dream to build a large painting studio in the space back of the house."

"I think of my painting as a record of my exploration, the activity, the doing of it. For a number of years I've made rubbings of the ground where sumac trees drop their twigs and leaves; I cover them with canvas and, using roofing tar, make a rubbing that is a record of the season." And the cement floor of his studio also bears the marks of years of painting, revealed by the multiple outlines of canvases he executed there.

Pointing to the east wall of his workspace, where a large array of flattened objects and papers are displayed, Rieke explains: "This collection of things I found on walks started ten years ago with a credit union slip that had been dropped in the street; and that one thing led on until, after a couple of years, I saw that it was a piece, itself. I like it when you can back into things that way, almost offhand."

"To me, what is important in art is seeing the significant form—the substance, the rightness. I look at a Celtic axhead and see that it's as good as anything at the Modern or anywhere else. The creative act is in the seeing. It's not the making [of art] per se; it's the recognition of the 'rightness' of certain objects, whether found or from our own hand."

When asked about his work habits, Rieke says: "For the past seven months I've been working six days a week and more than eight hours a day. Of course, I know there are some seasonal things, like upkeep of the house, that also have to be done. If I get into the studio by 9:30 or 10 in the morning, I'm doing good."

Growing reflective about the rhythm of painting, the artist adds: "After I have a show I feel flayed, raw. I'm really drained, so I need a down period. Then, like they say in the Midwest [where Rieke grew up], 'you take the bit in your teeth and you get on with it!'"

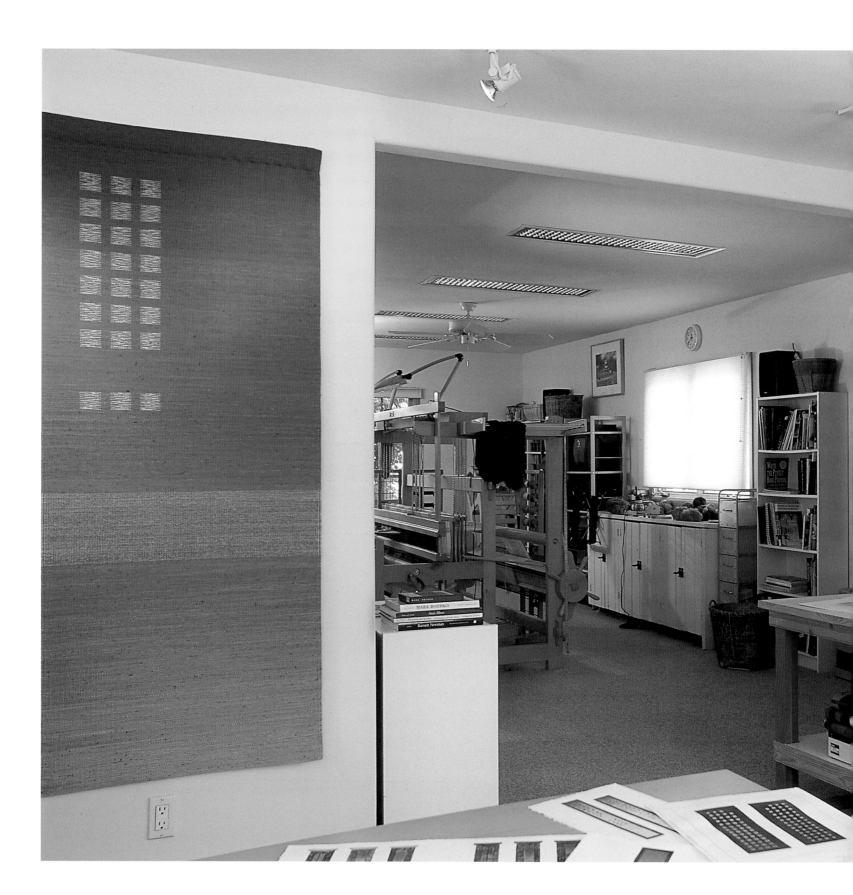

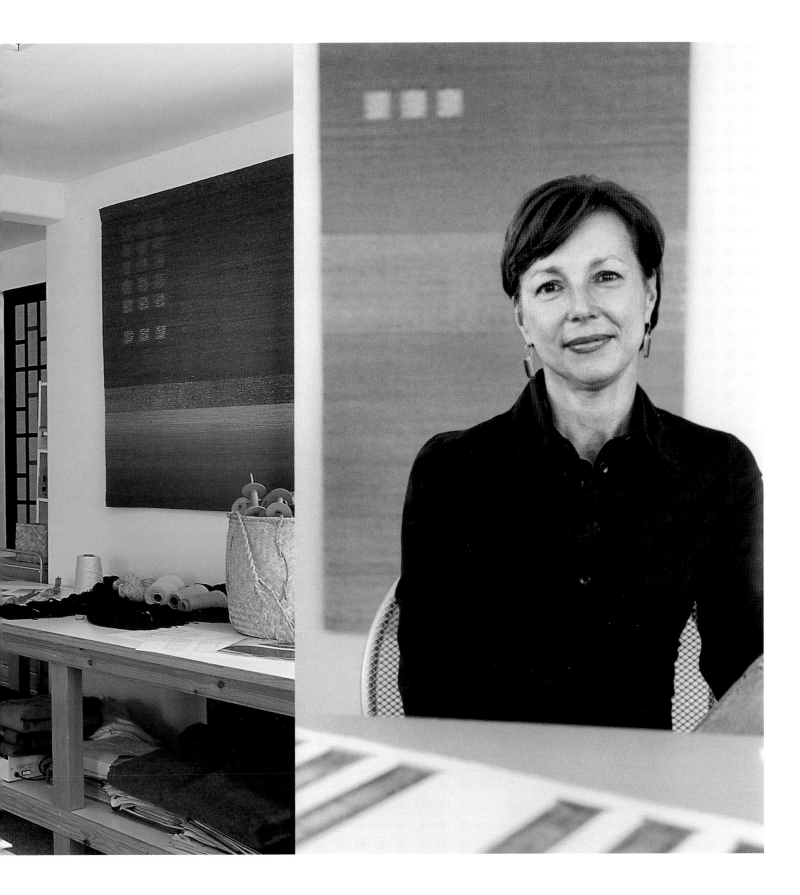

Rebecca Bluestone

Since 1988 Rebecca Bluestone has used an old woodworking shop on the side of her house as her studio; in 2000 she remodeled and expanded it. "I knew what the conditions were that I needed to work well: quiet, light, a very clean environment, with nature close at hand."

Located in a serene garden setting on the east side of Santa Fe, the six-hundred-square-foot space, divided into two rooms, projects a sense of order and formality. "I love coming to my studio," the artist says, "for here I have everything I need. This space has made my art career more concrete."

Bluestone is a studio-trained weaver who first learned her craft in Maine. In 1986, she saw an advertisement for a Navajo weaving class to be held in Santa Fe; she came west for the class and was so struck by the landscape that she moved to New Mexico that same year. After months of working intensely she completed her first body of work in 1988.

Bluestone speaks of herself as an artist rather than as a weaver. As she explains it, "Craft is focused on technique. When you take that technical skill and use it to express content—to communicate nonverbally—the work (whether ceramics, glass, weaving) becomes art."

She values her intuition and strengthens it daily through the contemplative practice of yoga. She states that doing her work is a meditation, and therefore she does not allow anyone in her studio during the process. Jake and Bosco, her two poodles, are the exception. They are always there.

The artist maintains a strict studio schedule. "Leading up to each piece I first do a series of colored pencil drawings to scale. It may take a year of preparation before I sit down at the loom."

Bluestone hand-dyes every thread she uses. The aniline dyes are coal-tar based and produce the most light-fast museum-quality yarns. "Just as a painter does, I mix my own colors with which I dye the silk. I weave in order to achieve the tonalities and the surface I want." She works exclusively with silk, explaining that moths are not drawn to it.

Bluestone's modern tapestries contain fields of modulated color and the occasional geometric invention. She lists the Abstract Expressionist masters Barnett Newman, Mark Rothko, and Agnes Martin as major influences on her work.

Agnes Martin

AGNES MARTIN's grid-based paintings are among the most celebrated artworks of our times. She identifies herself as an Abstract Expressionist.

I met the artist at her small apartment in the center of Taos, where she lives in a retirement community. At the age of ninety-one, she drives the quarter-mile to her small studio every morning in a white Mercedes that sports the bumper sticker "Hillary." This is the studio in which she has worked for the last two and a half years.

"I was born in Canada. I wanted to come to the United States. In those days, you could only get in if you had a lot of money or if you were a professional. I didn't want to be a dentist, so I went to school and became a teacher. I taught art in America for a few years."

It was a cold day in November; she came out of her house without a coat. When questioned about this she said: "I'm toughening up for the winter."

"I only work three and a half hours a day, but that doesn't count the hours I'm thinking about art. No, actually, I do think about painting in the afternoon."

"Some artists work by having their *painting* tell them what to do next. *I* just sit there and wait for inspiration. It comes, and I see the entire painting, every color—*everything*—and I just paint it the way I've seen it."

"I decided to come to New Mexico because it was the second poorest state. I could rent a studio for $15 a month—and live in it."

"I've had two big studios I've built with my hands. One, in Cuba, New Mexico, was made with big logs. The man said, 'Fifty cents a foot,' and I thought that was pretty good, but of course . . . it adds up. But I *still* think it was a pretty good price. The other studio was in Galisteo; it was adobe."

"When I was painting in those places I didn't think you could paint in a small studio." The painter is referring to her present studio, which is modest in size.

"You don't know the joys of living in a retirement home. They wash your clothes, they clean your house and make your bed. Every morning they give you breakfast—and it's good, too."

I mentioned that I had gone to the Harwood Museum there in Taos, where seven works she gave the Harwood Foundation hang in an octagonal room built specifically for these paintings. I sat for a long time on the bench in the Agnes Martin Room, surrounded by her work. I told Miss Martin how much I appreciated the fact that no one had come in to interrupt or disturb me. "I'm so glad those paintings wound up in a backwater town," was her firm, enigmatic response.

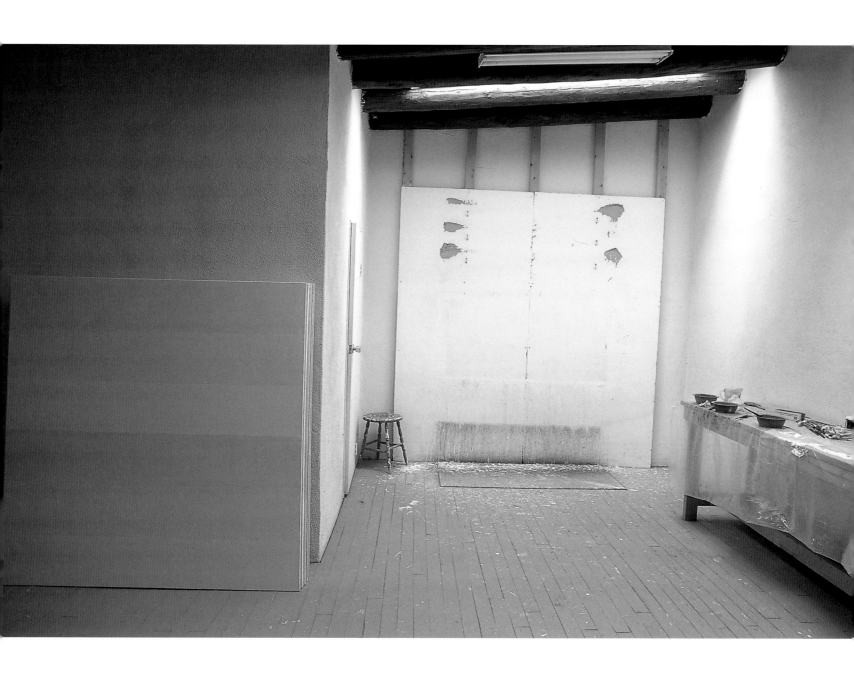

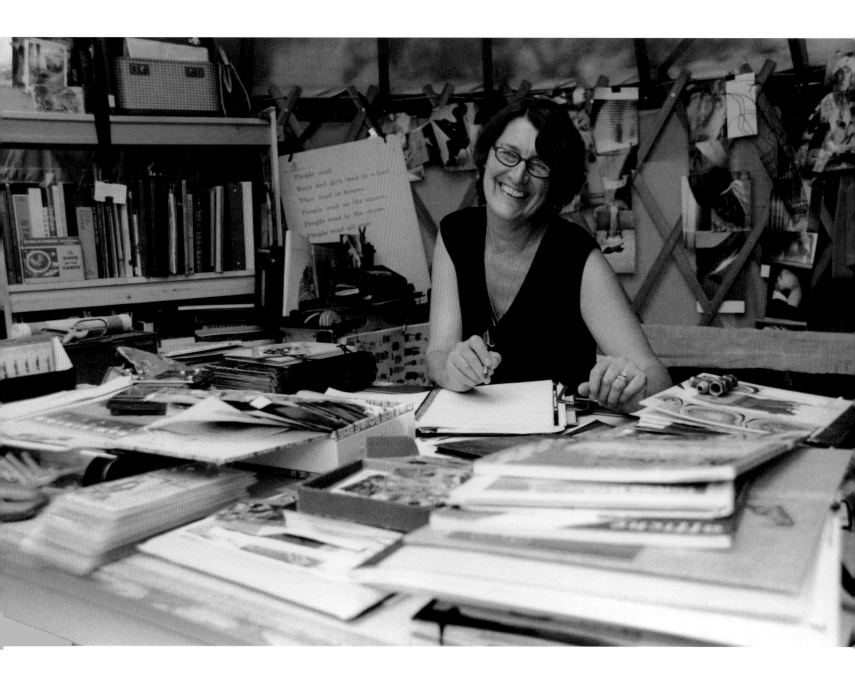

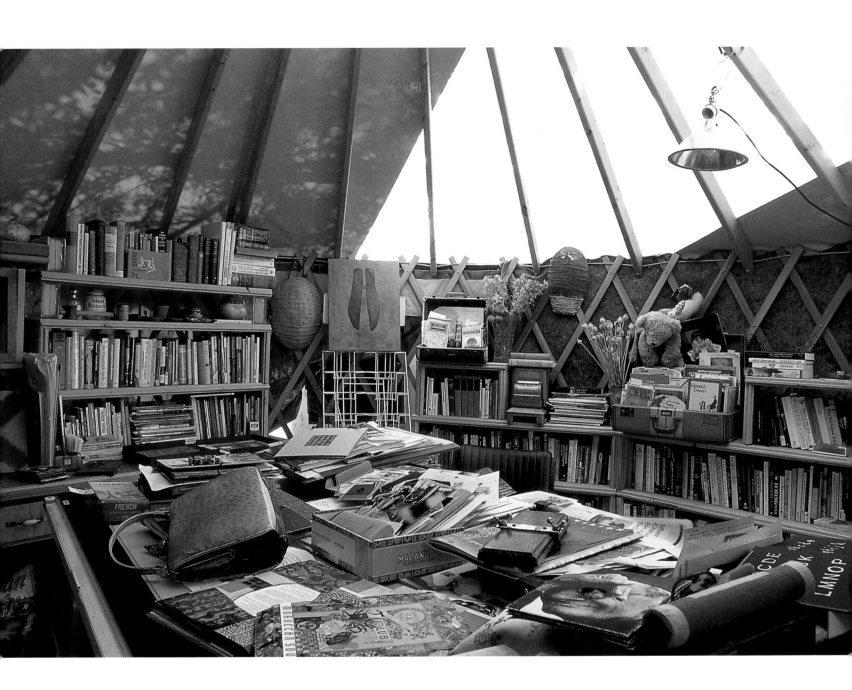

Suzanne Vilmain

SUZANNE VILMAIN and her husband, Steve Smith, live between Los Alamos and Santa Fe, at the point where the road crosses the Rio Grande. To the east of their home stands a yurt, its design based on the traditional round Mongolian habitat known as a *ger*. This is the artist's studio.

For many years, Vilmain worked in commercial art, heading her own design group. When she and Steve married in 2000, she left the graphic arts business and began making one-of-a-kind books. After working for many years in controlled environments, she now wanted a studio without corners, with no hard edges. This studio-in-the-round seemed the perfect solution.

Vilmain describes its construction: "This yurt came from a company in Montrose, Colorado. They say it takes only an hour to put together . . . it took us an entire afternoon. We invited architect and scientist friends to come over and help put it up. Steve set up the tongue-in-groove flooring, and I used a power saw to cut round edges. The wall is an expandable wood lattice with a tension cable around the top into which are notched the rafters that fit into a compression ring forming a skylight. The entire structure is covered with waterproof canvas — the Mongolians used thick yak felt."

In summer the artist hangs lengths of colorful fabric near the entrance to her studio. Periodically she showers these with a hose. As the breezes dry them, the evaporation cools the interior of her work area.

"I design books to be held. It is meant to be an intimate relationship," states the artist. Many of Vilmain's pieces are there in the studio, close at hand. Some are old volumes transformed with inserts and overlays of surreal collages. One piece is a large flat lavender handbag; when the clasp is undone and the bag opened, it reveals the pages of a private book. When the purse is turned upside down, the base of the bag opens out and reveals a second complete volume.

A sleek chrome art deco toaster stands on the artist's desk. When the two sides of the appliance are lowered, the pages of an entire book, segmented at the middle, are revealed.

"My studio has definitely affected my work. In the yurt, I'm in a cave where I'm encircled by the work and the materials from which to generate new pieces. I would feel hemmed in by an organized space. I have to have a little chaos. Even in my garden, that's true: it's round, and it's sheer chaos — flowers, snakes, vegetables, bugs. It's drama."

At any given time the artist works on half a dozen books, shifting her attention from one to another. "I move around a lot as I work. Sometimes I read. I usually write. I find connections. This is what I do. I do it every day." Vilmain looks to one side, thoughtful. "For all the action in this space, my studio is like a womb. It is safe — and it's wonderful."

Judy Chicago

IN 1991, INTERNATIONALLY RENOWNED feminist artist Judy Chicago and her husband, photographer Donald Woodman, bought a turn-of-the-century Victorian hotel in Belen, thirty miles south of Albuquerque. Although the building was in disrepair, its strong character and seven thousand square feet of space appealed to them both.

Woodman spent three years renovating the hotel, which now affords them each a large studio, storage space, personal office spaces, exercise facilities and living quarters. It is also the headquarters for the nonprofit Through the Flower, an organization that manages Chicago's major collaborative projects.

To create Chicago's studio, Woodman expanded what had been the hotel's parlor. A bank of windows, perhaps once covered by Victorian velvet drapes, faces the sidewalk of a major street in the old business district. White shades cover the windows in order to mute the intense light, and for privacy. The workspace is large, has high ceilings and is very white. "The whiteness is what I like. In fact, the Historic Preservation Association refers to this space as my 'refrigerator,'" Chicago says, amused.

Numerous long tables fill the room; standing empty they bring to mind a college chemistry lab. They are put to use when Chicago executes her colored pencil drawings and are available for the many projects in which she is involved.

The studio space is modified with each new undertaking. For *Resolutions: A Stitch in Time* —a "series intended to present images of a world transformed into a global community of caring people"—she closed off a portion of the back of the room and converted it into a wood-carving area, where she created the three-foot-tall "Resolutions" figure.

Her artistic vision directs her to learn skills appropriate to the realization of each project. She has taught herself embroidery, stained-glass work, airbrush technique, and for this project, wood carving.

Chicago's ambitious projects, both collective and private, require tremendous discipline and energy. She has a rigorous schedule that includes time set aside for exercise and running. Her hours in the studio are inviolate. She thinks it is an artist's obligation to keep current by reading the art publications but never, she emphasizes, during studio hours.

The artist first became famous for her pioneering collective-feminist project *The Dinner Party*, the aim of which was, in her words, "to end the ongoing cycle of omission in which women's achievements are repeatedly written out of the historical record." The iconic feminist installation was created in the 1970s by Chicago with the efforts of four hundred women. After being exhibited widely over the years, it will now be permanently installed at The Brooklyn Museum of Art, Elizabeth A. Sackler Center for Feminist Art.

Chicago relates how, early in her career, she met radical writer Anaïs Nin, and the two women developed a personal friendship and a professional alliance. Recently, Chicago completed a two-year undertaking, resulting in a limited-edition book of twenty sensuous watercolors paired to evocative phrases from Nin's erotic masterpiece *Delta of Venus*.

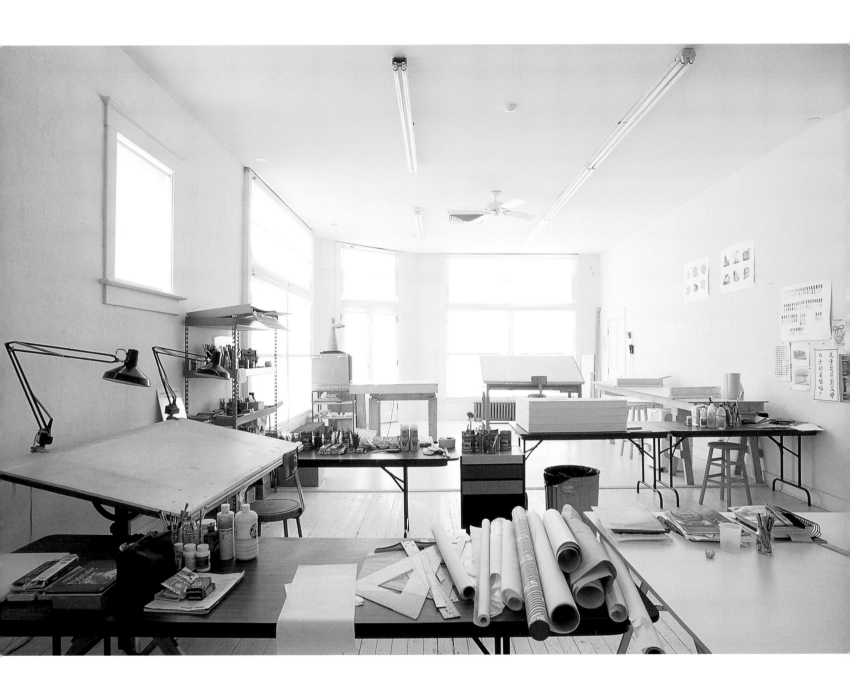

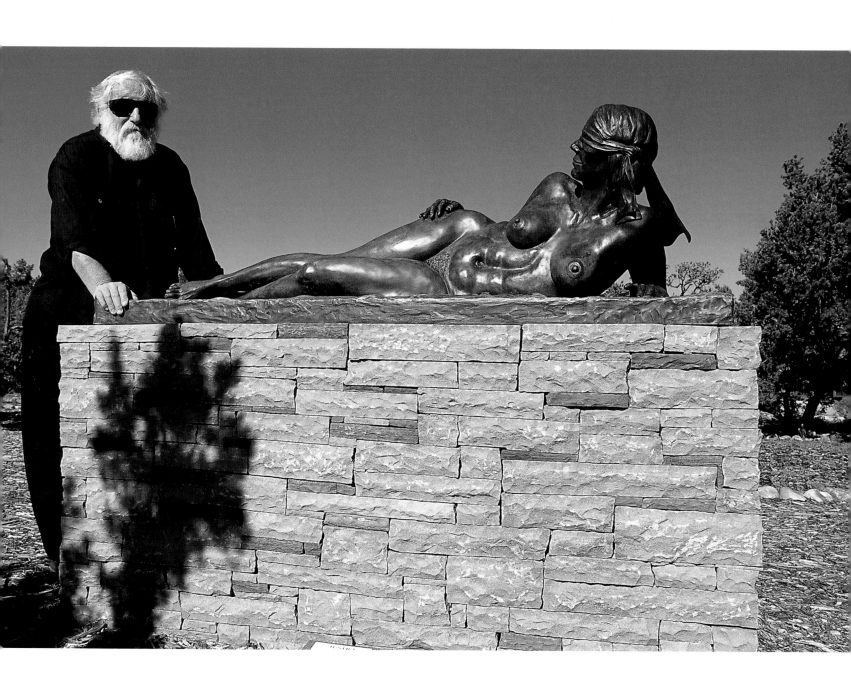

Ted Flicker

NEW MEXICO HAS TRADITIONALLY attracted and nurtured artists—amateurs as well as professionals. Sculptor Ted Flicker eagerly defines himself as one of the former: "I do not show my pieces in galleries and don't offer my sculpture for sale. After fifty years in showbiz, the disconnect of art from commerce is a thing of joy." He left the film and television business in 1979—he wrote and directed the cult film *The President's Analyst* and co-created the Barney Miller television series—and later wrote books.

As his interest in sculpture developed, he redesigned his woodworking shop and enclosed what was originally an attached double carport, transforming them into an airy two-room sculpting studio.

Flicker's studio is singular in that it is there that he creates sculpture using the unique "Tri-clops," a device he invented in 2001 with the assistance of computer technicians. Flicker recalls the process of development as agonizing; it took six months to create the computerized system, with its three cameras and rotating model's stand.

Using the Tri-clops, the artist photographs his subject from three perspectives: high, head-on, and low. The base, or turntable, rotates, stopping every 10 degrees, at which point all three cameras fire simultaneously. At the end of the 360-degree rotation he has 108 pictures. A separate computer program stitches these images together. Then the sculptor moves his laptop next to his sculpture stand.

Now he is able to rotate the model's head on the screen, and he has the option to look down on the head or up from underneath it. He is also able to zoom in so close that he can see the pores on the model's skin. This capacity allows him to study specific musculature as well as physiological details, such as how the eyes are set in the flesh of the face.

Flicker says he prefers to work from digital imagery, rather than from a live model. "I like being alone with the work. In 1995 I asked the sculptor Paul Moore if he would teach me. He did, and I discovered the richest, most profound experience of my life. I work every day. What a miracle to have this gift in the third act of my life."

Together, Flicker and his wife, Barbara, have created an extended sculpture garden for the display of his work and the sculpture in their collection. Barbara hand-placed in excess of twenty tons of round river rock to outline the pathways connecting the different exhibition areas, one of which is named "Avenue of the Gods." It is lined with sculptural portraits of the artists whose work they collect, rendered as mythological figures.

In other zones of the garden, Flicker has set a Holocaust Memorial and a place titled "Unconditional Love," honoring people he admires. One area of the garden is devoted to Barbara, celebrating her beauty and their thirty-eight years of marriage.

Harmony Hammond

HARMONY HAMMOND introduces the visitor to her Galisteo studio by saying, "This is my Guggenheim." When she received the prestigious award she said to herself, "I want to build a studio, and this will probably be the studio of my life, so I'm going to go for it."

The handsome structure has fourteen-foot walls and thirty-seven hundred square feet of floor space. She designed it with a pitched tin roof and the proportions of a northern New Mexico barn—so much so that the local Historical Society thought it might be old, she says. With its clean lines, it stands in artful contrast to her century-old stone house, which was itself a *lanera*, a wool barn.

The entry room is lined with shelves and tables holding supplies and tools needed for the fabrication, crating, and shipping of Hammond's work. Found materials—"piles of stuff," as the artist refers to them—weathered and rusted, that she adheres to some of her pieces, are stored with rope, wire, and tubing. In this context, the large alizarin crimson-and-black oil painting on the far wall has all the more impact because of its simplicity. Behind a draped entry there is a compact area where the artist stores older work; it serves as the anteroom to her main painting studio, an unexpectedly grand and open space.

"I love being in this studio," Hammond enthuses. "Working here is a very sensuous, erotic time and space for me." When she is not teaching (Hammond is a tenured professor of art at the University of Arizona in Tucson), she goes out to her studio as early as she can each day. She works in silence, no music or radio. "I want to hear where my thoughts and feelings are going."

The studio time is focused and intense, she says, and when she needs a break Hammond lays down her Styrofoam tray palette and retreats to the house to make calls or to have coffee. "I like to leave, in order to walk back in, so I can have a few moments of really seeing, a few moments of clarity."

A door on the west wall of her studio opens up to her office, where Hammond does her writing. In her roles as pioneer feminist/activist, writer, and lesbian theoretician—which she says are very much a part of her art—she spends a good deal of her time corresponding, preparing grant applications and exhibition proposals, and writing for various publications. Her award-winning book *Lesbian Art in America, A Contemporary History*, published in 2000, is considered the definitive text on the subject.

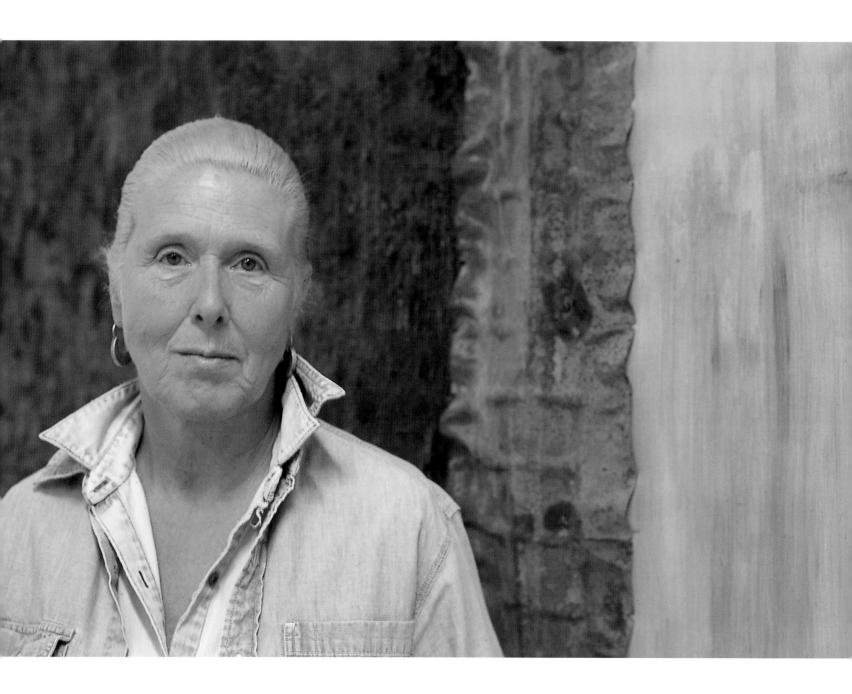

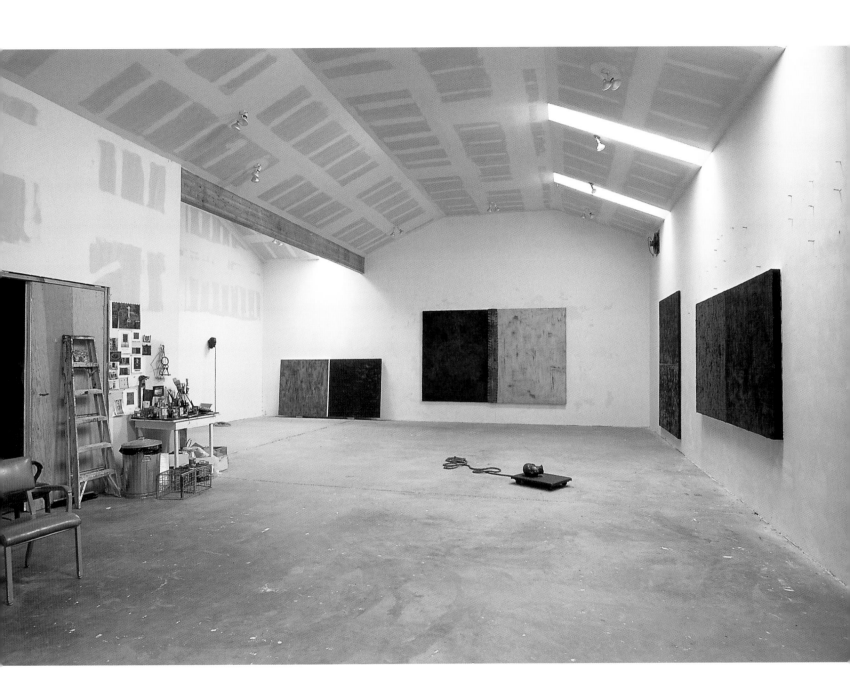

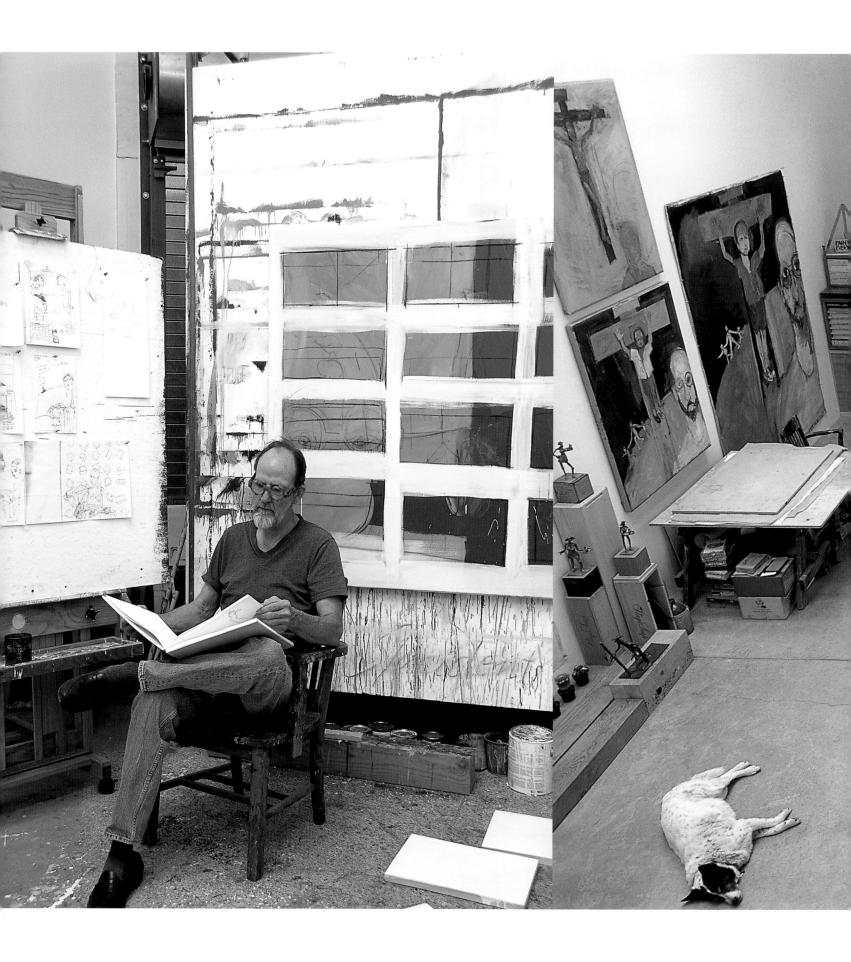

Patrick McFarlin

THE MAJESTIC BUILDING, with its clean lines, is at the end of a long dirt road on the edge of Santa Fe. No other building is in view. A brick path leads to a small yellow-orange kitchen. A brilliant chartreuse coffee maker stands beneath a hand-painted sign:

Café Meow

Max Cap 5

Next to the kitchen—and a compact bedroom—is the studio of Patrick McFarlin, painter and sculptor. The artist wanted the walls of his studio to be as tall as possible; at twenty-four feet they are as high as the county allows. His working space is completely sheltered from exterior sounds and imagery. There is a sensation of being in the quiet and calm of a medieval church; the deep-set windows, at level with the eaves overhead, reinforce this impression. On days when the studio is cold, warmth is provided by radiant heating in the cement floors. A wood-burning stove is used "to banish morning chill or to provide a sense of coziness in the cooler months."

A balcony off the small second floor—an office/sitting area—provides a dramatic view of the work being done below. McFarlin paints at an easel, as well as up against the walls, to which he tacks his huge canvases. His brushes are stored upright in lengths of rusted pipe. Open sketchbooks reveal some of the many drawings that document his earlier studios. Over the past four decades, he has had workspaces in Arkansas, California, and New Mexico.

About ten years ago, McFarlin began to paint portraits outside the studio, in very public places, often in open conversation with audience and sitter. Of this process he says, "I try not to worry about painting a likeness of the person—or even if it is good! Mainly when making a portrait I want to have 'a conversation' in a little more depth."

In addition to painting, McFarlin has always produced sculpture. He describes himself as "a painter who makes sculpture. Us painters make the best sculptors, we think. . . . Think about it: Picasso, Matisse, Degas, Daumier. . . . " He smiles broadly.

As a boy McFarlin attended private art classes in Little Rock, Arkansas, later winning a scholarship to Memphis Academy of Arts, where he was influenced, he says, by the Abstract Expressionists. He spent three years at the University of Arkansas and worked for a time in cartography and advertising. Then, in 1964, he migrated to California, where he encountered Berkeley, the Beatniks, and Zen. He was to spend twelve years in northern California, ten of them studying Buddhism.

In his studio he has posted several small signs with succinct messages. One of these states: It Paints. This sign reminds him, he says, of that point in painting where thinking is suspended and it is as if the image paints itself.

A wryness and an irony permeate much of McFarlin's conversation. He shares a story about Phillip Guston, which is of course also about Patrick McFarlin—and all creative efforts.

Guston once said, "When I go into my studio, they're all there: my teachers, my dealers, the critics, my patrons. I begin painting and as I paint, slowly, they begin to leave, until at last I am the only one left in the studio and, if I'm lucky, *I* leave too!"

ADA MEDINA's immigrant father was a barber in south Texas. She remembers that his *escritorio*, the desk in his barbershop, had a single drawer. One day, when she was nine years old, she opened that drawer and discovered her father's secret drawings: roses depicted in red ink. From that day on it became a ritual, her opening of the desk drawer and his ongoing drawings, shared without a word passing between them. For many years Medina continued to look in that drawer. It was for her "my first image of someone creating something over time."

In 1999, after more than twenty years of drawing and painting, Medina made a radical shift in her work toward the three-dimensional — yet she thinks it is limiting to call her present work "sculpture." The artist relies on exploratory processes that she internalized during her many years of drawing. "I'm still drawing," she says, "but now it's in space."

For ten years Medina had a studio in Santa Fe. When that building was sold she had to leave it. A friend offered her the loan of a country studio outside Santa Fe. That was five years ago. "It was hard leaving that earlier space; but what I thought of as a loss became an internal gain."

Medina muses that previously she had a possessive sense of her workspace, thinking of it as *her* studio. "Because this current space is not mine, it feels lighter to me. I feel the studio as an activity rather than a possession. I became aware that artists are often very possessive of their studios — forgetting that, no matter what, those spaces are as impermanent as we are."

In this country studio the artist finds herself in relation to "the land." She appreciates that, in her words, "Here I'm on the soil, and each season is directly around me. I work with color, yet it's basically colorless color akin to this very colorless land."

Medina does not use the studio for socializing. "It's such a relief to come out here for wordlessness and to go to work. This isn't a sexy space; it doesn't assume to be anything but a very practical working studio."

"I think of *studio* as a stove; like the vessels of alchemy, the studio is a container in which processes of change and generation are set off with the right time and heat. I come to the studio and I cook. Gradually, each day, by rasping, by sawing, I learn the rhythm of the piece."

After a day of work, by three or four in the afternoon, the conditions may be right for the integrity of the work to emerge. "It takes time for the heat of the stove, the studio, to do its work."

Ada Medina

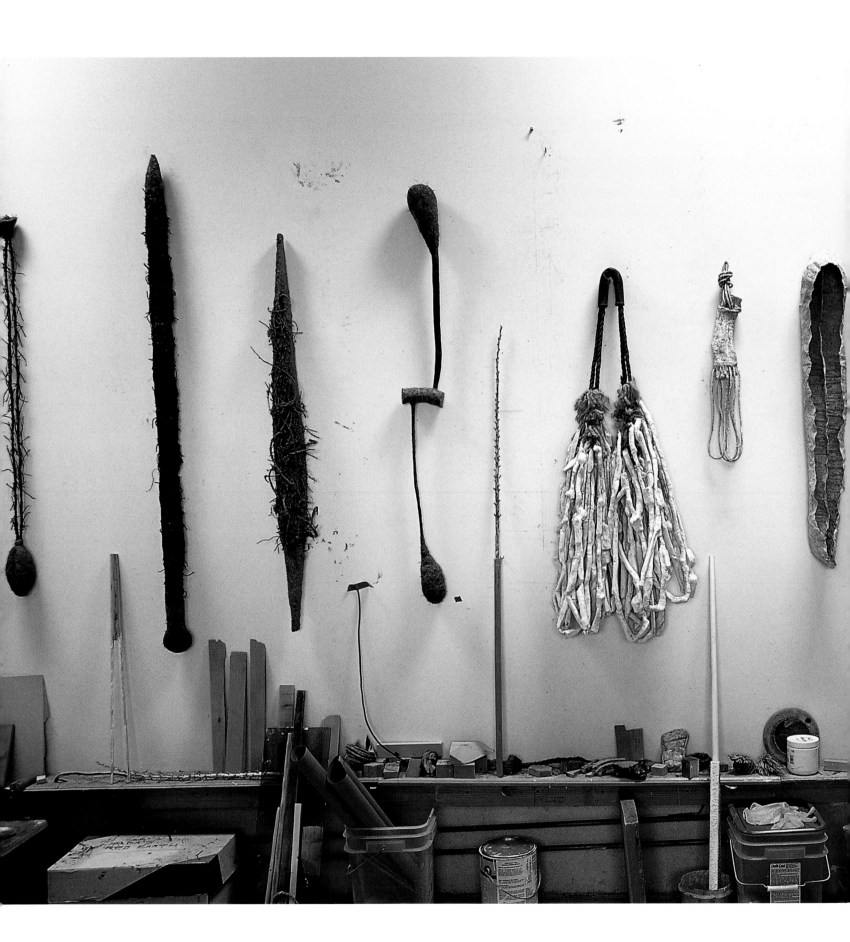

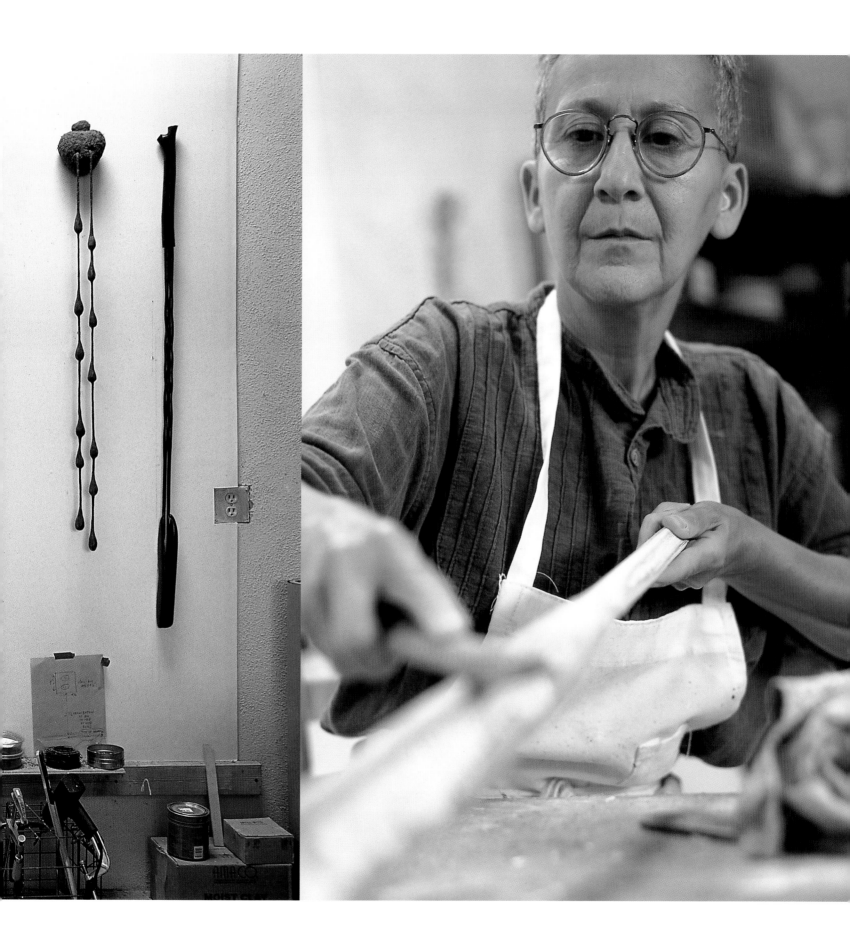

Patrick Oliphant

OF THE TEN-BY-TEN-FOOT ROOM in which he creates his political drawings, Patrick Oliphant says, "It's as big as it needs to be." Although small, its window looks out onto a pleasant patio and garden. He expresses his affection for the space, saying, "The irregularities of these adobes, it's perfect for me."

In nearly fifty years of professional life, Oliphant, who was born in Australia and moved to the United States in 1964, has generated canny, incisive drawings that scrutinize national and world politics at the amazing rate of five a week; five years ago he cut down to four a week, and in the year 2000 he reduced his output to three.

He's up at five o'clock in the morning. After watching the news on television or reading the newspapers, the artist moves to his drawing area to make his comment on the day's events. Working out his ideas in rough sketches, he then rerenders the drawing using India ink and a crow-quill pen in larger form on Strathmore paper. He scans it into the computer, from which it is transmitted to the newspaper syndicate that distributes his work. The whole process takes some four hours.

"My deadline is midday," Oliphant explains. He closes the door to his drawing area and moves into the larger part of the studio. After decades of newspaper work, "to the neglect of other things," he now devotes more time to painting, sculpture, monotypes, and most recently, etching.

Over the last twenty-five years he has made many expressive bronze sculptures — simultaneously beautiful and humorous — based on the famous and infamous in politics. In recent years Oliphant has moved on to work that is, in his words, totally nonpolitical, even at times entering the world of portraiture.

In the studio he displays some of his own work, as well as the work of artists he admires, including Leonard Baskin and Fritz Scholder. Also on exhibit are a number of political cartoons by the nineteenth-century French artist Honoré Daumier, Navajo weavings, a paint-encrusted palette Oliphant used as a youth in Australia, and an eclectic mix of antique firearms, Amazonian spears, and photographs.

Oliphant's editorial-page drawings are immediately identifiable by the little black-and-white bird that appears at the foot of each panel and offers an irreverent take on the day's politics, politicians, and their foibles. "I call him Punk. I met him in Australia, and he helped me through some tough times when I was working for a very conservative newspaper in my early years. He started life as a penguin and became very popular after we met. Perhaps I invented him, perhaps he invented me. I was never quite sure."

Janet Stein Romero

Born in Brooklyn, Janet Stein Romero has been drawing and collaging since childhood. She received her master's degree in painting and drawing from the University of New Mexico ("Gypsy Star Works" was the title of her thesis). She now lives with her artist husband, Nicasio Romero, in the Pecos Valley village of El Ancon, where he has long been the *mayordomo* of the *acequia* (irrigation ditch) an important post in the old community.

Her studio, which was initially a barn, is across the dirt road from their hundred-year-old adobe house. The artist smiles as we enter and confides: "I have a gift for clutter. I like having my collections all around me. An ethnic junkie, that's me."

To cross the threshold into her working space is to enter another world. This reality is multilayered, very personal, and slightly zany. The inventory includes: dolls, vintage kimonos, oversized green chiles, masks, platform high heels from the 1940s, fossils, kachinas, old toys, art deco *objets*, puppets, and archaeological finds. And then there is her own work— small and large cut-out women figures, fantasy shrines, and haunting faces of women peeking out from her overlaid collages, monotypes, tiles, watercolors, and paintings.

Occasionally, visitors are uncomfortable with the intensity—and quantity—of objects and imagery they encounter here; some may have been expecting a clean, crisp working area and, understandably, this space could be intimidating to them. Other people, Stein Romero notes, may be entranced by the vividness, the variety of what they see, and "these visitors have to examine every object and all of the art."

The environment she has created provides her with random influences as well as the concrete juxtaposition of materials, both of which are so essential to her imagery.

Stein Romero finds that she can make collages, draw, or paint in almost any setting. As an art teacher at Robertson High School in nearby Las Vegas, she is accustomed to working in a loud and active environment. In contrast, her studio must seem solitary to her. The first thing she does when she enters it is to turn on the music. As you would expect, her musical taste is eclectic: world beat, samba, classical.

The artist confides, "This is my little nest." Maybe this refers to the shelter she feels here. In another sense of the word, the nest is the place to which, like some members of the raven family, she brings the striking fragments, the brilliant colors, she has collected.

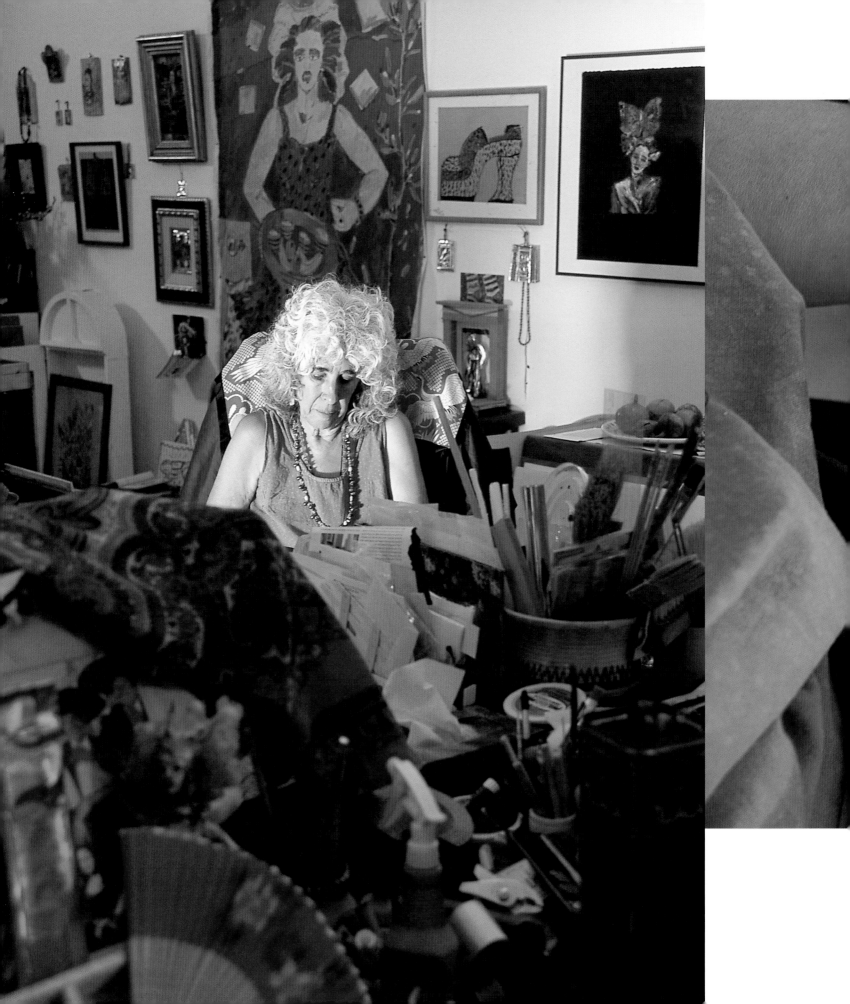

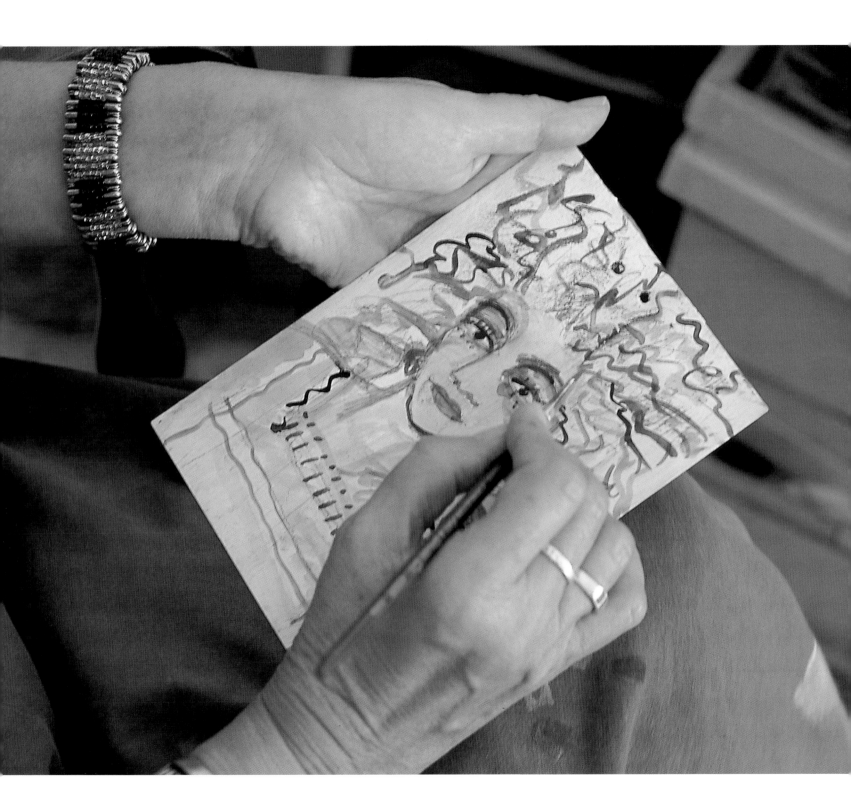

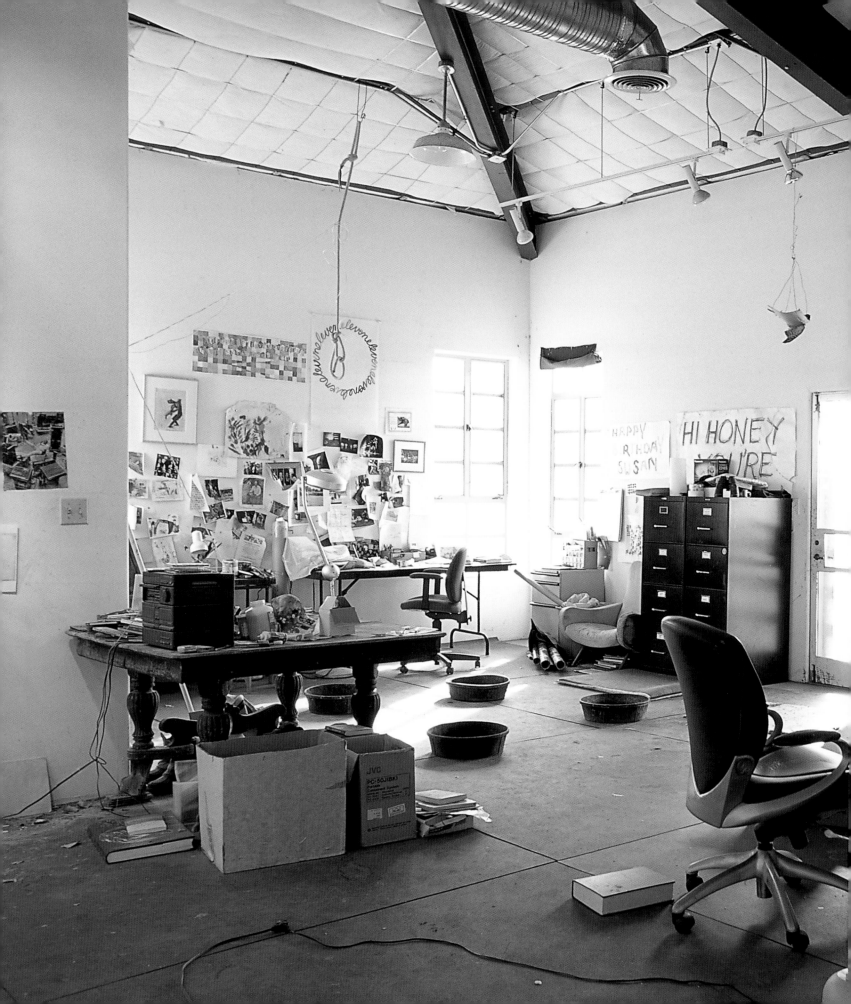

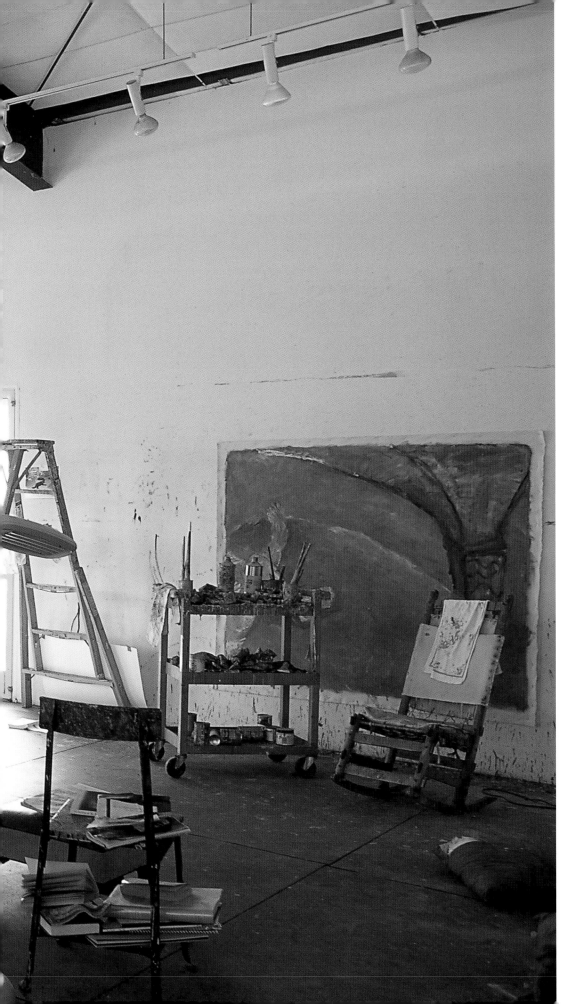

Susan Rothenberg

PAINTER SUSAN ROTHENBERG's first New Mexico studio was a three-sided enclosure with a metal roof that was built for her by her future husband Bruce Nauman so that she could work during her intermittent visits from New York. Subsequently Rothenberg, who had lived in the city for just over twenty years—years during which she gained stature as a major American artist—left her New York studio for good in 1990 and came to live in New Mexico.

Rothenberg and Nauman, who married in 1989, purchased land in northern New Mexico in a setting that has dramatic views. The first structures to go up, even before their home was built, were two large buildings that had been custom-prefabricated to serve as their studios.

Unlike many who come to New Mexico, Rothenberg was not enchanted by the light; in fact, she found it overwhelming at first. "I wanted to crawl into a cave," was her response. The design of her studio emphasizes expansive painting surfaces rather than abundant light. The paned windows are relatively small and have become dusty with time—homes for spiders—softening what light does come through.

Her studio reflects a particular New York attitude on making art, a rugged, non-decorative, let's-get-down-to-business approach. She staples her canvas directly on the wall—rather than relying for support on the traditional stretcher bars and easel.

The painter recalls: "Originally I thought I would set up this new studio to be comfortable, yet I didn't want my studio to be homelike; I wanted to focus my attention on the work." So instead of outfitting it from scratch, she had everything, except for the art supplies, shipped in from her New York loft. When she started working, the furnishings—the various chairs and lamps, the rocker, the worn couch—were all familiar to her; everything except for a handsome old table that Nauman gave her.

The couple owns five dogs, all of them rescue cases. Big dog food dishes are on her studio floor, inside the entry; dog pads, toys, and bones are all around. Clearly, the artist shares the space with the canines; they appear in a good number of her recent paintings, including *Red Studio*, *Yellow Studio*, and *Green Studio* (all dated 2002–03).

On one wall there is a singular dog portrait. To make it, the artist used hair shavings from some of her dogs and adhered them with matte medium to a large piece of white paper. "Highly unstable," Rothenberg says wryly.

She has had a picture of musician Stevie Wonder up on view in her studios for more than fifteen years. In the worn photograph, Wonder—surrounded by a tangle of audio equipment and wiring—leans back in his chair, one leg kicked up in the air. He is wearing his shades, playing his harmonica, and his face is radiant. He is in his glory. This is his realm. Rothenberg says of this photo, "That's what I want my studio to feel like."

Stacey Neff

WHEN ARTIST STACEY NEFF dresses for work, she puts on coveralls, latex gloves, arm and wrist guards, skullcap, respirator, goggles, and work boots.

"I love this space, and this is a great neighborhood," says Neff, referring to the Rufina Street and Trades West Road district, so different from the tourist board's image of adobe Santa Fe. This is the nuts and bolts of the city; here among the small entrepreneurs, manufacturers, and auto-part distributors, Neff creates her contemporary glass sculpture. Some of her neighbors—an auto-body shop and a boat-building business—employ the same materials and similar procedures to those she uses.

She starts her pieces indoors, blowing glass forms at the gas-fired furnace. The next step involves materials that give off toxic fumes. Even though her studio fans provide ventilation, Neff moves her operation outdoors, weather permitting. There she modifies the blown forms by applying many layers of resin and fiberglass; depending on the project she might add refractive pigments or glass beads as she builds those layers.

Her work schedule is dictated by two primary considerations: the responsibility to attend to her daughter and the inflexible time demands imposed by the furnace.

For reasons of economy, once the furnace is fired up it must be kept burning without interruption until all glass parts are blown, which can take from one to six months. This imposes an urgency on the artist to use the time as efficiently as possible; during these sessions Neff often works extremely long days and some nights. She plans ahead, sometimes hiring an assistant to generate forms for her future projects, as well as current works.

The studio is organized for production and efficiency. Her many tools are arranged neatly along the walls. A dental cabinet holds metal parts, drill bits, hardware, blades, and, as one box is labeled, "Small Stuff!" The evidence of her process and the detritus of her art—glass pieces, glass shards—litter the floor.

A small display of Neff's finished art pieces hangs on the wall in a separate office/sitting room, located to the front of the building. In one corner, her daughter, Hannah, has a play area with a kid's table, paper, crayons, and other distractions to engage her while her mother is working.

Stacey Neff graduated from the Rhode Island School of Design, majoring in glass; she has an active exhibition career. Her work has alluded to organic forms that bring to mind plant and marine life and, more recently, considerations of time and space. The artist says she has no material allegiances but acknowledges a preference for glass, an ancient material that, in the hands of this artist, comes alive as a modern medium.

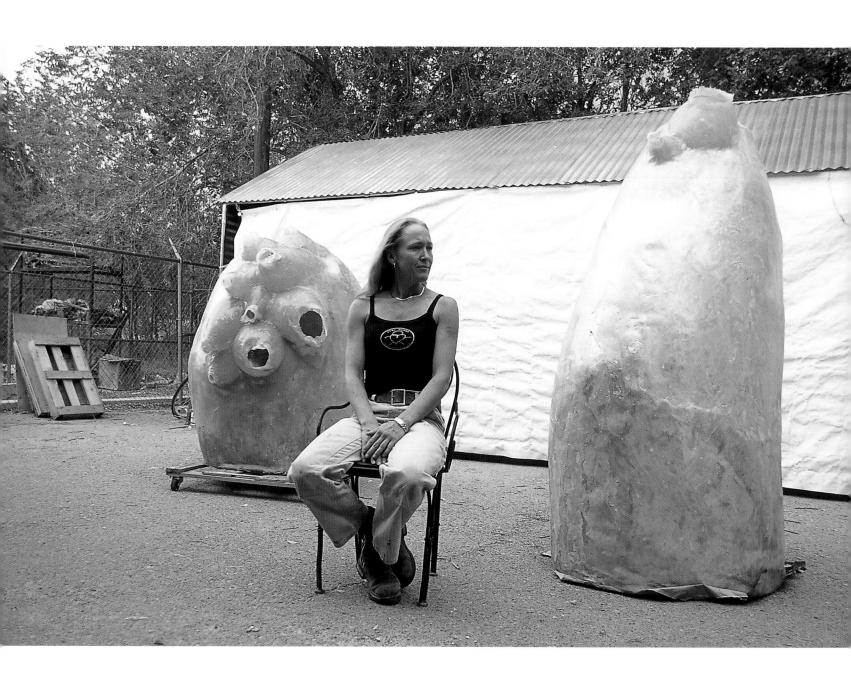

Stacey Neff

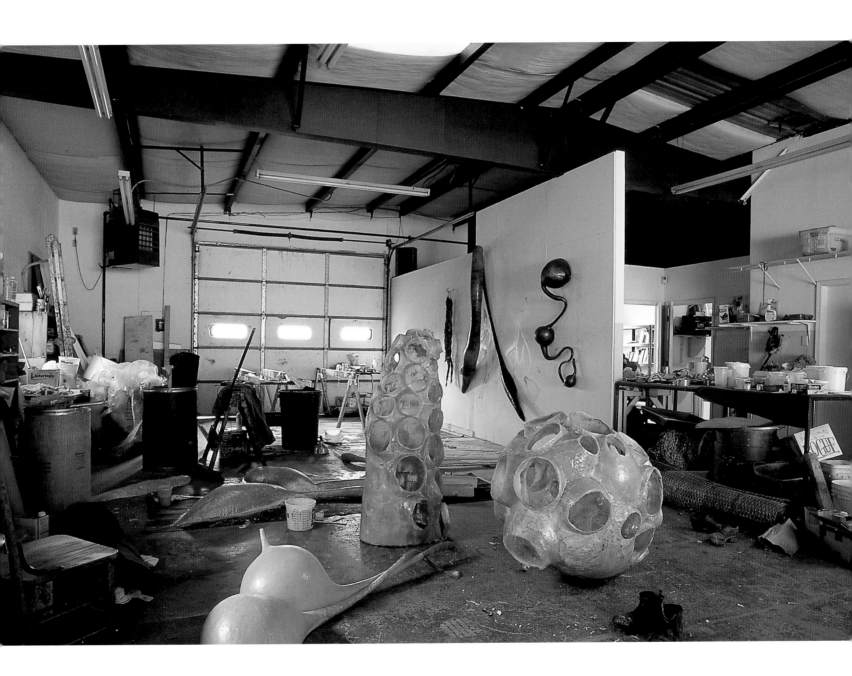

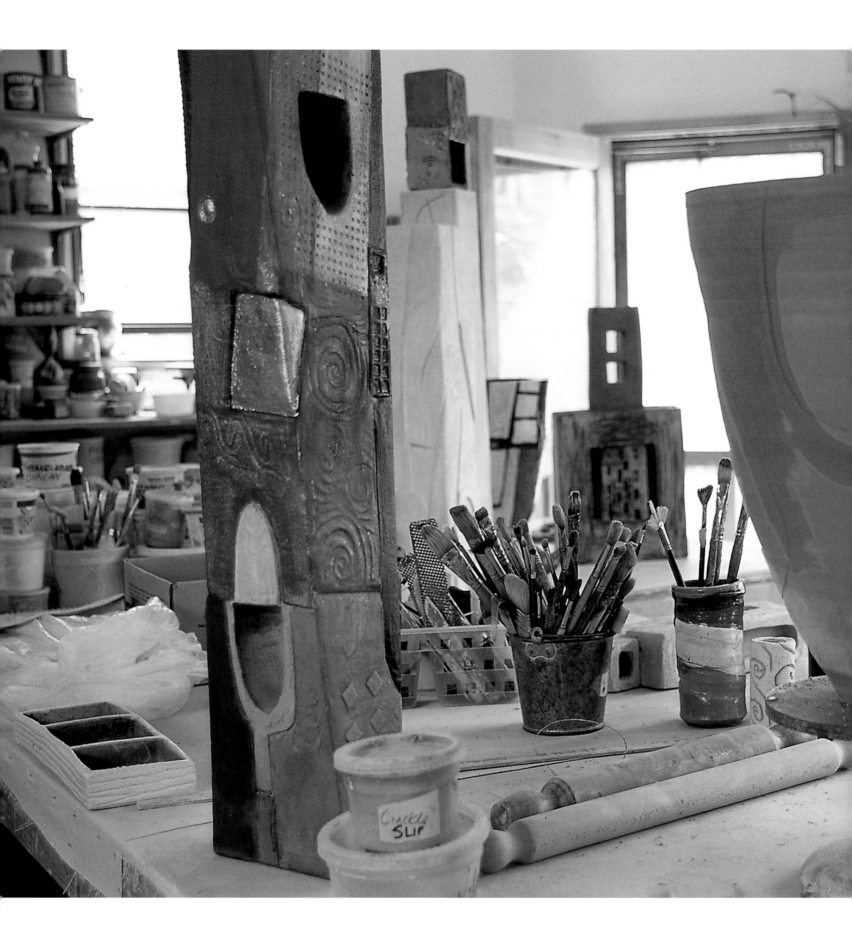

Gretchen Wachs

THE SETTING OF GRETCHEN WACHS'S studio is foothills land northeast of Tesuque, environs for artist and studio and a wide cast of characters that includes peacocks, dogs, guinea hens, and ten-year-old son Ryan. Then there are the Tonka trucks, fruit trees, sunflowers, and woodpiles that serve as props.

"I'm five steps from the house. I can go there for a cup of tea or to check on Ryan. But when I walk into the studio, I leave the house and its concerns behind," the artist explains.

Wachs and her husband, Michael, built the studio ten years ago during her pregnancy. It is a two-level structure next to the house. The upper floor is devoted to ceramics; three steps down is the painting studio.

Long recognized in the Southwest as a fine-art ceramist and printmaker, Wachs is making the transition from clay work to painting. The shift is quite natural, she believes, since paint, like clay, is plastic. She's standing in front of the easel as she speaks. She continues to work, adding some color, then retreats and looks at the result. In her hand is the plastic lid of a green chile container; this is her palette.

Ryan comes in, and when he's asked about his mother, he says clearly, "All my friends really like coming here and think it's great that my mom's an artist. I can make art whenever I want." When asked about the paintings in progress in the room where we are talking, he says, "I watch the way she works; it's like part drawing and part painting. She draws the real things and then she sort of abstracts them."

"That's sort of how it works," Wachs confirms. "The paintings start as gesture and abstraction. I work fast, emptying myself onto the canvas, so to speak." The canvas is actually a shallow inverted wooden box. She applies a coat of Venetian plaster to the surface to give it a slight texture, then she draws on it, sands certain areas, paints on it, sands it again, and repeats the process. "Things slow down as shapes and forms emerge," the artist explains. "I may add torn pieces of my monoprints as collage elements. I spend a lot of time looking, but at some point it's time to get out of the way."

She glances around the workspace and then confides: "Making art keeps me sane. The world is changing. These are challenging times. But I can come in here and paint and feel like I'm connecting to a deeper place. This is my refuge."

Ramona Sakiestewa

RAMONA SAKIESTEWA's studio is built into a hillside on the east side of Santa Fe, with fine views to the west. A path of massive flagstones leads to the entrance, which gives access to a small exhibition space where historic ethnic textiles and an early photograph of a Navajo weaver are displayed under glass. This exhibit is an appropriate introduction to the studio of artist-weaver Sakiestewa, who in recent years has also become known for her work as an architectural designer.

Looking back, Sakiestewa, who was raised in Albuquerque by her German-Irish mother and Hopi Indian father, recalls that she always thought of herself as an artist, even as a child. She learned to sew when she was very young, and her sense of design was deeply influenced by her stepfather's huge collection of Navajo rugs.

Her studio has high ceilings and two deep-set skylights. Warmed by radiant heating, the space is open, neat, and filled with sunlight. Architectural plans, as well as color charts and samples, cover the tables. Long diagrams of ongoing projects, including the site plan for a Chickasaw Memorial to Fallen Warriors, are pinned to one wall; multiple bookshelves hold volumes referring to world art, design, culture, and history.

"The creative work happens on the tops of these tables," the artist says, "and we meet with our clients here also." She and her husband, architect Andrew Merriel—with whom she collaborates frequently—each have a large office adjacent to the working area. The character of these spaces is emphatically professional.

For the last ten years, Sakiestewa has been committed to her ongoing work for the National Museum of the American Indian (NMAI) in Washington, D.C., which opened in fall 2004. As part of the core design team, she has had input into every aesthetic aspect of this enormous project.

It was Sakiestewa's idea to use American Indian bird designs at the back of each elevator, evoking for passengers the flight of natural creatures. Another of her contributions, on the ground floor of the museum, is the curving woven-copper "Screen Wall," reminiscent of pre-Columbian basketry.

NMAI is devoted to the exhibition and preservation of the history, life, literature, and arts of Native Americans; it represents every tribe in the United States, as well as the other indigenous peoples of the Western Hemisphere.

Sakiestewa intends to continue her design work but looks forward—now that the museum project is realized—to a time when she can experiment with more intimate art forms, including collage and works on handmade paper.

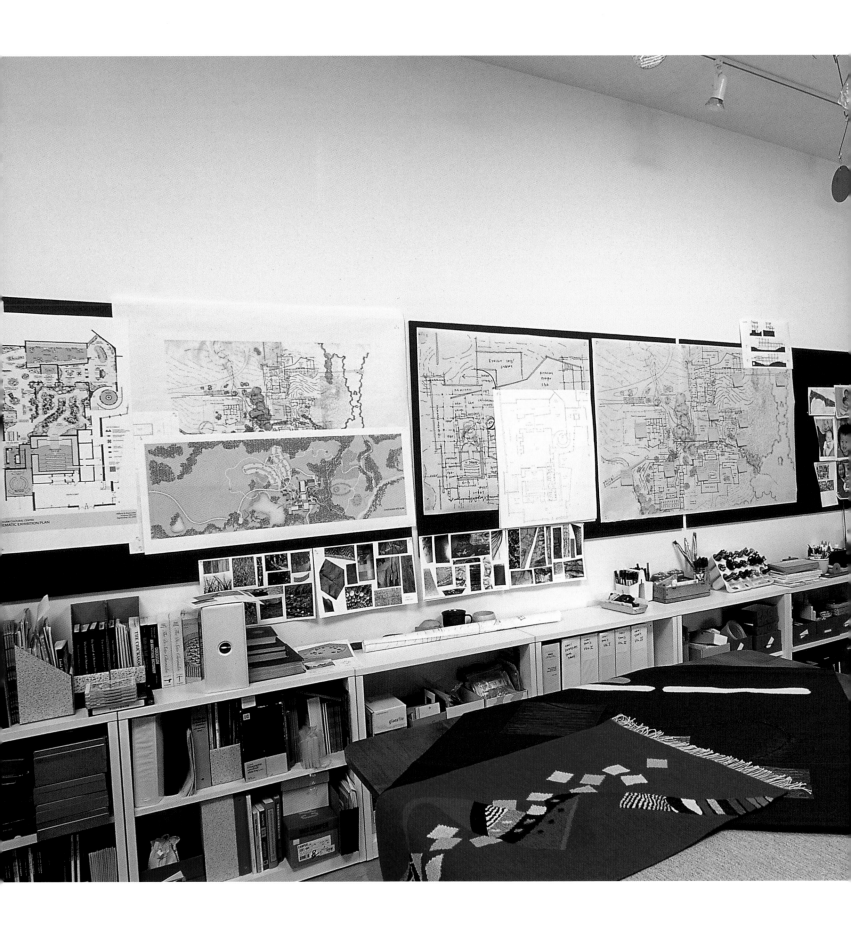

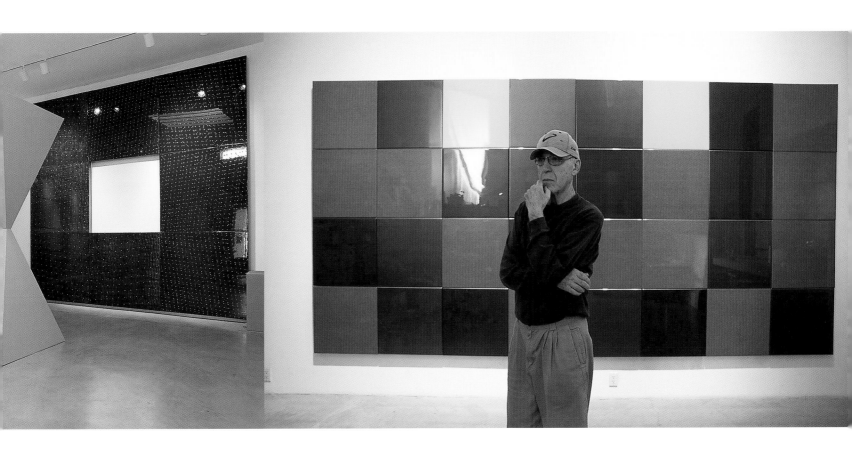

Paul Sarkisian

THE STUDIO IS AT THE END of a winding private road, north of Santa Fe. Stands of aspen, leaves flickering in the sunlight, surround the imposing building. Its twenty-foot-high outer walls are fortresslike, but the subtle angles of the walls, combined with the occasional thin vertical window, soften the suggestion of a bastion.

The handsome front door seems rather spare in size, in contrast to the scale of the building. This may be a momentary illusion, or it could be an architectural strategy. Its seeming slightness does add to the impact experienced when passing through the door and entering the six-thousand-square-foot studio of Paul Sarkisian.

Inside, the walls are also set at slight angles—creating large, sometimes asymmetrical rooms. There is a spacious living room/kitchen, a bedroom and, to one side, a private room where Sarkisian's artist wife, Carol, creates distinctive jeweled ornaments and objects. Above the bedroom, on a second floor, is a space where hundreds of Sarkisian's works stand shrouded in white sheets; another area on the ground floor is for the storage of oversized pieces.

There are two exhibition rooms. One displays a dramatic black-and-white piece, fourteen by twenty-one feet in size, created in 1972. It is an airbrush painting of a storefront rendered in such meticulous detail—the window, the merchandise behind the glass, the various wood grains—that it compels viewers to step closer, to scrutinize. "Is this image photographically produced?" they must ask themselves. Situated right across from this is a recent work: a wall-sized piece made up of vivid squares of gleaming color placed flush against each other to create a giant horizontal rectangle of brilliant orange.

"Not an easy color to deal with," the painter interjects. "Most artists stay away from it."

On another wall there is a gigantic blue piece. The great size of this room permits Sarkisian to view his works in relationship to one another; from these observations, he gains insights that carry him forward to the next piece.

The viewing area is adjacent to the painting studio, with its sixteen-foot-high walls, where the artist uses multiple resin pours to create the individual panels—the elements that are composed into each vast painting. It is the final arrangement of these squares, however, that he finds most challenging. Sarkisian estimates that he makes two hundred and fifty trips up and down the stepladder, positioning and repositioning the squares on the wall, before he succeeds in resolving their placement.

Navajo artist Emmi Whitehorse is a slender woman with long black hair. There is a seriousness and elegance to her presence. She wears gold-and-turquoise pendant earrings. Her smile, when given, is radiant.

The artist's twelve-hundred-square-foot studio, built adjacent to her house, is set in a pleasant countrylike neighborhood south of Santa Fe. Piñon-covered hills and blue mountains are visible through its windows. The greater part of the room is dedicated to painting. In addition, there are several other well-delineated areas: a compact jeweler's workspace; an office with a long, curved, glass-topped desk; and a sitting area defined by an early Navajo rug, its reds now muted.

The light is good from the deeply recessed windows nine feet up. The large, high-ceilinged room is cool and reserved, reflecting the artist who works there.

Emmi Whitehorse grew up on the open land northeast of Gallup in a family where only the Navajo language was spoken. As sheepherders they moved with their animals, using a lean-to built by her grandmother as shelter and sleeping in a tent by night.

In her childhood she looked at American Indian textiles, jewelry, designs, and the utilitarian objects that were part of her daily experience. She recognizes now that she may have been drawn toward abstraction by these early impressions.

While attending high school in Arizona, she entered and won a state art competition. It was this experience, she believes, that led her to choose a life of making art. Her winning composition, as she remembers it, showed two planets in space, with emphasis on the perspective. She had, even then, abstracted the planetary spheres.

Now her mature abstract work is exhibited internationally, and Whitehorse travels to Europe often. While there she looks "at everything: fashion, furniture, architecture, interiors."

In New Mexico, her daily work routine begins with a morning cup of hot chocolate as she looks through magazines and catalogues. In lieu of reading the art journals she prefers to visit museums and art sites directly, and like many other artists today she finds style magazines graphically informative. The periodicals one sees in her studio include: *Belle, Jalouse, Elle, Decor, Space, Nylon, Azure, Paper*. At about 10:30 A.M., after her morning routine, she turns on music and goes to work.

A series of paintings Whitehorse is working on at present was inspired by the variable surfaces of water seen in natural settings such as slow-moving streams or ponds. She builds this effect slowly. First, she applies a coat of acrylic medium to a very large sheet of Fabriano paper. Then she introduces color from thick oil bars. She sometimes smoothes the surface with the palm of her hand, until sunlight seems to dapple the paper—and the water's surface.

This work—a daily record, an abstract journal—functions for her as "an emotional account of a particular moment in time."

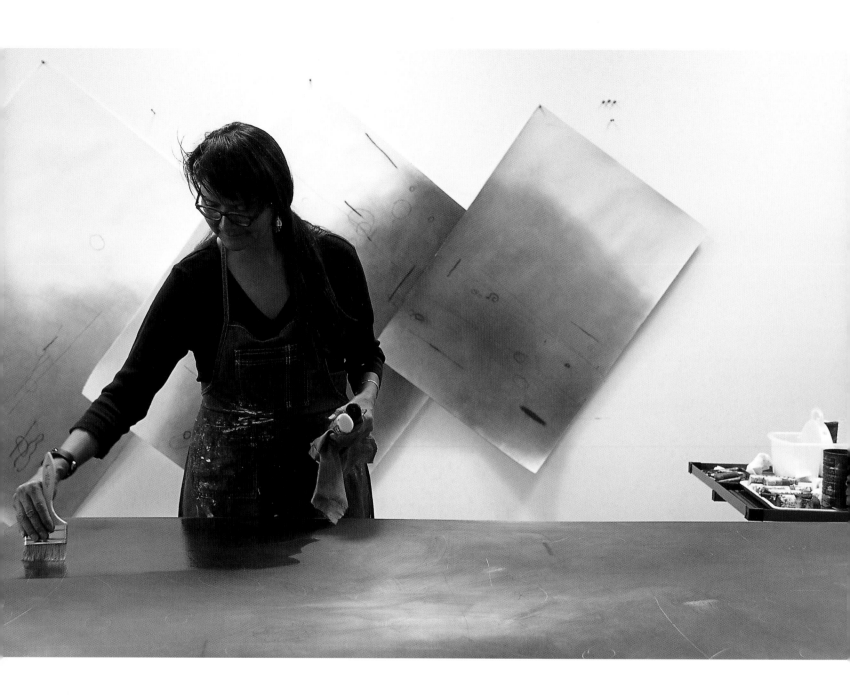

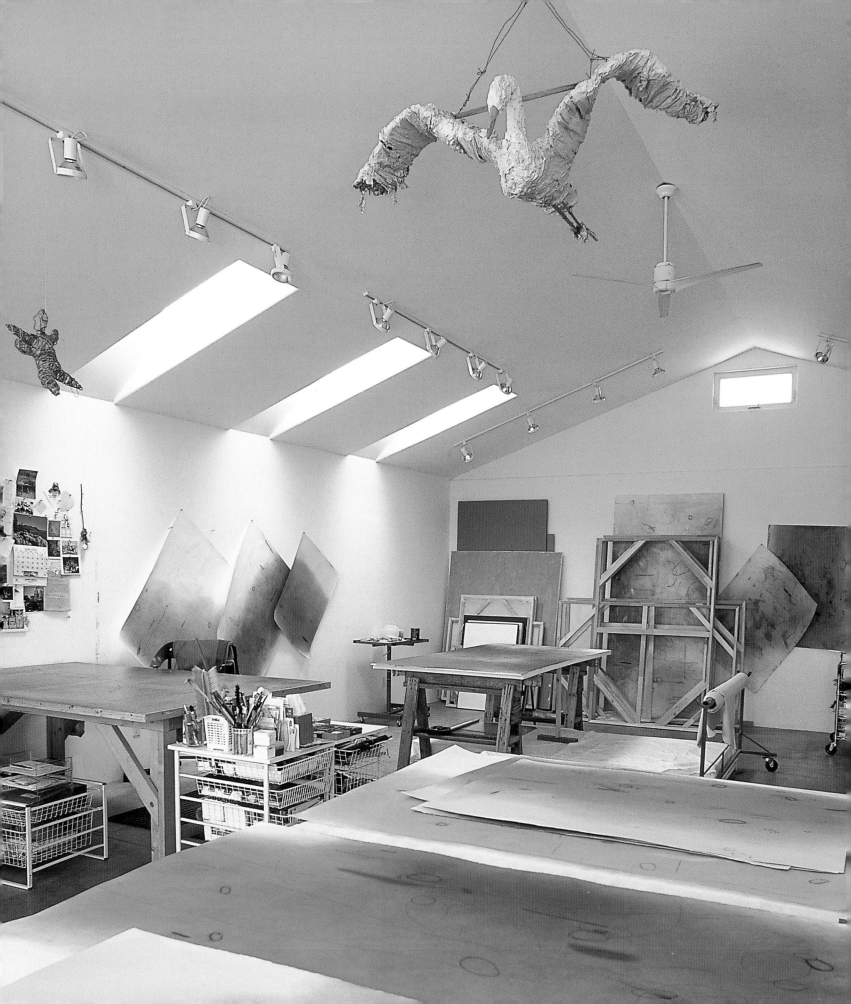

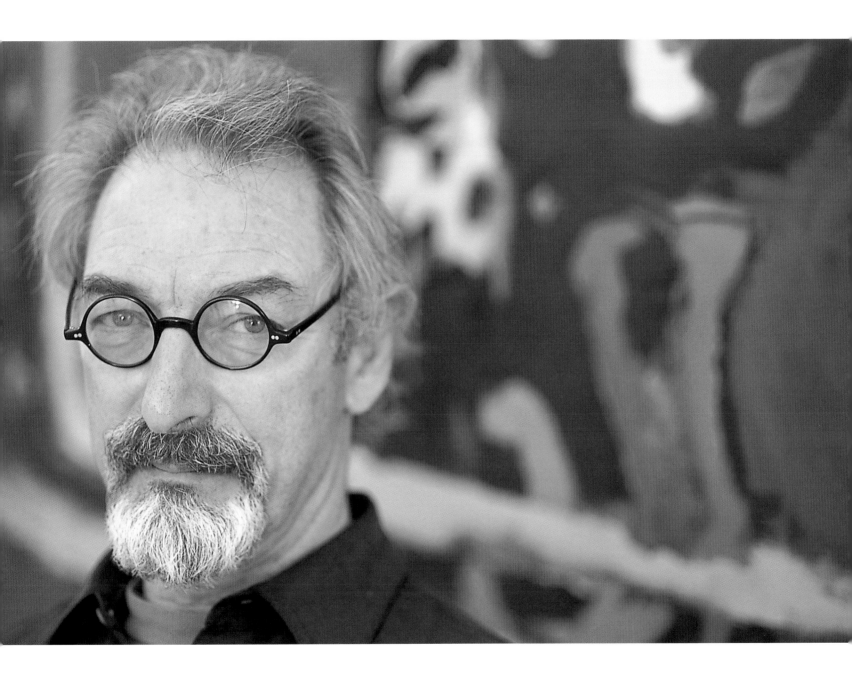

Paul Shapiro

"Years ago, I wanted to eliminate the concept of the studio. Van Gogh had no studio. And it would be so convenient not to be involved with a specific physical space. Yet I know I am totally dependent on my studio. Everything I need is here. It's all set up. It's my own personal laboratory. It's my own universe." All of this is spoken with great intensity by artist Paul Shapiro.

The painter can get very serious about politics, as well as art. Asked about elegance, and its place in painting, he shot back, "Elegance? I am a *proletarian*!"

The artist grew up in Winthrop, Massachussetts, and studied at the School of the Museum of Fine Arts in Boston. In the late 1970s, Shapiro and his friend, colorist David Barbero, made several painting trips to New Mexico; he moved here permanently in 1982.

In the 1980s, Shapiro painted southwestern landscapes with the vivid palette and strong gestural brush strokes associated with Fauvism, an early twentieth-century art movement. It was a very successful time for him financially and allowed him to design and build a studio for himself in Santa Fe. When he recalls that studio, it is with a certain sense of nostalgia. It had sixteen-foot-high ceilings, eight skylights, and a separate storage room; the painting area itself was thirty by forty feet. "It was huge," he recalls, "and I could work on six to eight large paintings at once. Before, I had always had to adapt to other people's spaces. At last I didn't have to adapt to anything."

In 1990, Shapiro had a life-altering dream: "I went to the mailbox, and there was an art magazine in it. I left it behind, and then I woke up with an incredible sense of loss. Two weeks later the meaning of the dream hit me: It was time to give up what I was known for—landscapes—and return to abstract painting!"

"I want my paintings to hit you in the face. No colored smoke screens for me. I want everything to be right there."

In his present studio, which is attached to his house in La Cienega, southwest of Santa Fe, the painter works in an elongated space, eighteen feet wide by seventy-four feet long. He uses the back section for storage, the middle area for building frames and assembling collages, and the front third to paint in—and to play his guitar when he is away from the easel. Shapiro also composes music here. Recently, he completed a piece called "Evil Government Blues."

"Playing music is good for me. An instrument uses your whole body," Shapiro says. "I make paintings for my madness—and music feeds my soul."

Jaune Quick-to-See Smith

SURROUNDING HER STUDIO there is a wild, exuberant garden filled with bees and butterflies. Walking through it on the way to her studio, the artist proclaims: "I am a gardener of small ecosystems, which incorporate not only birds, small animals, and toads but many kinds of insects."

Jaune Quick-to-See Smith is an enrolled member of the Confederated Salish and Kootenai Nation of Montana. Her father, she says, "was an illiterate horse trader" who raised Jaune and her younger sister on several Indian reservations in the Pacific Northwest. The artist and her family continue to maintain their connections to the Flathead Salish.

Smith's studio consists of two buildings. One is an adobe that she uses for printmaking and storage; a second she recently added is a twelve-hundred-square-foot painting area. "I drew up the plans on a piece of graph paper. I knew what I wanted. It is an industrial steel building forty feet long. The ceiling is twelve feet at one end rising up to fourteen feet at the other. There are four clerestories. I didn't want windows at eye level because I knew they would be too distracting."

Although Smith's art has a distinctively contemporary feel, it remains close to her native roots. Her large canvases incorporate collage elements gleaned from newspapers and magazines that whisper humorous and serious asides to the careful viewer:

Pay Now—Save Later
Bitter Medicine
Wolves Not Out of the Woods
For Help Call: 1-800-COYOTE

Smith thinks of herself as a cultural-worker–artist who delivers wry commentary on social, environmental, and political issues. In 1995, in an oblique reference to fast-food giant McDonald's, she painted a long vertical canvas of descending oval shapes with the words "Fry Bread—6 Million Now Served."

Jaune Quick-to-See Smith travels extensively to lecture on her art, as well as that of other contemporary American Indian artists. Her work has been described by the Cuban art historian Alejandro Anreus as "always a critique that celebrates the marginal, the organic, the authentic."

Concerning her working methods, the artist says that once in the studio she turns on the radio to NPR or she puts on a tape—it could be Vivaldi or perhaps Maria Callas. "Callas just lifts me up and puts me in a different space," Smith enthuses. "The Eskimo poet Uvavnuk writes that the sea, the earth, and the great weather 'move my inward parts with joy.' That's how I feel about music and my environment, especially in the morning—and of course, all good painting."

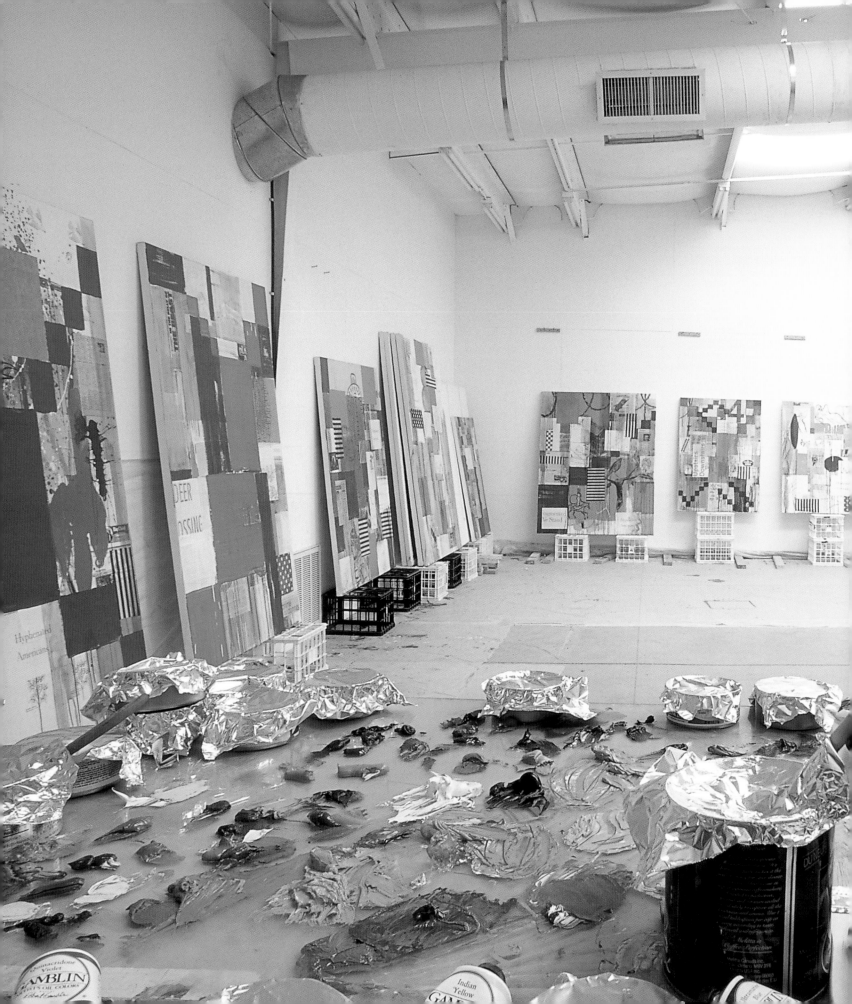

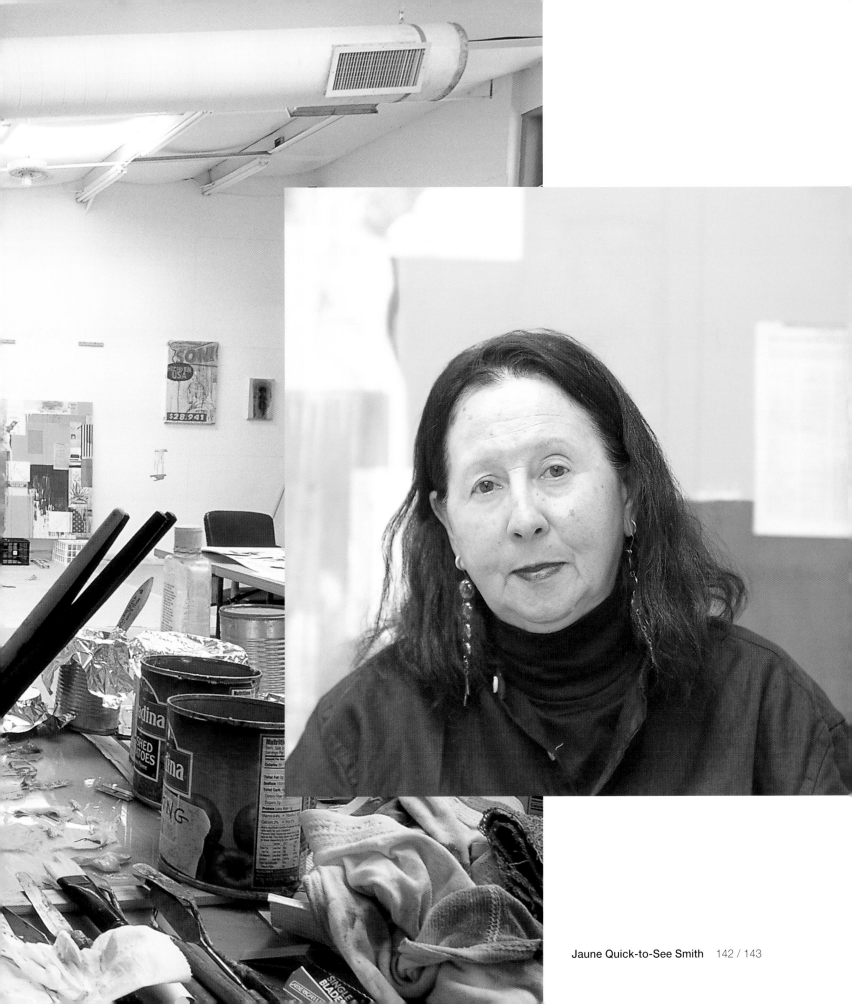

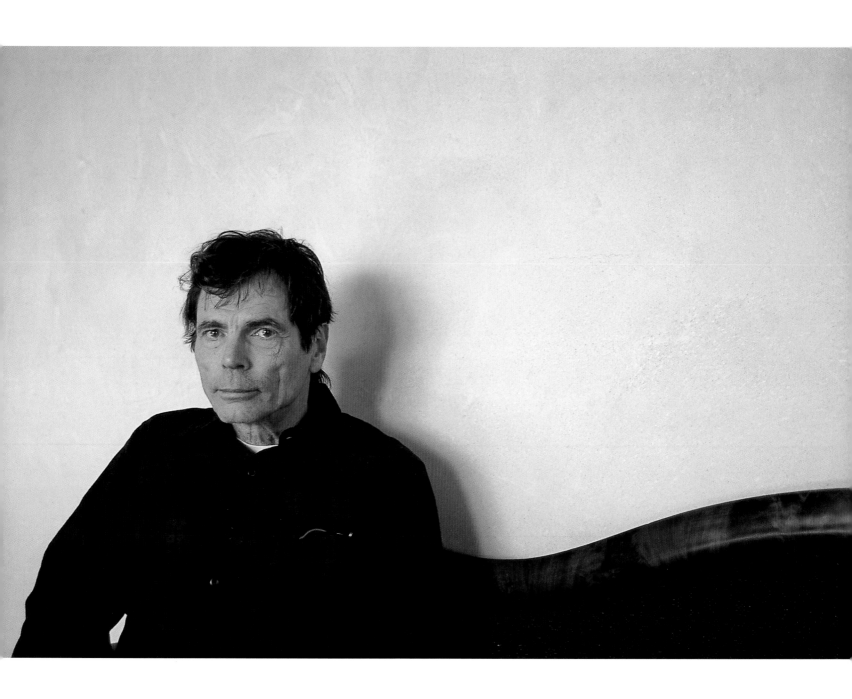

Richard Tuttle

"My generation uses the museum as our studio. It is as a socially dynamic center for life, not a mausoleum."

Richard Tuttle, the respected contemporary artist—well known for his museum installations—places the notion of "studio" at arm's length.

"I am basically anti-studio. I think one's body is one's studio. When one goes to work one goes inside it."

And then, in another context: "When art and life become the same thing, wherever I am living is where I'm working. I've operated this way for years and years, so my workplace has become more than anything else a retreat from family life."

The workplace, in this case, is the building that stands against the wind on top of a dramatic northern New Mexico mesa. It is a simple cinder-block structure, nine hundred square feet in area. One wall is made of glass bricks; light coming through these creates a watery effect.

Nearby on the same property is the adobe studio of his wife, poet Mei-mei Berssenbrugge. The couple's residence, a storage building, and a building dubbed "Turbulence House," which is under construction, complete the complex. Designed by architect Steven Holl, Turbulence House is, in Holl's words, "a collaboration"; indeed, elements of the structure resemble some of Tuttle's small sculptures. The artist and his wife champion the virtues of good design and think of this building as a prototype. They hope that the metal biomorphic structure, which gleams silver in the sun, will be available to the public as a pre-fab kit.

Tuttle and Berssenbrugge have also put great care and attention into the planning of their home, which they call a "Safe House." It is made of adobe, natural (untreated) woods, and completely toxic-free building materials. Health and a desire for a wholesome environment influenced Tuttle's part-time move to northern New Mexico from New York City, where he has a studio in Tribeca.

One of the features of the mesa top he chose to live on—one that counts for Tuttle—is its geological complexity. It is composed of beautiful and subtly differentiated strata. On the mesa, the blue sky is unending, the view is 360 degrees, and the land falls away into valleys, dramatic shadows, buttes, and far-off mesas.

In contrast to the magnificence of the landscape, the studio feels modest and contained. Indeed, there is an offhand quality to the room. One work area consists of three sheets of plywood painted matte white that are nailed to one wall. Across these panels the artist has drawn a horizontal pencil line, in reference to which he tacks his pieces-in-progress, one next to the other.

There are two chairs from which to observe the work—one worn leather, the other overstuffed—each with a lamp next to it and stacks of books to read. He uses a small woodstove, which requires frequent feeding, to warm the room.

Steina and Woody Vasulka

"STUDIO IS NOT ABOUT COSMETICS—or slickness—or tidiness," artist Steina Vasulka speaks forthrightly. "It's about what works!" Behind her, electronic components and equipment cover every surface. There is a bank of twenty identical Sony televisions to her left.

Steina and Woody Vasulka, internationally acclaimed digital artists, live in the village of Agua Fria just west of Santa Fe. There they have renovated and expanded an old adobe. As Woody says, "I got into my building mode, which always costs time and money."

The oldest house in the village, it was originally twenty-five by fifty feet. "It's better now" says Woody, "not total freedom, but what the hell. Our generation was accustomed to huge open spaces—lofts!—and this influenced the whole medium."

In speaking of his generation, Vasulka is referring to the group of experimental artists who in the late 1960s and early 1970s pioneered the modern fusion of technology and art, thereby giving rise to such alternative media as video, happenings, and installations. Much of that took place on the Vasulkas' turf when, from 1971 to 1973, they operated a space in New York known as The Kitchen. In an old hotel that had seen better days, they sponsored an open situation in which experimental artists, themselves included, tested their work, engaging new audiences in an interactive environment. It "cooked," and the era of video and digital art was launched.

The Vasulkas' road to New York, and then New Mexico, came through Prague. Woody was born in Czechoslovakia, where he studied engineering and, later, filmmaking. Steina was born in Iceland and was trained as a violinist. They met in Prague in 1962, when she came there to study music, and were married a couple of years later.

The artists moved to New York and became enthusiastic about the new technologies. Woody started bringing the apparatus into their apartment, saying it was necessary to be "living with the equipment." He also argued that electronic-tool designers should be considered artists.

The Vasulkas are still "living with the equipment." Steina acknowledges the incongruity of housing their modernist laboratory and studio inside a deceptively conventional-looking residence in this old-fashioned community. Sometimes she feels crowded and looks forward to a bigger space, something like a warehouse.

"Art is about storage!" Steina's smile is broad, her eyes crinkle with humor. "For years we rented studios, and it was always about getting 'space'—to find the 'space,' to change our lives through 'space.'" The issue is ever more pressing as the artists organize and catalogue the vast collection of visual materials that will constitute their legacy.

Although the Vasulkas' studio does not have the ample dimensions of the lofts they formerly occupied, in moving to New Mexico they gained a different kind of space. "From the time we came here in '80, we've moved to outdoor shooting," Steina says. "Especially me. I have a camera that is suited for the blasting sunlight of New Mexico. The whole of New Mexico has become my studio."

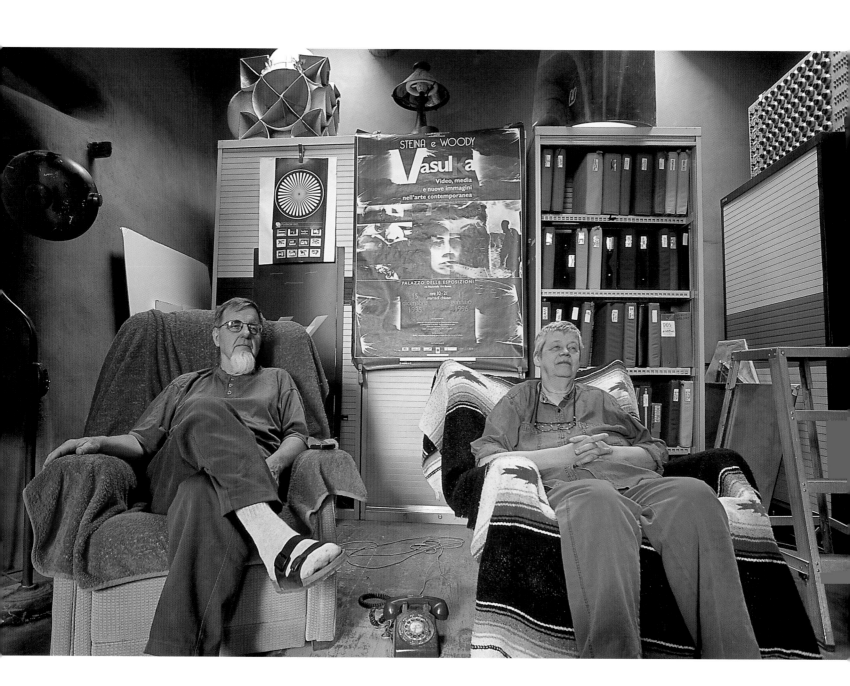

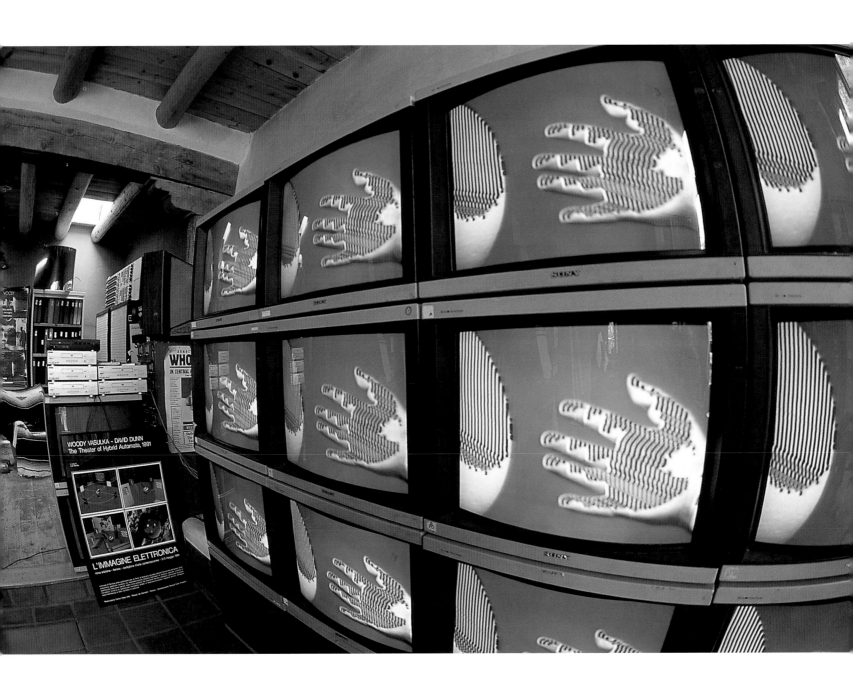

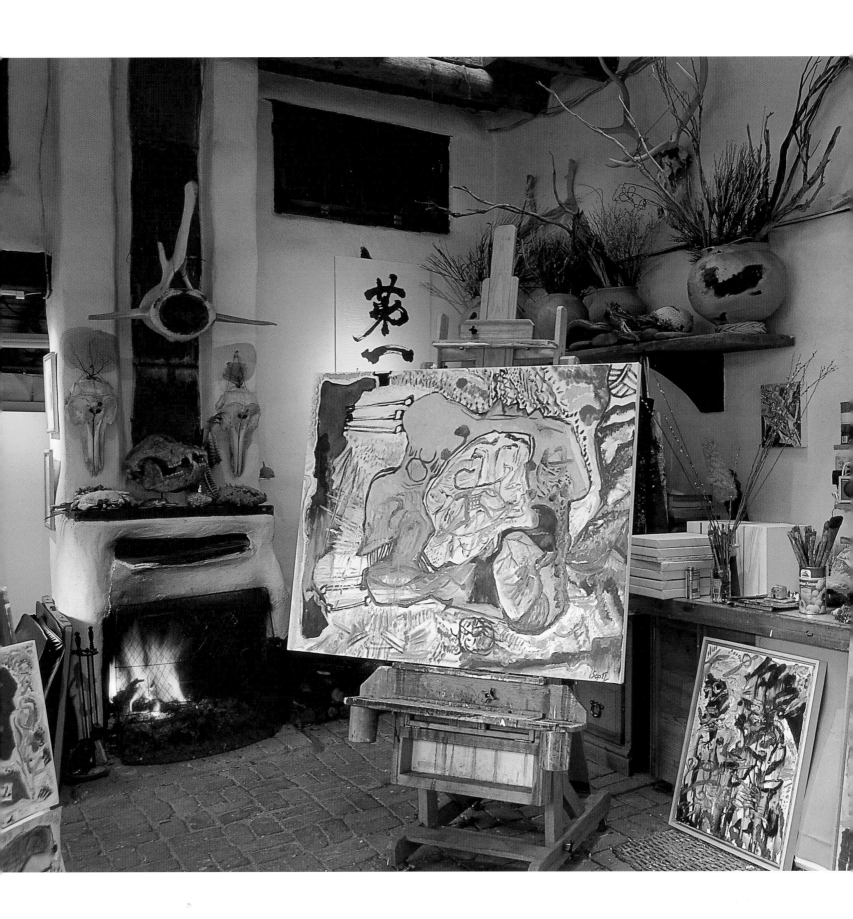

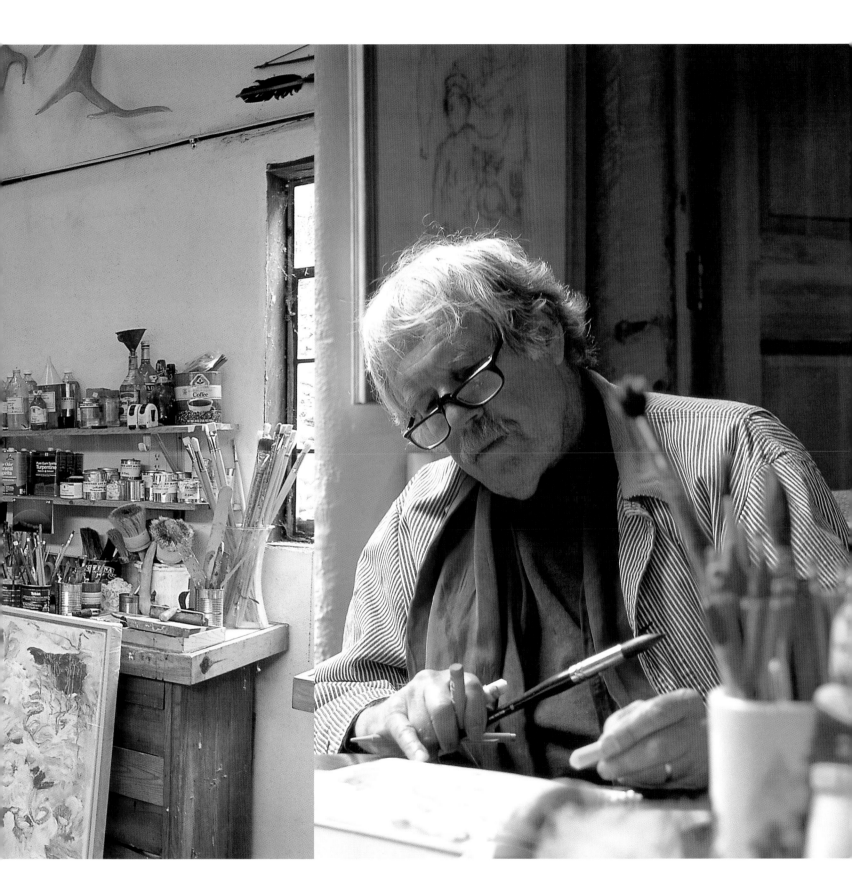

Sam Scott

SOME YEARS BEFORE moving to New Mexico, Sam Scott lived in Europe, where a visit to Florence inspired him to dedicate himself to painting. The young artist, who had until then concentrated on sculpture, came back to America and enrolled at The Maryland Institute, studying there with the Abstract Expressionist masters Grace Hartigan and Phillip Guston.

An inveterate traveler, Scott arrived in Santa Fe in 1969 after living and working as far afield as Venezuela, Alaska, and New York. Two years later he bought a small wooded hillside lot west of town. There he built and refined a complex of buildings—an art compound—with separate areas designated for sculpture, print-making, watercolor, and oil painting. The original residence now houses an art library, gallery, viewing rooms, and an office.

The main painting studio was built by Scott, with the help of artist friends, on the site of an ancient Indian camp. While digging the footings he found shards and charcoal that anthropologists have dated to A.D. 850. This long human association gives a sanctity to the place, Scott believes, and he savors the idea of painting here.

The adobe structure has large windows east and west, and a north-facing clerestory. Scott prefers to paint by the early morning light, which floods the studio. "I've seen the light of Provence, of Italy and Spain, North Africa and Greece," he says. "Those lights are all very beautiful, but I find the quality of light here in New Mexico exquisite. It is richly modulated through all four seasons."

He works at three easels at a time, on canvases that are more or less six feet to a side, which he considers a "human scale"—a term he also applies to the dimensions of his studio. He points with pride to the Ettan press on which he makes his monotypes; he purchased it as a gift to himself in 1984, when he withdrew from a tenure track in the University of Arizona system.

Scott doesn't listen to music as he paints because he wants to be aware of the sounds of wind, birds, the scrape of a branch against the window. He speaks of himself as a nature painter, and he draws daily inspiration from natural forms. "The clues, for me, lie there in the natural world," he says.

On his property, very near his studio, he has constructed two Japanese teahouses. These have become favored retreats, where he meditates on the landscape and observes each season as it declares itself.

Erika Wanenmacher

WHEN ARTIST ERIKA WANENMACHER talks, her mobile features show intelligence, earnestness, and vitality. Eyes, mouth, hands—all are extremely expressive. "I've likened my [creative] process to a tornado: I'm reading . . . thrifting . . . wandering"—here her words speed up— "looking, pulling in, and in. Then I begin to see the spin, and it goes faster! I start making things. I manifest objects! My studio becomes a cosmic vortex! . . . and I've learned to be unbelievably thankful for this whole process."

She says that when she moved to Santa Fe, it was the first place that felt like home. Twenty years ago the community was still a Latino majority, and she knew somehow that being here would be good for her.

Wanenmacher and her partner, musician Scott Cadenasso (who labels his music as "post-punk folk funk"), moved into a working-class neighborhood on Agua Fria Street. Scott built Wanenmacher's solar studio over a period of time. It is a sixteen-by-twenty-four-foot room attached to one side of their house.

The room itself is full; stacked against the walls are sheets of cardboard, metal, plywood, and two bicycles. Pinned to the walls and hanging from the ceiling are many pop-cultural touchstones and surreal fragments. Several small altars are set up, among them a "Work Altar," made of scraps from her many shows, and a "TV Altar," celebrating "everyday stuff," as she says.

Also at hand are a drill press, kiln, band saw, and a small forge—all evidence of Wanenmacher's democratic attitude toward technique. In addition to painting and wood-working—skills she learned early on—she has over the years taught herself smithing, welding, molding and casting, glass-blowing, sand-painting, and needlepoint.

"The pieces I make refer to specific ideas I want people to think about. Each thing I make is a spell. The very basic element of a spell is intent. I put the intent out front, and it drives the work. I'm a witch!" Here Wanenmacher chuckles at the connection. "Not an Olde Tyme English one. I'm a contemporary witch," and here she becomes gleeful, "I'm a *culture* witch!" She smiles and continues with this thread: "My studio, it's like a field I've generated. I'm surrounded by all this stuff. *Sanctuary* is not the right word for *my* studio!" Lest anybody think that, for her, making art is a serene or calming activity, she declares, "This is where I have the most power. The magic is most effective here."

"Once I finish a big batch of work, I experience postpartum depression. I've learned it's a natural part of the [creative] experience, but it is a very uncomfortable part. Then you begin to wait for inspiration. It's very humbling. You're waiting there with your begging bowl. The art comes not from you but through you. . . . I get ready by cleaning my workspace, gathering info, sweeping off the pathways of my brain."

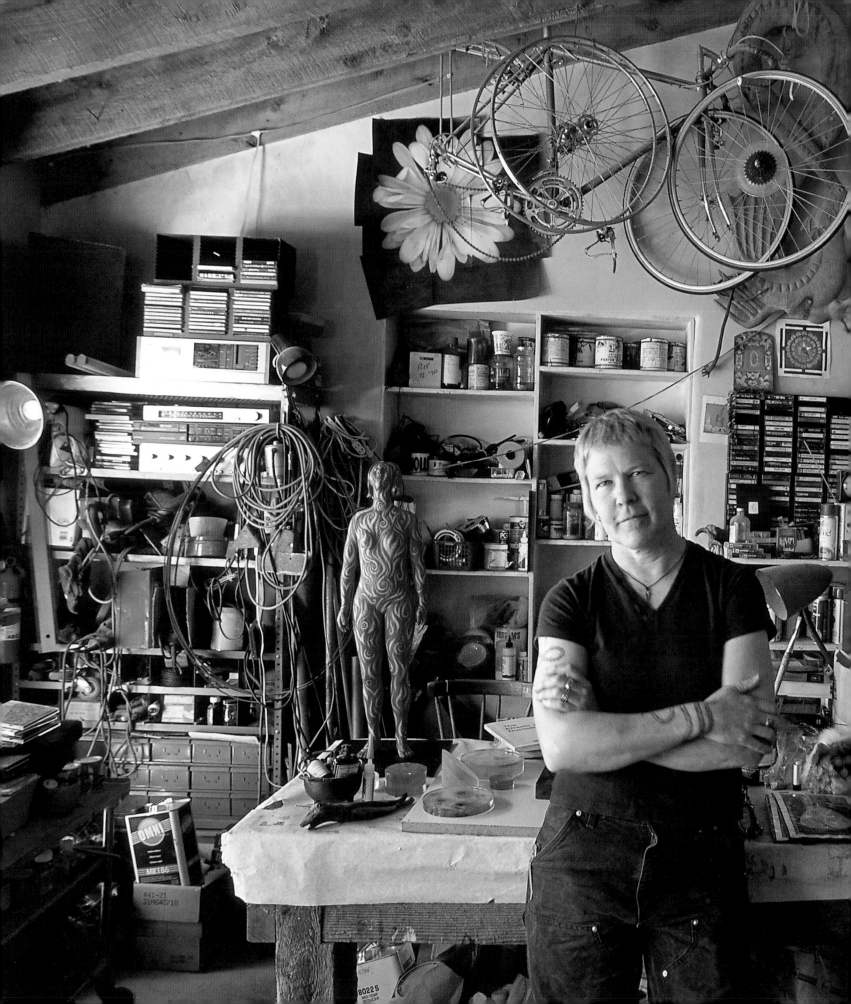

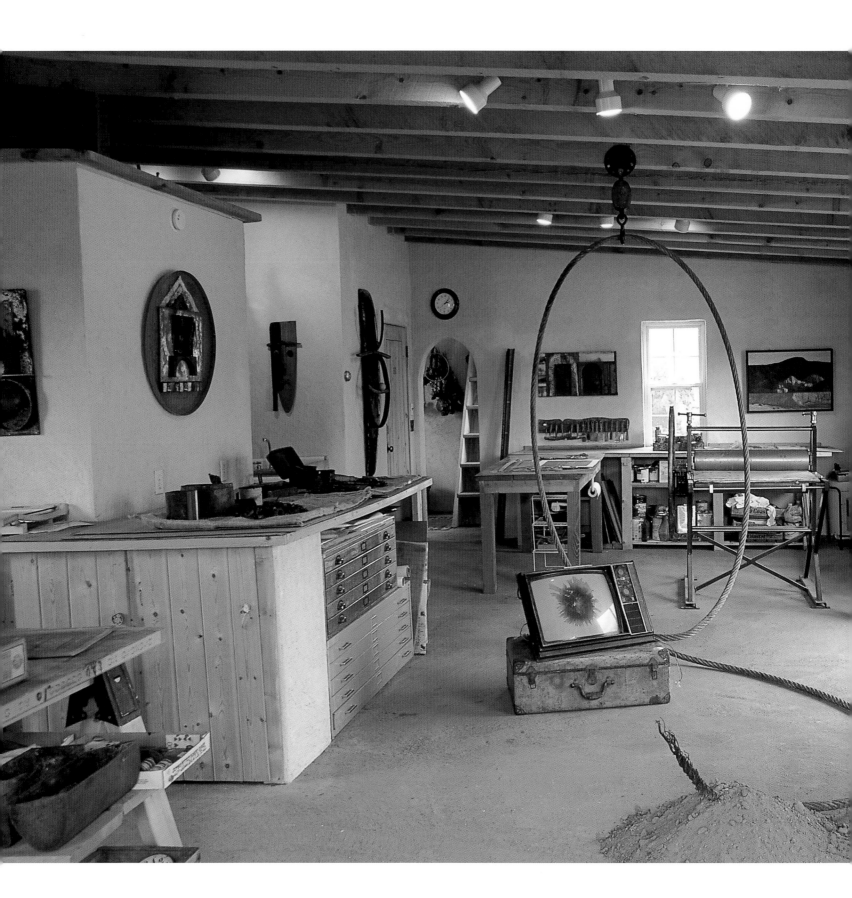

Iren Schio

Iren Schio's studio is in Abiquiú, close enough to Plaza Blanca—the subject of one of Georgia O'Keeffe's most famous paintings—that Schio, who likes to hike, often explores that legendary landscape.

When this artist says she built her studio, she means just that. She dug the foundation by hand, operated the cement mixer, and laid twenty-five hundred cinder blocks. She recalls that "putting up the beams was really a trip."

Not only did she design a beautiful studio, she also made sure it would be practical. The ceiling is high, as it is in many artists' studios, but not so high as to waste heat because, as she says, "We do have cold winters here in Abiquiú." The cement floor has an attractive finish that she achieved by applying polyurethane mixed with local earth over the roughened slab. It has the added advantage that it never looks like it needs to be swept.

In addition to the working space, the building includes a small upstairs bedroom and a full bath. Altogether, Schio says, the studio is perfect for her needs. And what, exactly, are the needs of this artist?

Since Schio makes collages and assemblages, she needs space for the organization and storage of a huge number of old and odd objects. Shelves, and the floor, too, hold leather suitcases, wooden crates, rusted metal bread pans, and cigar boxes. These in turn each contain objects organized by category: advertising pencils, doll parts, seashells, wooden blocks or rulers, tiny glass bottles, curls of wire, birds' eggs, patinated knives, scissors, bolts, nuts, tableware, rope, and rusted tools.

When materials spill over onto the window ledges, they create impromptu art pieces.

These disparate objects come from friends, secondhand shops, and ancient dumps. Each year Schio makes a trip to her native Switzerland and brings back suitcases filled with nineteenth-century books, old lace, medical tools—pieces of the puzzles that only this artist can assemble.

Schio sometimes turns these scraps and geometric fragments into playful male and female figures. Speaking of another Swiss artist, Paul Klee, whose work she admires, the artist asks, "Have you seen the puppets that Klee made? It's interesting how often artists—Calder, Picasso, Baumann, Braque—made marionettes and puppets. I think it's because these may have provided artists a way to interact with people, since we artists are always alone in the studio."

Whenever Schio goes to her storage area she reaches up to a bar that spans the top of the doorway and—easily—chins herself. Being fit is important to her; she and her husband, Bill Baird, play volleyball and go rock climbing. The east wall of her studio is a professional climbing wall. "By using your body, hiking, building, gardening, you bring a balance to your art life."

Eugene Newmann

In 1996 painter Eugene Newmann and his wife Dana, the author of this book, moved to Ribera, forty miles east of Santa Fe. The artist, who had always rented studios, had the opportunity for the first time to design his own workspace. "Well," he says, "it's laughable that when I finally got my shot at it I got it all wrong. I didn't place the windows high enough. I'm already feeling short of wall space. The lighting makes me uncomfortable. It doesn't seem to matter, though; the particulars of the studio don't make that much difference to me. Somewhere I've read that DeKooning said that the powerful gloomy hues of Rothko's late paintings were influenced more by the muted light that barely penetrated the filthy skylights in Rothko's studio than by any psychological factors. That sounds like a serious endorsement for the role of environment—but I think the Dutchman was pulling the interviewer's leg. In any case, I don't buy it."

During the more than twenty years that Newmann lived in Santa Fe, he occupied ten studios. He had long tenancies in two large industrial-scale buildings: one in the Sanbusco property on Montezuma Street, before it was converted into a shopping arcade; and the other on Early Street, where he shared the yard with the Capital City taxicab company. Sculptor John Connell had his studio in the same prefab metal building. The Raft Project, a collaboration between the two artists, grew out of conversations they had on visits to one another's studio and on coffee breaks at Dunkin' Donuts, which was a short block away. In this case, the space played a large part since the project, which traveled to museums in the late 1980s and early '90s, required mural-size paintings that would have been impossible to realize in any of the little "studios of opportunity" that the painter occupied before and after that.

A small window at one end of Newmann's current studio lets him look down a long view of the Pecos Valley. Here, New Mexico's characteristic patches of juniper and piñon are threaded by a ribbon of light-green cottonwoods that escort the river on its southward course towards the Gulf of Mexico. "Before coming here I never painted from the landscape," Newmann reflects. "I didn't even consider it." In recent years, however, references to landscape elements have appeared in his work—a grudging admission, perhaps, that environment does play a part, after all.

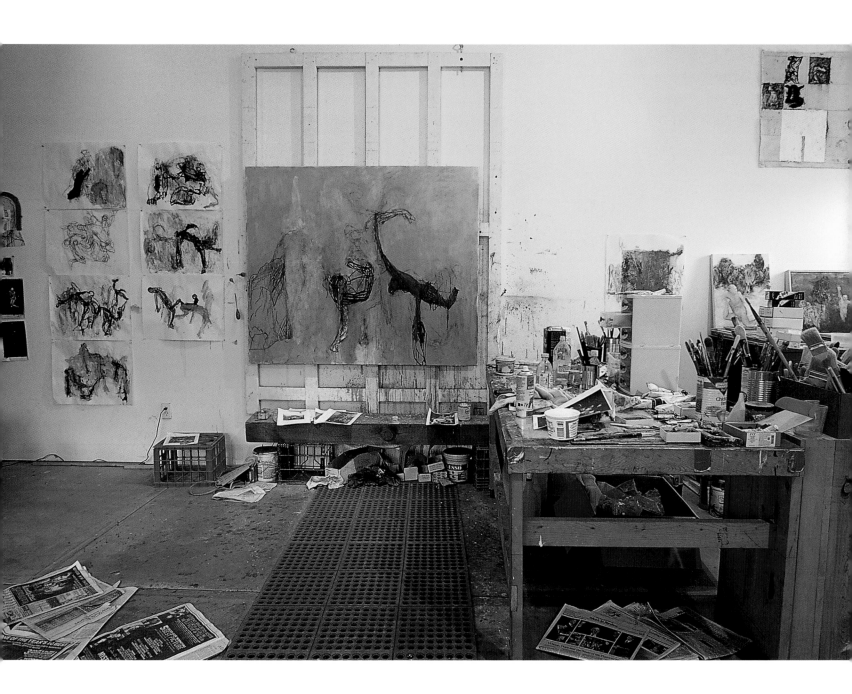

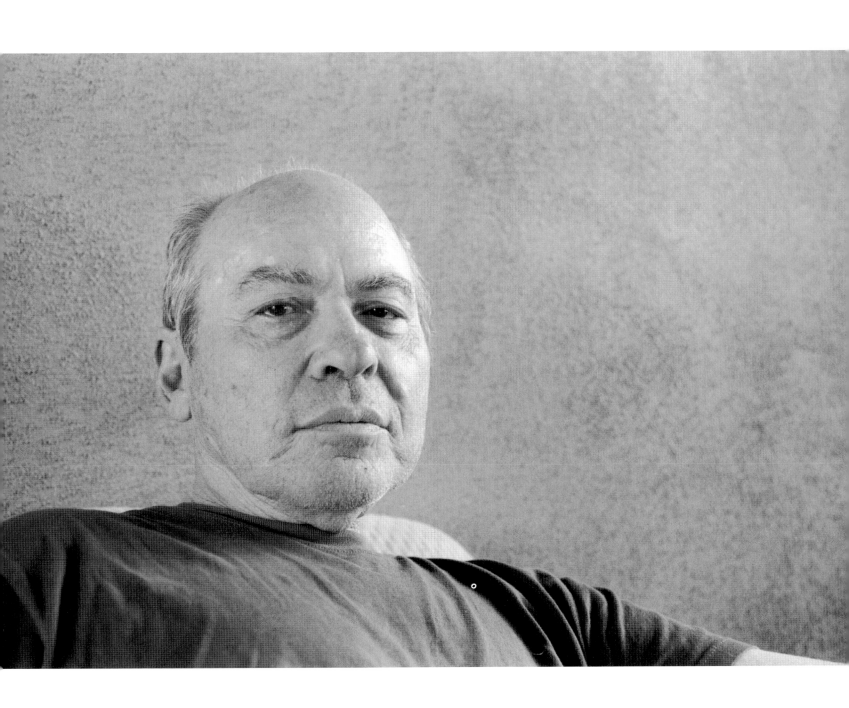

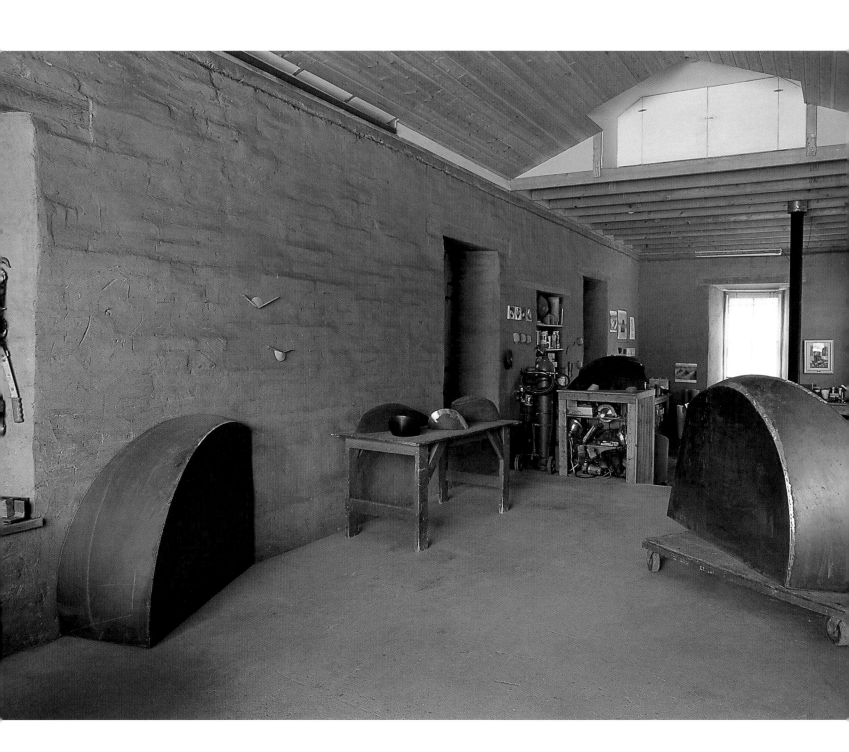

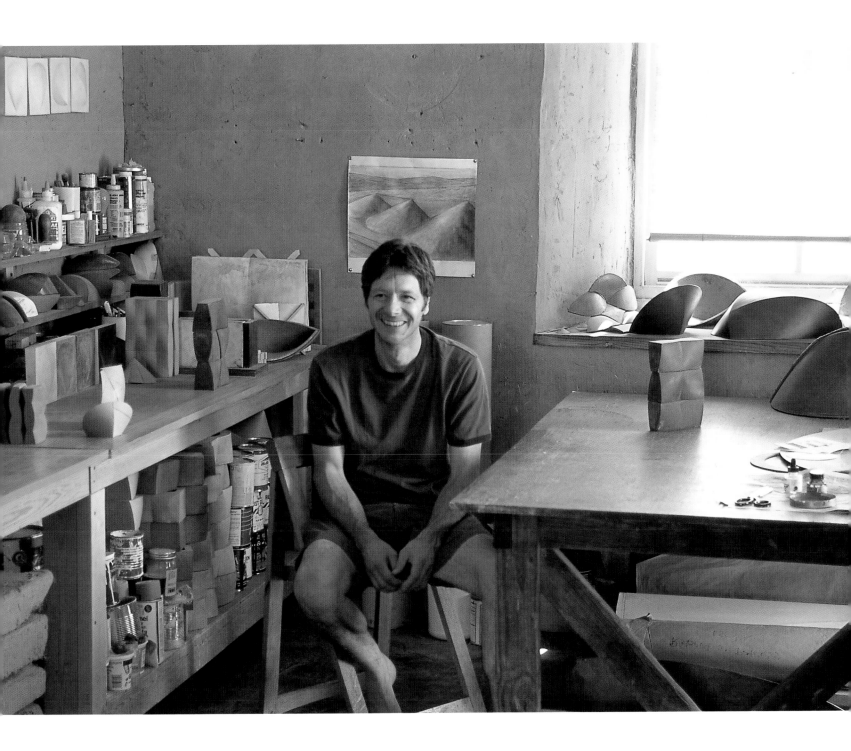

Tom Waldron

Last summer, Tom Waldron made a road trip through the Midwest observing and documenting the grain silos of the farmlands. The sculptor is drawn to the beauty of these austere giants standing formally at the edges of wheat and corn fields. It is this kind of observation of the common shapes of everyday experience that Waldron distills into the simple, but in each case individual, forms in his sculpture.

It was in architecture school that Waldron first started making maquettes, small models of proposed structures. On the lower level of his studio, beneath a long table, there are dozens of empty six-pack cartons and scores of shoestring potato containers. If you didn't know better, you might think that he lives on Dos Equis and potato snacks. The artist explains that he "had to eat all of those potatoes because the containers were exactly the right weight and shape for the models I make, and Dos Equis cartons are also excellent for making the maquettes for my sculpture."

Waldron has long worked in a narrow studio he built at right angles to his residence in Corrales in Albuquerque's North Valley. The space has two levels: the lower one designed for drawing plans and building models, the upper for the execution and finish of the pieces. In making the structure, Waldron used the traditional elements of rural New Mexico architecture: straw-flecked adobe walls, old-fashioned packed-mud floors, inset alcoves known as *nichos*, and deep recesses for the windows and doors that are visually framed in pine casements. He brought to the fabrication of his studio the same qualities of attention, reserve, and precision that are seen in his welded-metal sculptures.

When an artist builds a studio, he can't know what lies ahead. In 2001, Waldron was awarded a commission to design sculptural elements for a highway reconstruction project. He made a minutely detailed model, four by eight feet, of the I-40/Louisiana Boulevard interchange in Albuquerque and the complex groupings of simple landforms he means to construct there—forms that would combine with and, at the same time, provide an artful respite from the harsh contours of the freeway.

The model was built on a table with wheels for easy mobility, but even so the space where he makes his sculpture was continually compromised. For two years, welding dust would settle over models and engineering drawings—all of which set him to thinking about making a new work area.

Eventually, Waldron plans to construct a separate building off the courtyard behind his house. As he considers what type of structure will work well on the specific site, he is clear on one aspect of the proposed design: the work area must be flexible enough to accommodate whatever unusual requirements future projects may demand.

AT THE TURN OF THE TWENTIETH CENTURY, the Southern Pacific Railway built a majestic circular building on the outskirts of Las Vegas, New Mexico. This train repair station had thirty storage bins, each forty by ninety feet, with forty-foot-high ceilings.

Today the roundhouse is privately owned. Flocks of pigeons reside in the dim cool interiors. Occasionally a semi or thirty-foot-high piles of cattle feed are stored in a bin. This is also where, for the past fifteen years, Jerry West, painter and printmaker, has had a studio.

"I've always been impressed by the great integrity of this building," West states, "and I'm well aware of the magic of working and painting here."

In a space made available to him by the owner, the artist has built a working/living area in the back corner of one of the bins. The frame-construction walls and ceiling are covered with a double layer of heavy plastic. The modest interior space is twenty by thirty feet, which West has carpeted. There is an L-shaped painting and viewing area, with a small office-bedroom to one side. Here, a narrow bed is neatly covered with a fine old quilt made of tiny cotton triangles. The artist uses a two-ring hot plate for cooking and has created a simple ventilation system to bring fresh air in from outdoors. He has electricity for painting and reading at night, but there is no plumbing. "I actually like being primitive," West says.

In the winter, when it is too cold to work in the roundhouse, he paints in the studio he built himself on the old family property south of Santa Fe, a ranch that was originally owned by his father, painter Hal West.

He reflects on how he has made images all his life. It was drawing, he says, that got him through his early school years. Santa Fe was smaller then, so when West entered high school, the art teacher, Jozef Bakos, had heard of the teenager's talents. "He was ready for me," West chuckles.

Bakos (1891–1977) was one of the legendary Cinco Pintores of early Santa Fe. Besides being well known as an artist he was also a fine carpenter; he built many of the now-historic studios and houses of the other Pintores. Bakos became a mentor for the young West, and on weekends taught him carpentry and the art of fine plastering. Decades later, West would himself build beautiful distinctive homes and studios for many of his artist friends, including Carol Anthony, Eugene Newmann, and photographer Joan Myers.

Although he has traveled, taught, and exhibited throughout America, West is deeply Santa Fean. His artwork, whether oil paintings, prints, or murals, is grounded in the lore and landscape of New Mexico: parades, huge skies, cottonwoods, Zozobra, horses, adobes, and his childhood memories.

Jerry West, the artist, builder, teacher, is the quintessential Renaissance man—southwestern style.

Jerry West

(following page)

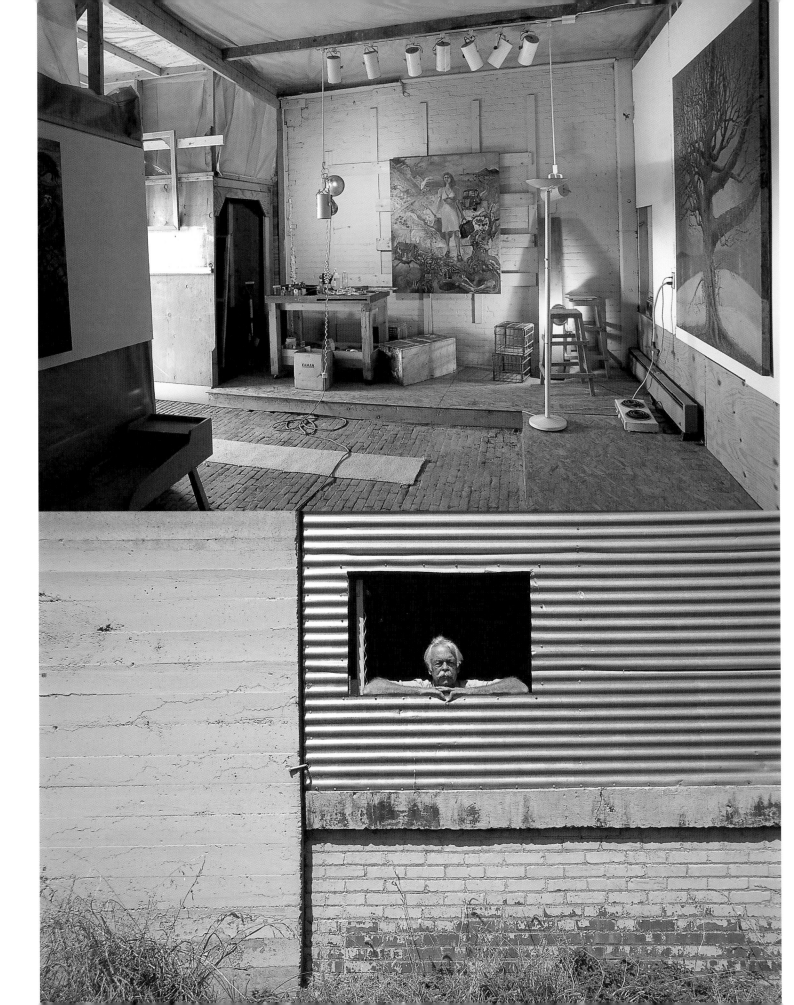

W<small>HEN</small> D<small>ANA</small> N<small>EWMANN</small> suggested that we do a book together on artists' studios, I was immediately drawn to the idea because I had been photographing non-stop for a number of books and magazine articles on homes, architecture, and decor. The idea of documenting artists' studios was a welcome change and challenge—the studio is a working place, not a showplace, with all the unconscious edginess of the artist giving his or her space an energy and individuality indifferent to the visitor, the photographer, or the collector of art. I could take a deep breath realizing I didn't have to make these spaces look beautiful, sexy, or alluring. Instead I could concentrate on the more daunting task of capturing the individual spirit of these work places.

As the project developed I quickly realized that each of the spaces we found ourselves in had an integrity that reflected the needs and constraints of the artist and his or her work and this provided an inspiring kind of beauty. An ex-basketball court housed a rearing horse, a stone schoolhouse mutated into a gallery filled with brilliant red and black canvases, a yurt was filled with hand-made books and found treasures, and a roundhouse for locomotives was now a granary and storage space for eighteen-wheelers and, incidentally, a studio. Living rooms, bathrooms, garages all became the necessary spaces within which to create.

I was also excited to have the opportunity to see the art and the artist in their own space. I've always admired artists greatly for, among other things, their perseverance in putting their own personal vision out in front of the world, and doing it again and again. To be in the space where this vision is refined, questioned, and examined imbues the individual studio with special meaning. These are private, not public, spaces and generally not meant to be visited by outsiders; thus they often have have a cloistered feel to them, a serious weight even when they possess a lighness of touch. In photographing them, we wanted to see the art but have it be secondary to the space, yet part of the space. We also decided to have photographs of the artist so that the reader would have the portrait along with statements by the artists to complete the experience of seeing the artist at work.

Finally, it was inspiring to see work in the studio before it was shipped to a gallery or museum. There is a comfortable intimacy about work in the studio, an almost neutral feel to it before it's exhibited in its new home, as if it hadn't yet assumed its worldly importance but was still attached to both the artist and the space around it. At this stage it's still all about process and the encompassing space.

BIBLIOGRAPHY

Baca, Elmo. *Mabel's Santa Fe and Taos: Bohemian Legends* (1900–1950). Salt Lake City, Utah: Gibbs, Smith Publisher, 2000.

Bell, Barbara G. *Modern Themes in New Mexico: Works by Early Modernist Painters*. Santa Fe, N.M.: Gerald Peters Gallery, 1989.

Bernstein, Bruce and Rushing, W. Jackson. *Modern by Tradition: American Indian Painting in the Studio Style*. Santa Fe: Museum of New Mexico Press, 1995.

Coke, Van Deren. *Andrew Dasburg*. Albuquerque: University of New Mexico Press, 1979.

Ellis, Simone. *Santa Fe Art*. New York: Crescent Books, 1993.

Historic Santa Fe Foundation. *Old Santa Fe Today*. Preface by John Gaw Meem. Santa Fe and Albuquerque: The Historic Santa Fe Foundation, University of New Mexico Press, 1991.

Liberman, Alexander. *The Artist in His Studio*. New York: Viking Press, 1960.

Luhan, Mabel Dodge. *Intimate Memories: The Autobiography of Mabel Dodge Luhan*. Albuquerque: University of New Mexico Press, 1999.

————-. *Taos and Its Artists*. New York: Duell, Sloan & Pierce, 1947.

Mc Cracken, Harold. *Nicolai Fechin*. New York: The Ram Press, 1961.

Museum of Fine Arts (Museum of New Mexico). *Artists of 20th-Century New Mexico: The Museum of Fine Arts Collection*. Santa Fe: Museum of New Mexico Press, 1992.

Museum of Fine Arts (Museum of New Mexico). *Light & Color: Images from New Mexico*. Santa Fe: Museum of New Mexico Press, 1981.

Nelson, Mary Carroll. *The Legendary Artists of Taos*. New York: Billboard Publications, 1980.

Patten, Christine Taylor and Cardona-Hine, Alvaro. *Miss O'Keeffe*. Albuquerque: University of New Mexico Press, 1992.

Robertson, Edna C. *Los Cinco Pintores*. Santa Fe: The Museum of New Mexico, 1975.

Robertson, Edna, and Nestor, Sarah. *Artists of the Canyons and Caminos: Santa Fe, the Early Years*. Salt Lake City, Utah: Peregrine Smith, 1976.

Rudnick, Lois Palken. *Mabel Dodge Luhan, New Woman, New Worlds*. Albuquerque: University of New Mexico Press, 1984

————-. *The Unexpurgated Self: A Critical Biography of Mabel Dodge Luhan*. Doctoral thesis in American Studies, Brown University, 1977

Udall, Sharyn Rolfsen. *Modernist Painting in New Mexico 1913–1935*. Albuquerque: University of New Mexico Press, 1984.

————-. *Santa Fe Art Colony, 1900–1942*. Santa Fe, N.M.: Gerald Peters Gallery, 1987.

White, Robert R. *The New Mexico Painters*. Santa Fe, New Mexico: Gerald Peters Gallery, 1999.

White, Robert R. *The Taos Society of Artists*. Albuquerque: University of New Mexico Press, 1998.

Works and Words of Santa Fe Artists. Santa Fe, N.M.: C. R. Wenzell Publications, n.d.